Horst A. Friedrichs Stuart Husband

SCOTCH

THE STORIES
BEHIND SCOTLAND'S
ICONIC SPIRIT

PRESTEL

Munich · London · New York

CONTENTS

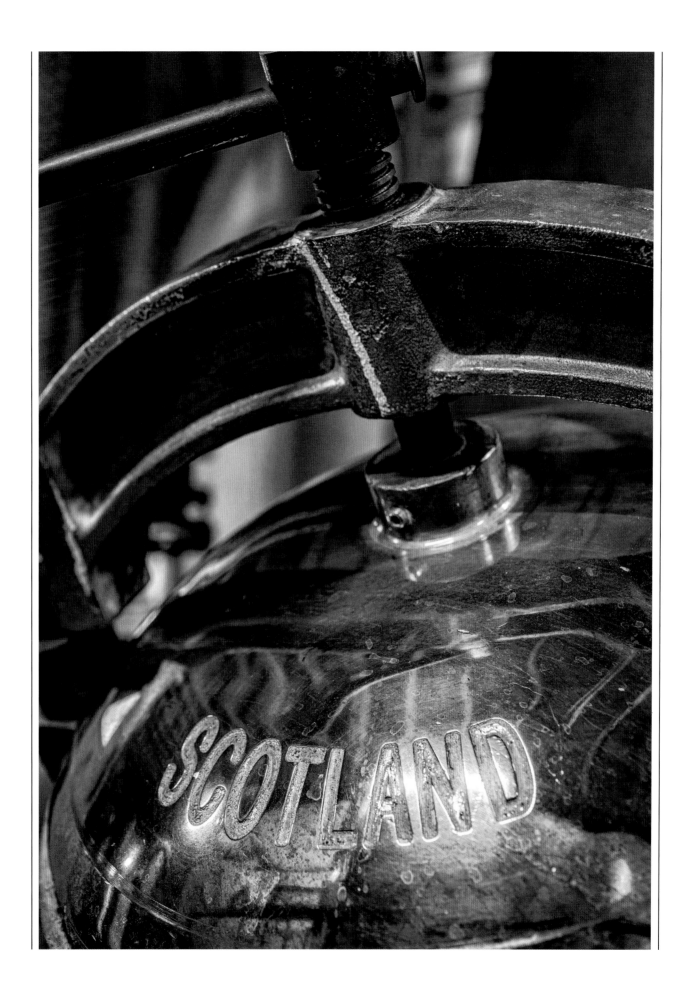

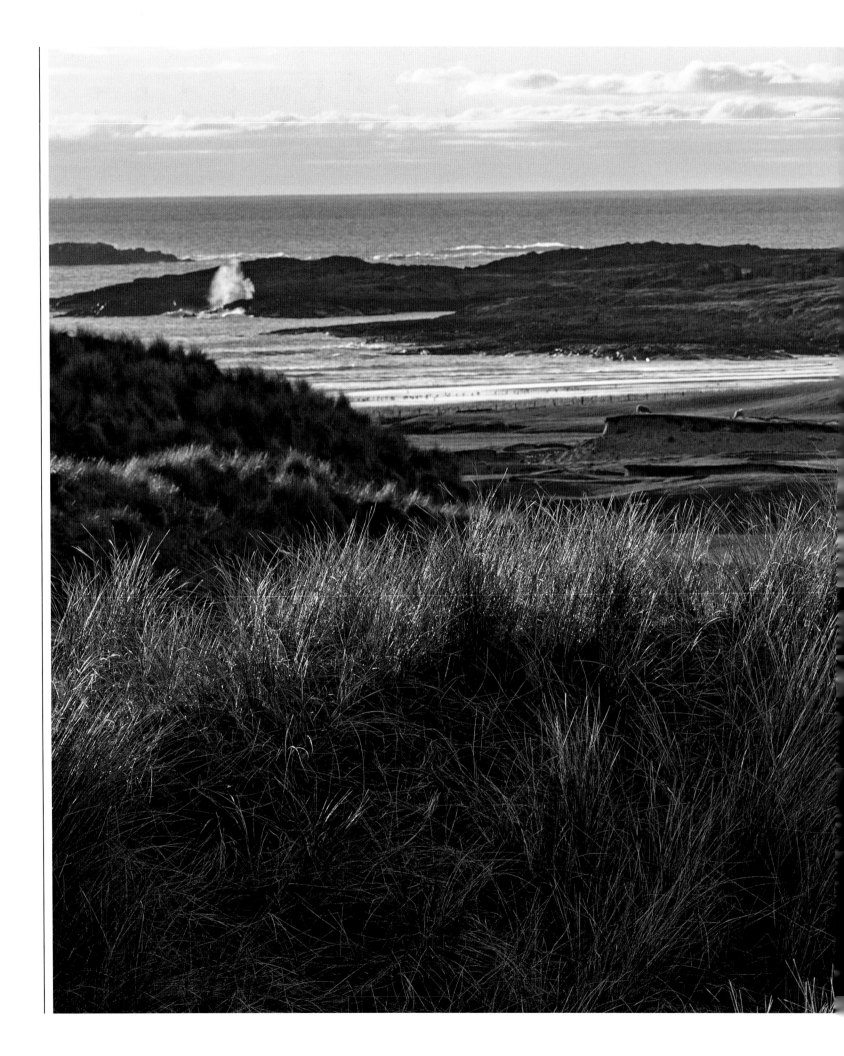

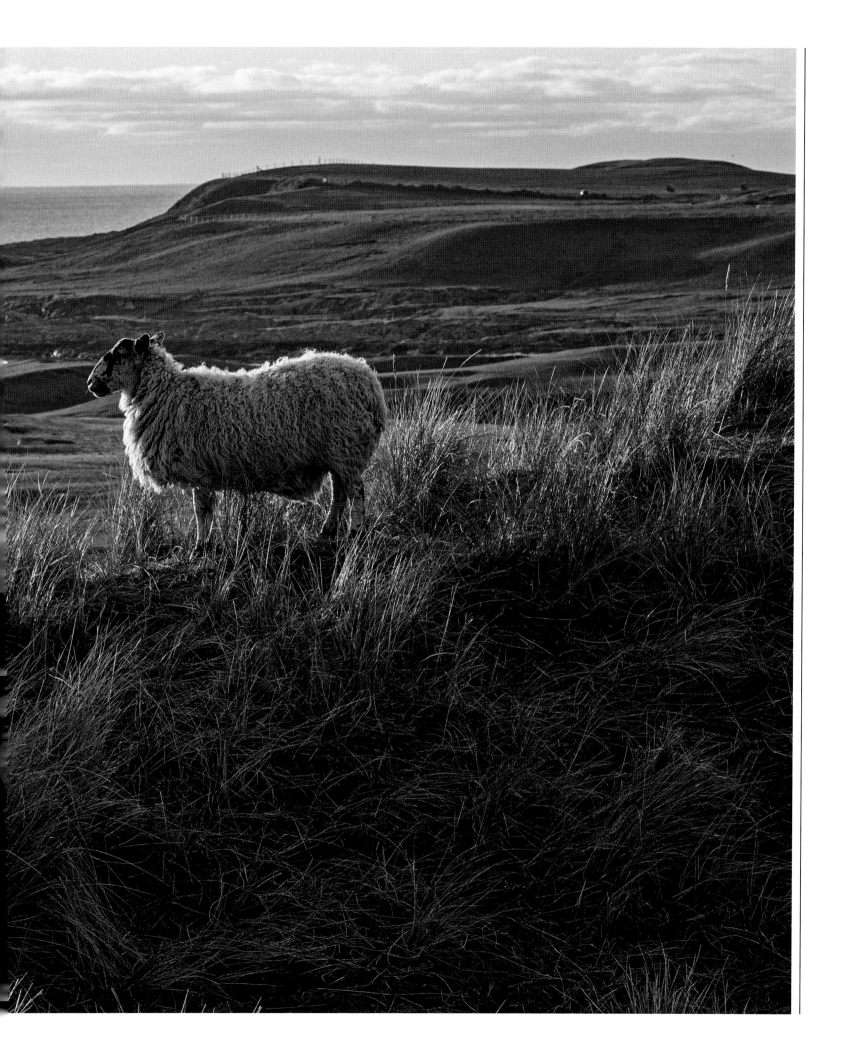

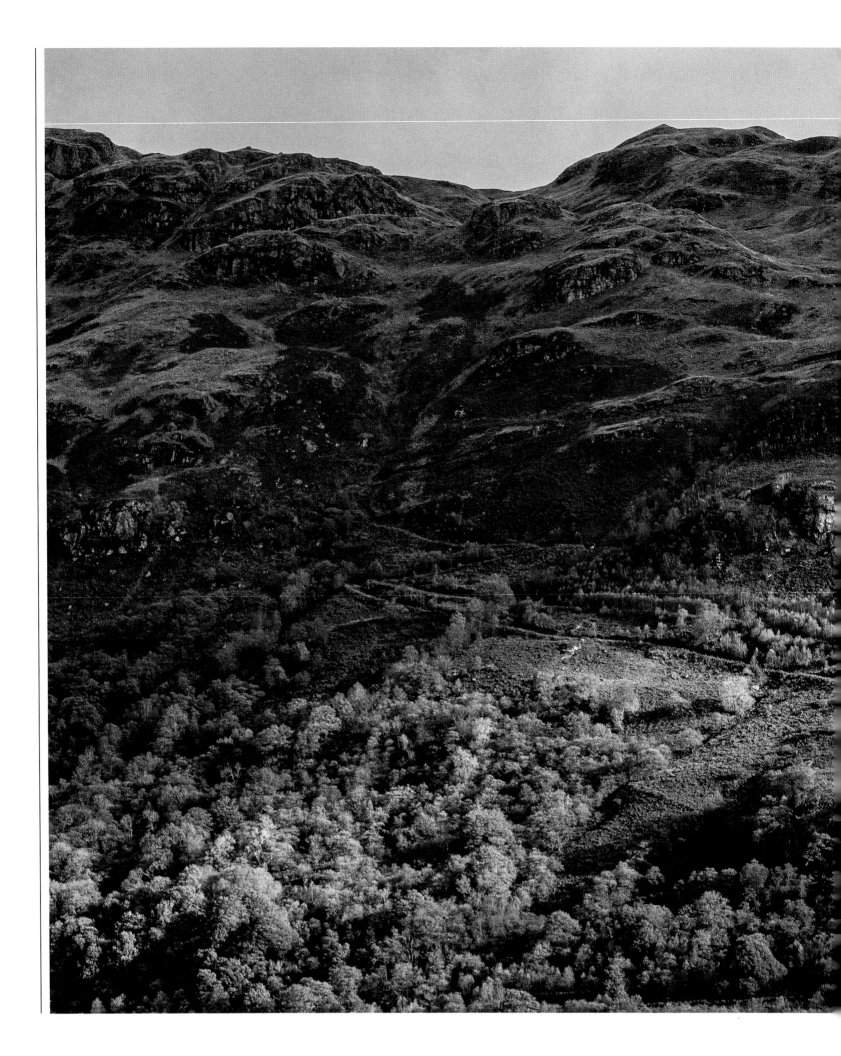

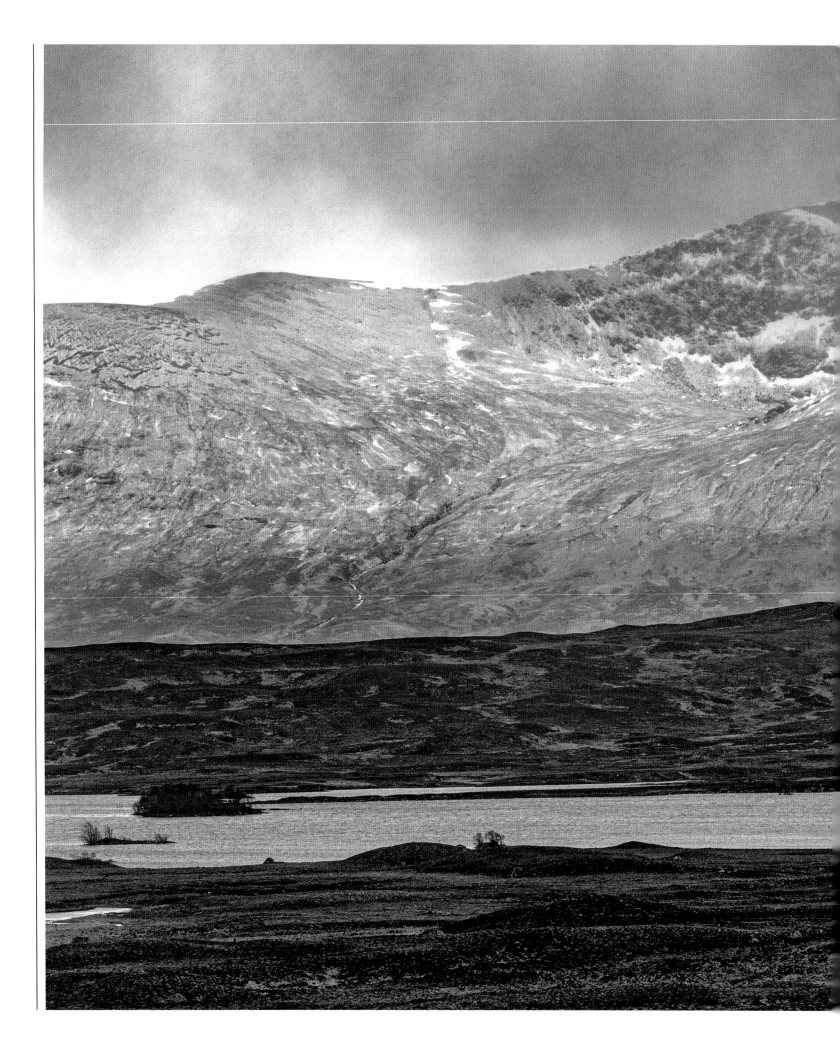

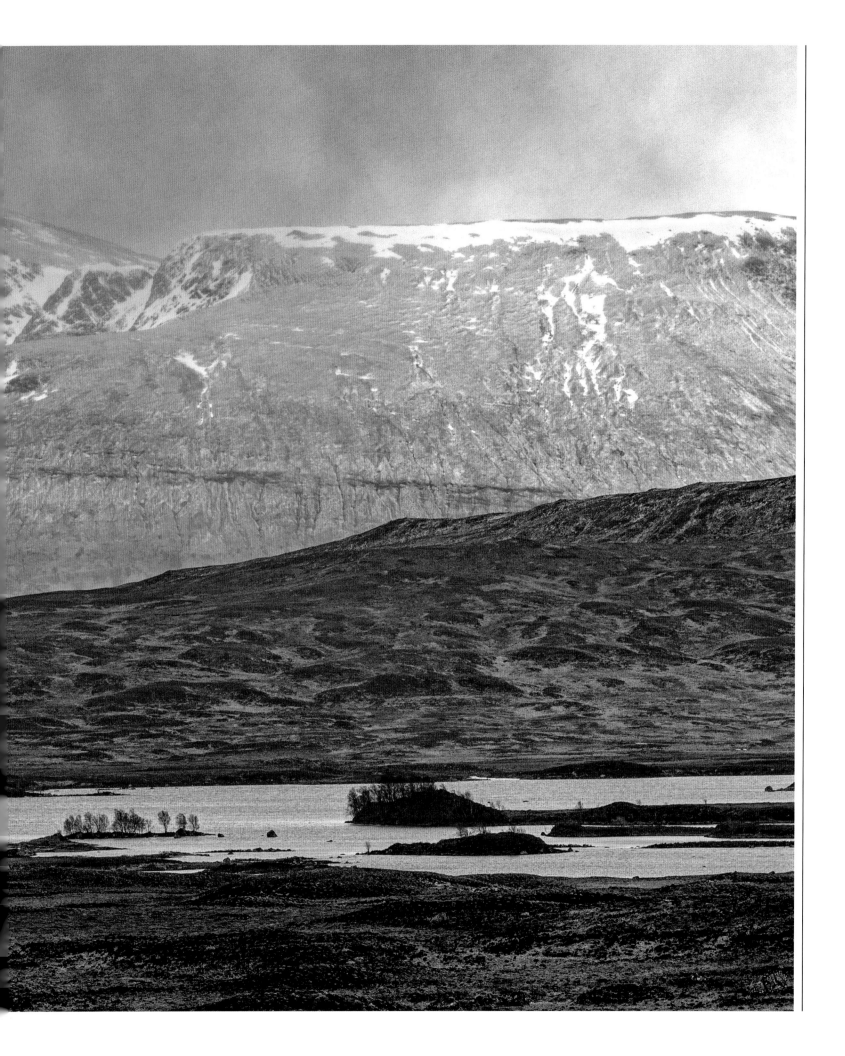

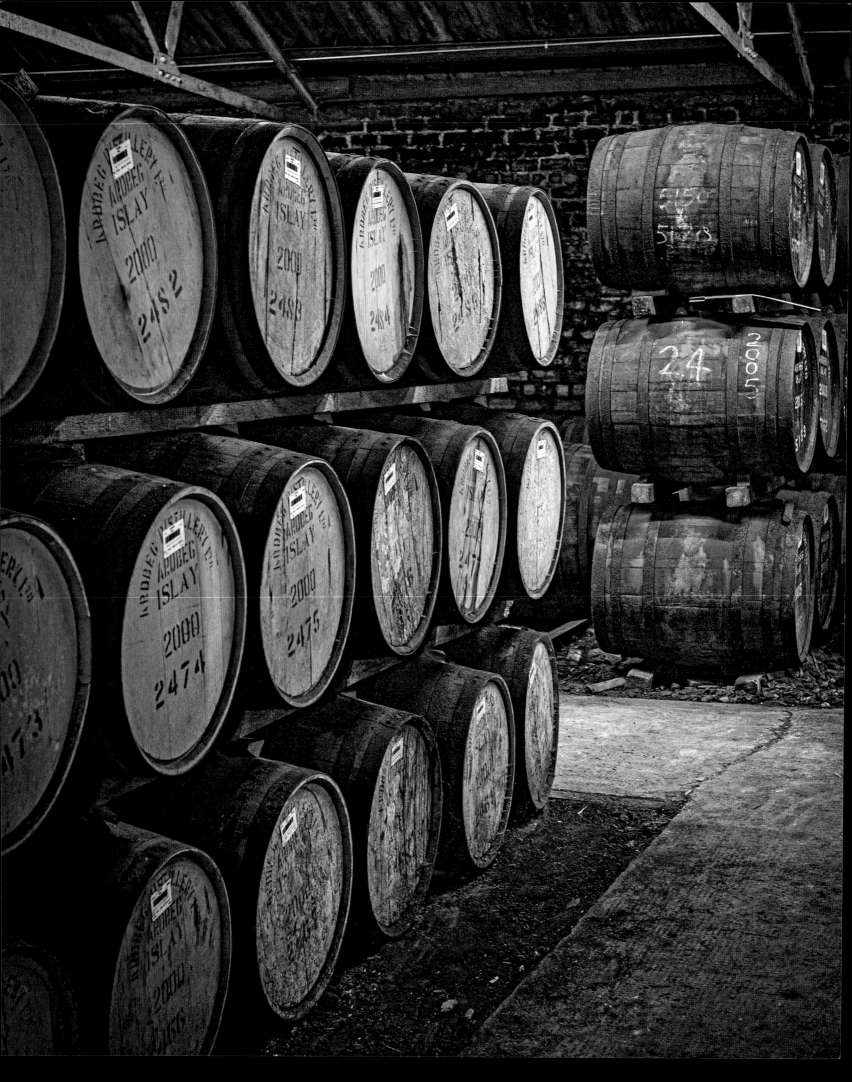

LIVING THE DRAM

Horst A. Friedrichs and Stuart Husband

Everyone has their eureka moment with whisky; that instant when it ceases to be a mere drink and becomes something more profound. For us it happened some time into our 8,000-mile road trip mapping the best and brightest of Scotland's distilleries. We found ourselves on the remote and rugged Morvern Peninsula, a long finger of land snaking along the Sound of Mull. Having gotten a little stir-crazy from vehicular confinement, we decided to take a typical Scottish walk; a lochside eight-miler to a ruined castle and back. It turned out to be more typical than we could have imagined; as the path arched up over the sound, the squalls threw horizontal rain in our faces whose drops landed like miniature darts. The wind roared; sea eagles wheeled overhead; the mist descended. By the time we returned to our bunkhouse we were comprehensively, radically, unsparingly drenched. Naturally, we had some whisky at hand. Reflexively, we reached for it. The sense of warmth and wellbeing was instantaneous. Suddenly, it all made perfect sense; whisky as medicinal fillip. Whisky as restorative balm. Whisky as an earthy elixir distilled from the elemental landscape we'd just experienced in all its ferocity and grandeur. Whisky as friendship-fixer and memory-maker.

We hope that sense of warmth and wellbeing imbues all the stories you'll find in this book. The seventeen distilleries we visited, from Campbeltown to Speyside, from the Highlands to the islands, and from rural redoubts to urban hubs, all add their own ingredient – passion, commitment, vision, innovation, sheer bloody-mindedness – to the barley, water and yeast that are intrinsic to any great Scotch. Ranging from the ancient floor maltings of the legendary Springbank distillery to the twenty-first-century single malts being produced by a new generation of Scotch pioneers, we pay homage to the time-honoured traditions of whisky production while showing how today's distillers are putting their own contemporary stamp on Scotland's iconic spirit. Slàinte, then, to all the wonderful whisky folk for sparing your time and sharing your drams. What have we learned? That there's a Scotch for everyone, whether you're more partial to peat heat or fruity mellifluousness. That there are compelling reasons for the cult-like auras that surround certain distilleries, both old and new. And that Scotch is to be savoured. From mesmeric mouthfeel to lingering sultriness, it all boils down to George Bernard Shaw's deft distillation: "Whisky is liquid sunshine."

A NEW SPIRIT

by Charles MacLean M.B.E., Master of the Quaich

This book arrives at a time of significant change in the Scotch whisky industry. A time when many distilleries, especially the recently commissioned ones, are rethinking product and process, sustainability and the role of distilleries in local communities.

Scotch benefits from the fact that neither author or photographer are experts on the subject, so approach it candidly, from a layperson's perspective, with an "innocent eye". Horst Friedrichs' photographs are, frankly, stupendous. They capture the wild beauty of the Scottish landscape, the intrigue of distilling equipment and the personality of the distillers portrayed, while Stuart Husband's engaging text allows the distillery operators to express their own views, while adding personal thoughts and anything else which inspires him.

Before I consider the issues outlined above, I propose to look at the recent history of the Scotch whisky industry, which provides the background to the subject.

The past twenty years has been a period of unprecedented growth in production capacity: forty-two new distilleries have opened since 2004, and a further thirty-seven are currently proposed or under construction. In addition to these, many established distilleries have expanded substantially, some doubling capacity. In brief, over the past fifteen years the capacity of malt distilling has increased by 60 per cent, although not all distilleries are operating flat out.

Such optimism is based upon the anticipated global demand for Scotch whisky in the coming decades – a fiendishly difficult exercise, vulnerable to factors beyond the industry's control, including the global economy and international politics, not to mention sale-of-alcohol regulations, duties and fashion in over two hundred markets.

Blended Scotch is still the backbone of the industry, accounting for slightly over 90 per cent of the total market by volume, although single malt whiskies now contribute at least 35 per cent profitability by value. Until relatively recently, all but a tiny fraction of the malt whisky made went into blended Scotch. The blending houses – WALKER, BELLS, CHIVAS, DEWARS, and so on – were the customers. Indeed, production at any distillery in any year was geared to "filling orders" from blenders, who also demanded consistently flavoured spirit from their suppliers. Without this, it is well-nigh impossible to create consistent blends.

The demand for blended Scotch reduced during the late 1970s, however, leading to a reduction in the number of blending houses and the closure of many distilleries in the early 1980s. The situation was compounded by overproduction during this period, which left distillers with significant stocks of whisky on their hands. A possible solution to the problem was to bottle and promote their own brands as single malts.

In 1970, less than 1 per cent of malt whisky was bottled as single malt and sold to consumers; by 1990, this had risen to around 6 per cent and today it is slightly less than 10 per cent by volume, although, as I have mentioned, it accounts for significantly more by value. It might be argued that the renaissance of malt whisky saved the day.

Most long-established malt distilleries will continue to supply the bulk of their product to blenders, although some famous names – including seven of the eight "traditional distilleries" embraced by this book – bottle most of their whisky as single malt. But the option to sell spirit to blenders is not available to the majority of "new" distilleries: their single malts must stand or fall by their own merits for the consumer. As Anthony Wills, Kilchoman Distillery, told the author: "You have to capture people's imagination somehow."

The million-dollar question is "how?" And this is where the newcomers are able to differentiate their creations from traditional malts, untrammelled by the blenders' need for uniformity and consistency. "It's a really interesting time", says Simon Thompson (DORNOCH DISTILLERY), "with small guys like us, NC'NEAN, ISLE OF RAASAY and TORABHAIG, producing 'hands-on' single malts."

As will be abundantly clear from a perusal of the text, the new malt whisky distillers are passionate about what they do. All focus on flavour, quality rather than quantity, craft, creativity and sustainability. Many are acutely conscious of their responsibility to their local communities. ISLE OF HARRIS, in the Outer Hebrides, which describes itself as "the social distillery", employs a team of four distillers, all locals new to the craft, and their nosing panel is made up of six community volunteers as well as the distillery's team. Norman Gillies, manager of the equally remote ISLE OF RAASAY DISTILLERY and a local man, says simply: "The dream is to create jobs here, and to keep them here." TORABHAIG DISTILLERY on the Isle of Skye provides full-time rather than seasonal employment for locals and encourages its staff of nine to create their own "Journeyman's Drams" according to their own recipes.

At the end of the day, flavour is the most important factor in persuading consumers to "buy the next bottle". Although the distilling process is simple, the impact on flavour of every stage is hugely complex. Many of the new generation of distillers are exploring this, challenging tradition, asking themselves: "What is whisky? What can we learn from the past? What can we learn from brewing? What happens if we use non-traditional yeast varieties, longer fermentations, slower distillation, unusual casks... and so on?"

HOLYROOD DISTILLERY in Edinburgh is a good example. Here they focus on the malts used by brewers, heritage barley varieties and novel yeasts, in collaboration with Heriot-Watt University's Department of Brewing and Distilling. Assistant manager Calum Rae says: "I think we tried out around ninety-nine recipes in the last year, which is madness. But we can distil that down, pardon the pun, into a real solid information bank of what works for us."

In his interview with Stuart Husband, Holyrood manager Marc Watson concluded: "Our production is tiny – only 229,000 litres a year – so the spirit must be impactful and exciting, driven by something different to heritage, because we don't have that. We're putting Scotland back into the conversation of making amazing whisky and being creative with it. But in the end, we just want people to enjoy it."

That about sums it up.

CHARLES "CHARLIE" MACLEAN, described as "the doyen of whisky writers", has published a wealth of books on the subject, including his magnum opus *Malt Whisky* (1997). He received an M.B.E. in 2021 for his services to Scotch whisky, UK exports and charity, and has been a Master of the Quaich, the highest accolade the Scotch whisky industry can bestow, since 2009.

Springbank
produces
three distinct
single malts:
Hazelburn
(unpeated,
triple-distilled);
Springbank
(medium-peated,
two-and-a-half-
times distilled);
and Longrow
(heavily peated,
double-distilled).

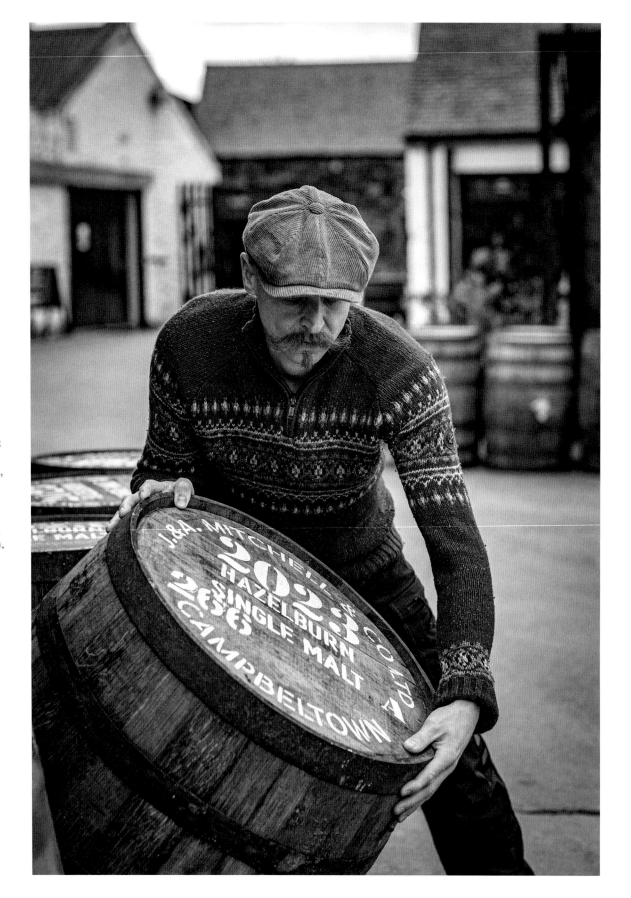

SPRINGBANK DISTILLERY

EST. 1828

CAMPBELTOWN

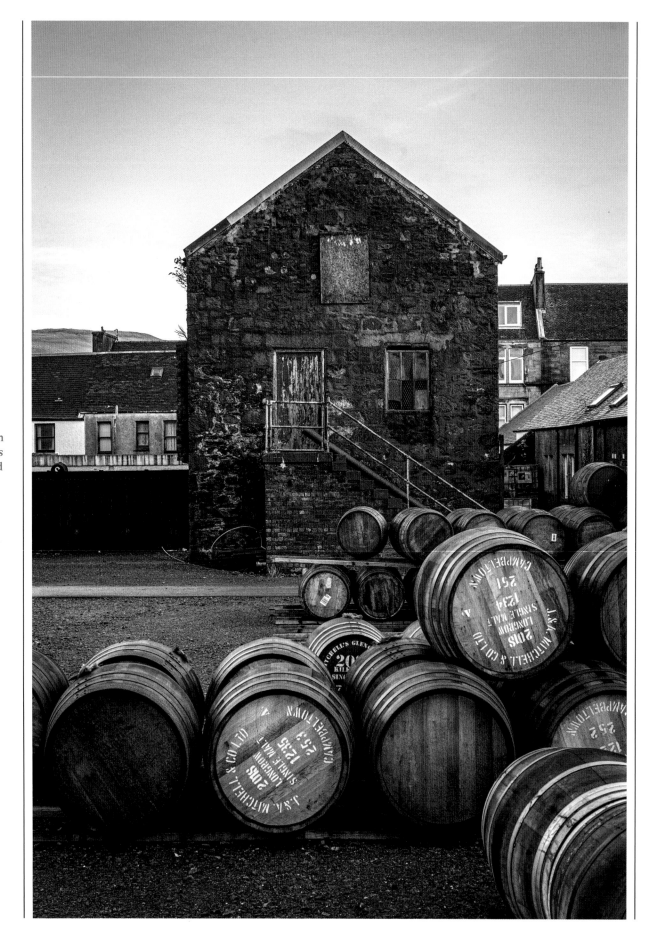

The Springbank "campus" – from weathered sheds to whitewashed warehouses – has pride of place in the very heart of Campbeltown.

Springbank Distillery

It's instructive to observe the reactions of Scotch whisky buffs as they enter the precincts of Springbank Distillery, in the heart of Campbeltown; there's a sudden verve in their step – the Springbank strut? – and, if they don't bend down to kiss the ground, it's only because they're not sure which part of the unassuming campus deserves their tribute most: the malting floor, straight ahead; the warehouses, dotted around the various lots; or the bottling hall, off to the left. The tower of the adjacent evangelical church might loom over the site, but, for those taking in the malt-raking or the barrel-rolling, this is the real hallowed ground, the place where a certain kind of holy spirit resides. In an industry that fosters strong loyalties, Springbank can possibly boast the cult-iest following of all.

Why so? According to the late author Iain Banks in his Scotch whisky travelogue *Raw Spirit*, it's because "it does all the things almost nobody else does – malts its own barley (grown locally), flavours and dries the barley over smouldering local peat, directly coal-fires its stills, doesn't chill-filter or use caramel colouring, and two-and-a-half and triple distils". This produces a "deep, convoluted, yet zesty and somehow youthful" spirit that combines "surf and turf", "salt sea airs" from the Atlantic swells, plus "root-tangled earth" and "quayside tar".

Some things have changed since Banks wrote those words in 2003 – there's now an oil-fire heater on the wash still, though the open flame thrillingly survives – but much else looks and feels pretty much as it would have done in 1820, when Springbank first threw open its doors. Workers spend a nine-month season turning 200 tons of barley into malt (with the raking so intense that the "human shovels" typically lose around three and a half stone over its course), and you'll also find open-top mash tuns and boat-skin larch washbacks. "I think this place is a bit like a Charlie and the Chocolate Factory for whisky," says David Allen, Springbank's sales director. "Tourists have come in the off-season, and they say 'This is a really nice museum, but where do you actually make the stuff?' But we're revered because we're the only distillery in Scotland that carries out the full production process on-site, and

we've always done what's right for Springbank and Campbeltown, not leant into trends and fashions."

Springbank's location is surely another facet of its allure. Despite the town's remoteness – visitors by road have to arc around the top of Loch Lomond before barrelling down the long, bony finger of the Campbeltown Peninsula – it used to be the whisky capital of the world, hosting thirty distilleries at its height in the late 1800s. There was barley, peat, coal from a nearby mine, and a fast sea route for exports from the deep-water port. Then boom turned to bust thanks to production peaks and quality troughs. Today there are just three distilleries (though at least three more are scheduled to open in the coming years), with Springbank the great survivor. "It's been the guardian, the custodian, the flag-bearer of Campbeltown," says Allen. "You can taste the place in the spirit – the robustness, the complexity, even the oiliness."

In fact, Springbank produces three distinct expressions – the unpeated, triple-distilled Hazelburn; the two-and-a-half times distilled, medium-peated Springbank; and the heavily peated, double-distilled Longrow. "It's unusual, and goes against the grain, no pun intended," says Allen, "but the reason we can do it is that we're fiercely independent." The distillery is currently in the hands of Hedley G. Wright, the great-great-great-great grandson of original founder Archibald Mitchell, and perhaps the starkest example of its contrarian streak is that, despite doubling production in 2018 and currently employing a hundred people, it produces only 15 per cent of its nominal annual capacity of 750,000 litres, thus provoking sneaker-drop-like levels of feverish anticipation among fans (including, reportedly, Bob Dylan, no mean contrarian himself) for its new releases and limited editions. "We could double production but we don't want to lose our core market, who've been drinking Springbank for longer than I've been alive," says Allen. The look of fulfilment among the pilgrims as they make their way from the Washback Bar to the distillery store and the singular delights within only confirms Allen's Willy Wonka analogy; access to Springbank, for the lucky few, is a golden ticket.

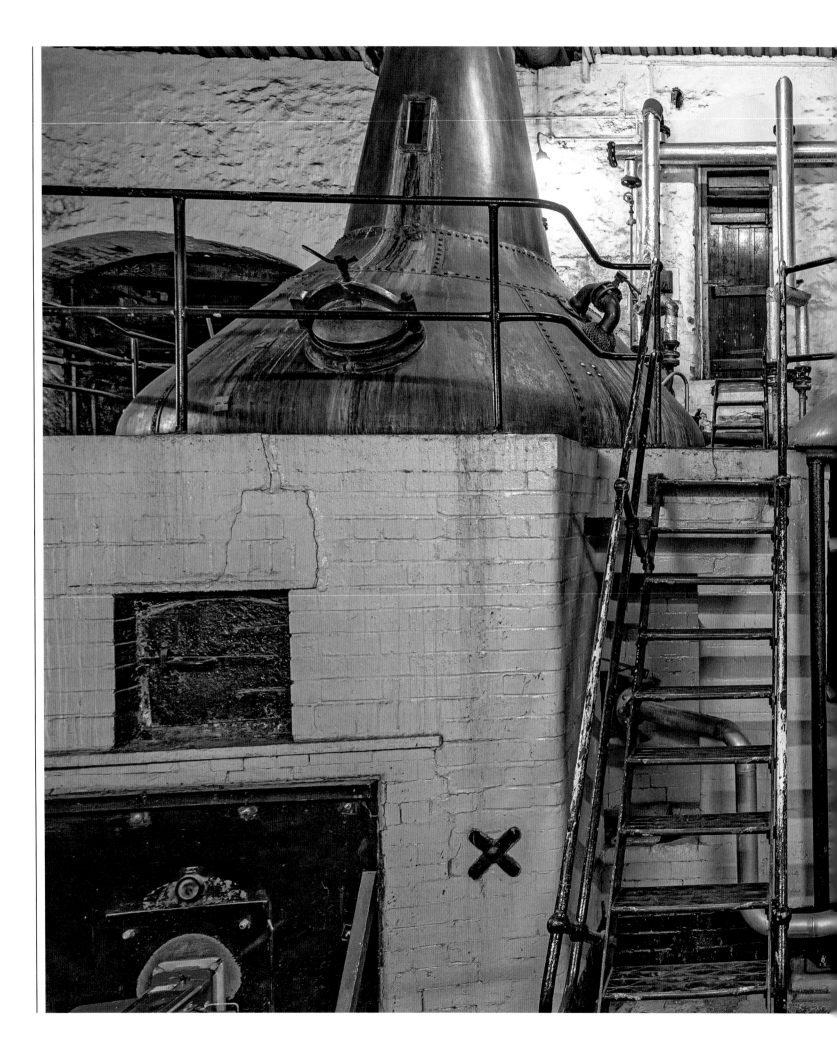

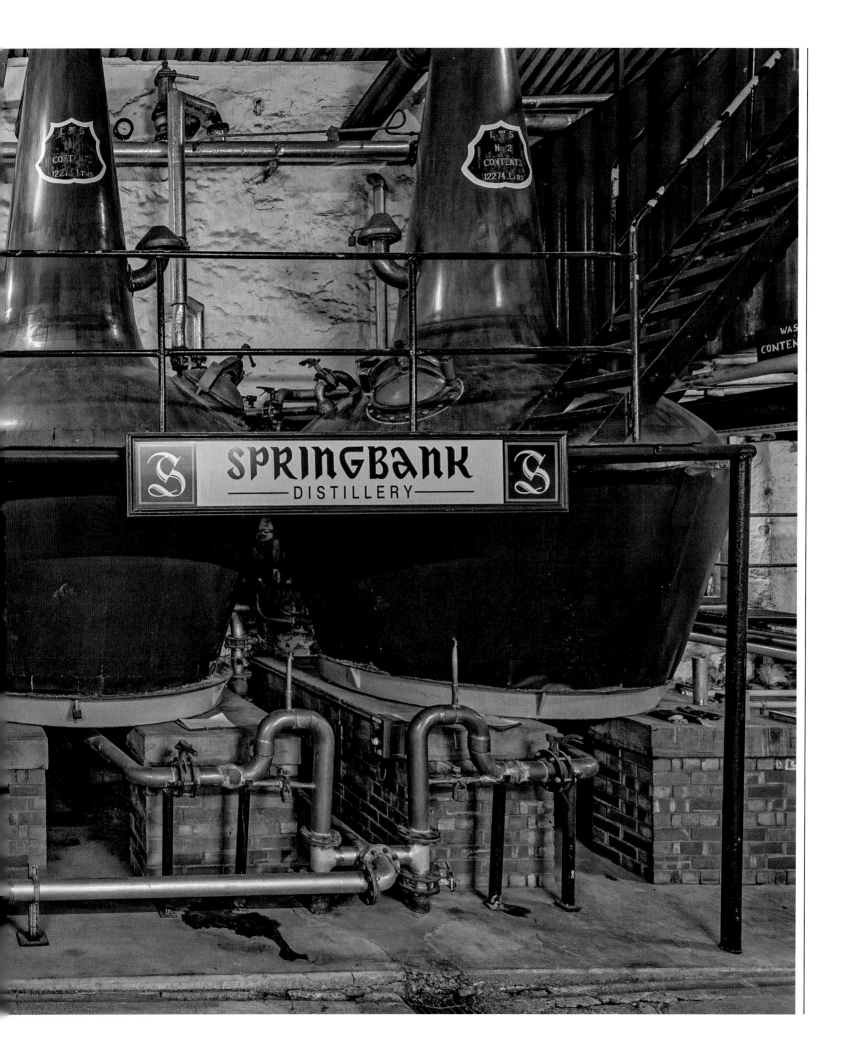

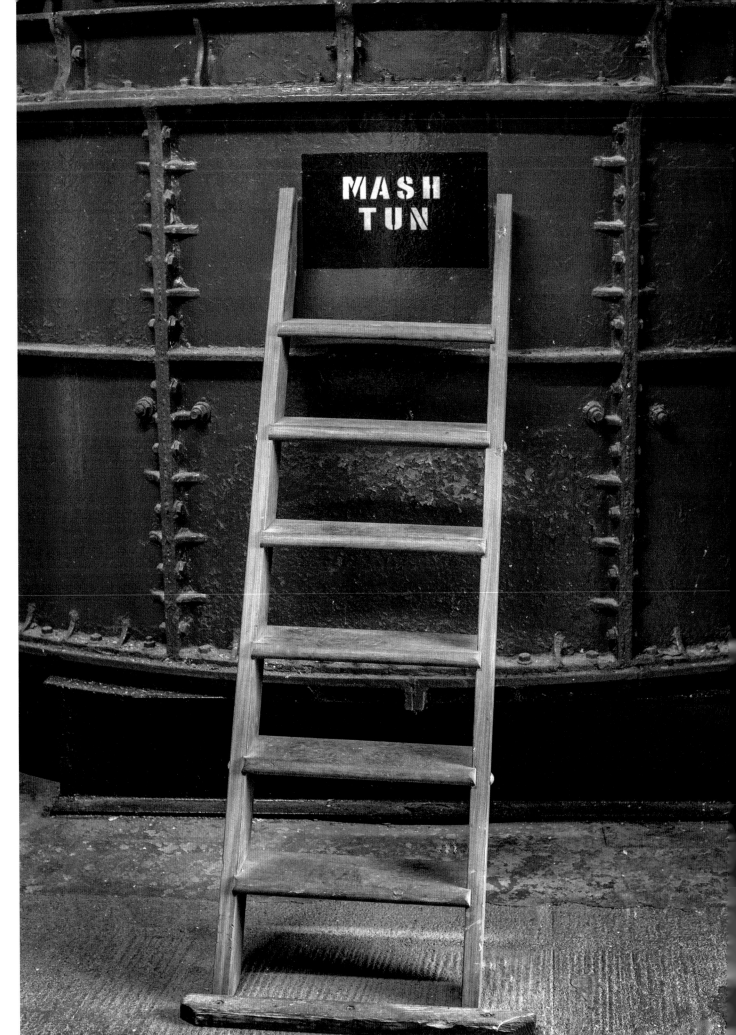

There's an "if it ain't broke…" philosophy to the distillery, from the open-topped mash tun to the malting floor, which opened in 1992 at a time when virtually every other distiller had closed theirs down.

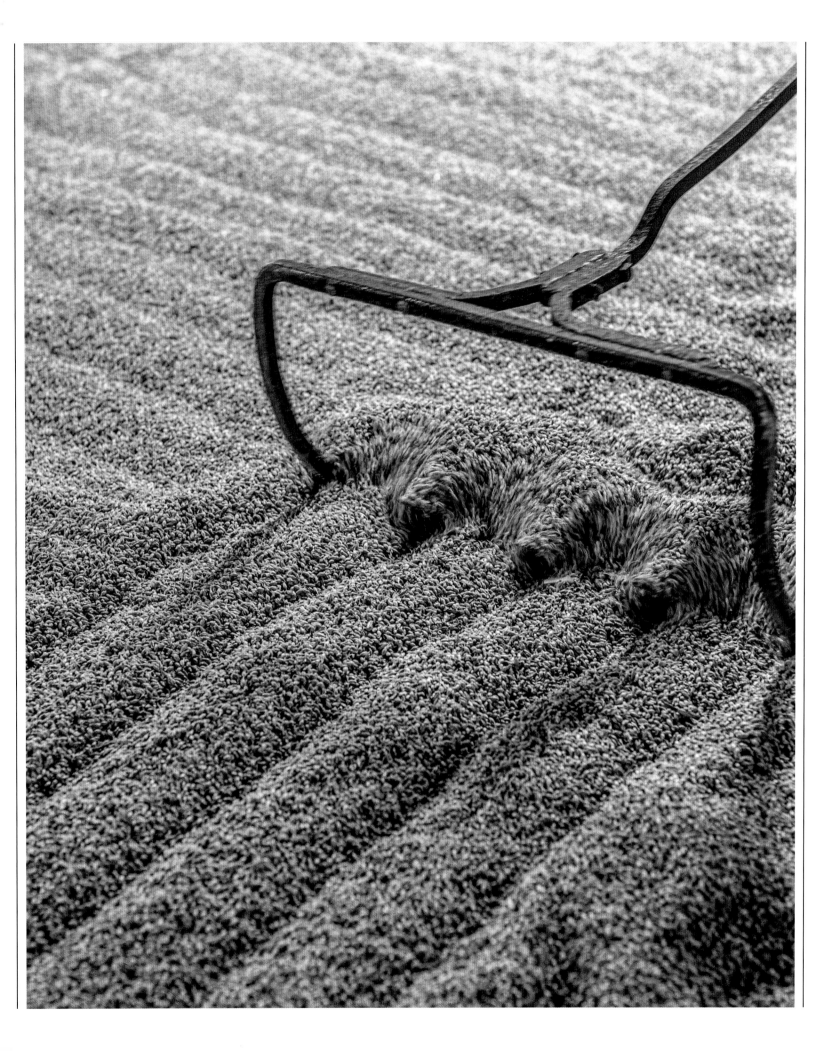

Springbank is apparently Bob Dylan's favourite malt. Like the singer, the distillery has become legendary for going its own sweet way.

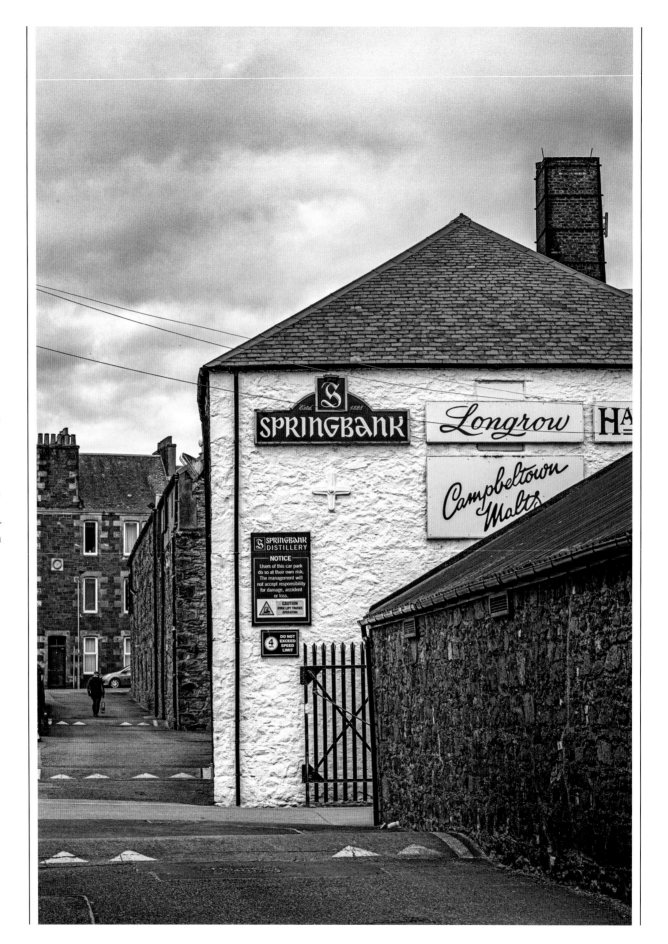

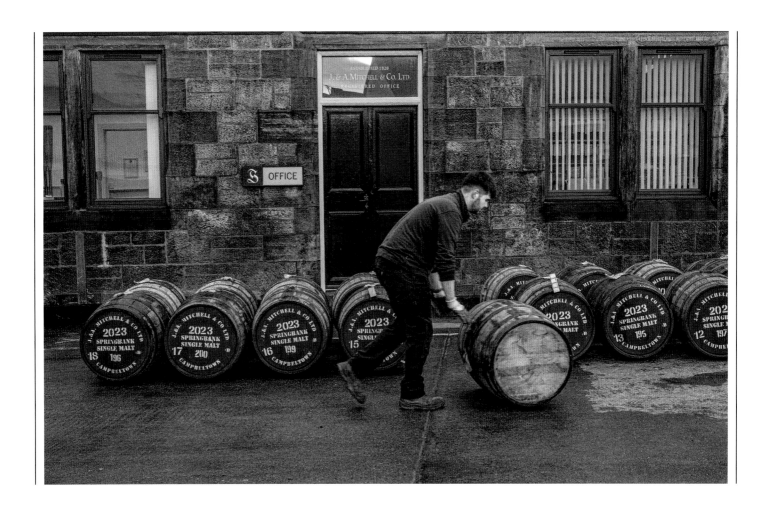

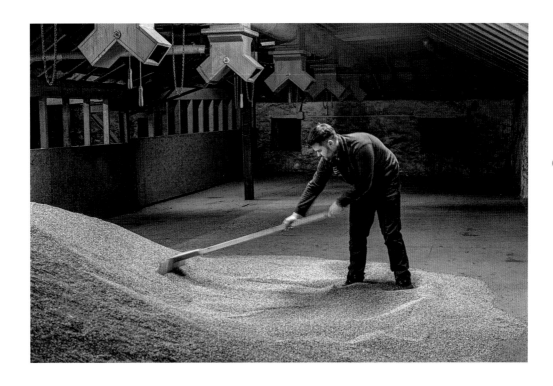

Campbeltown
barley is
lauded in the
industry as
"liquid gold".

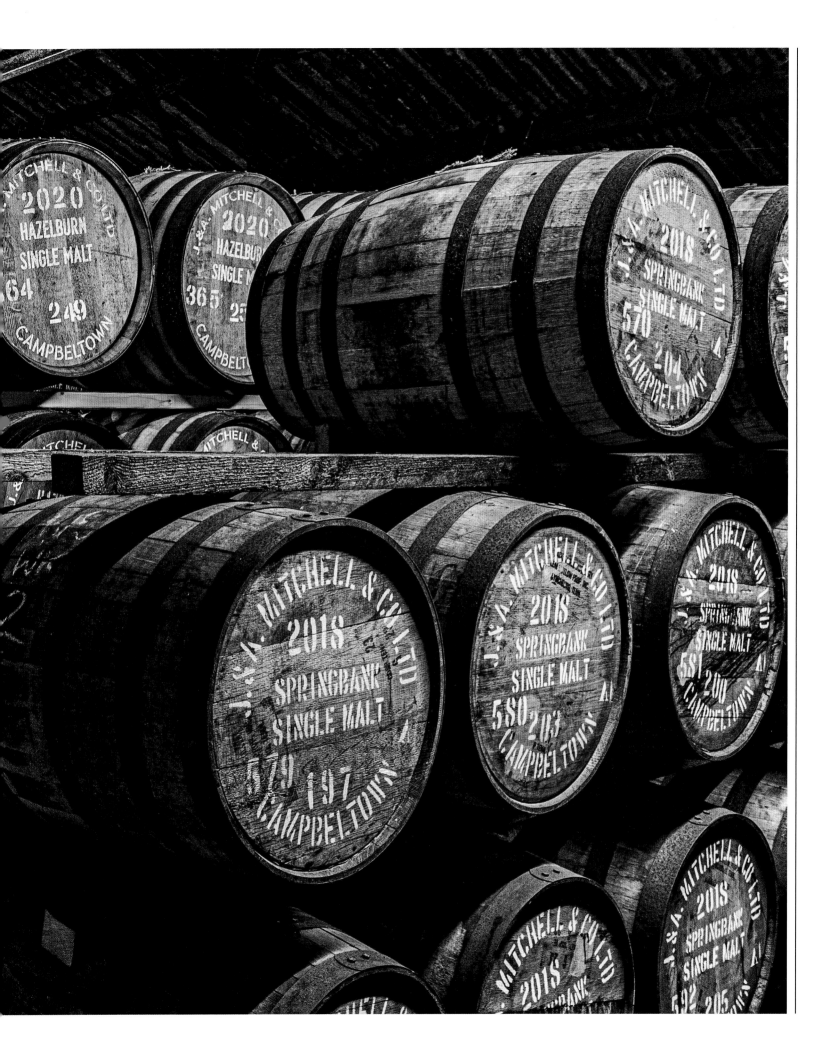

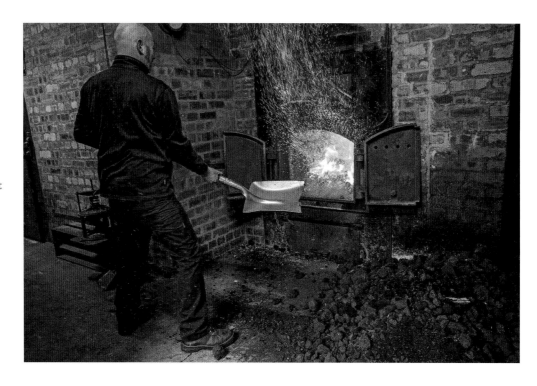

Direct fire
ensures a
charring effect
that deepens
the flavour
profile.

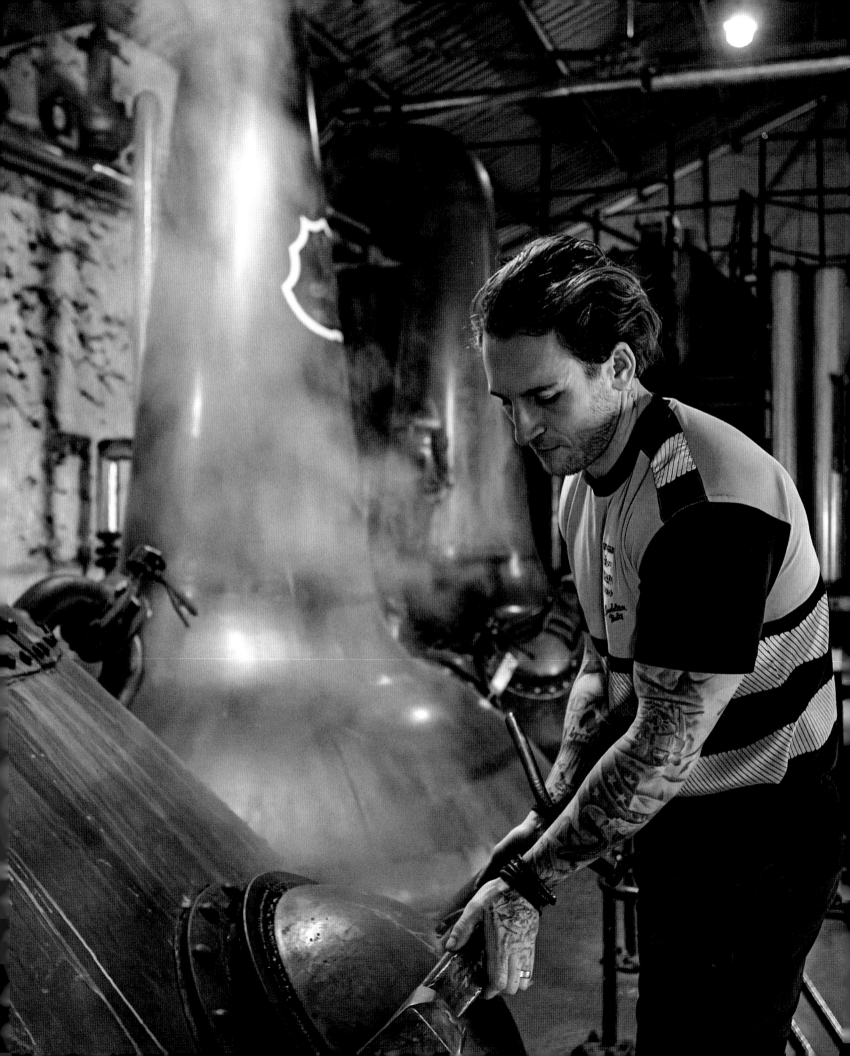

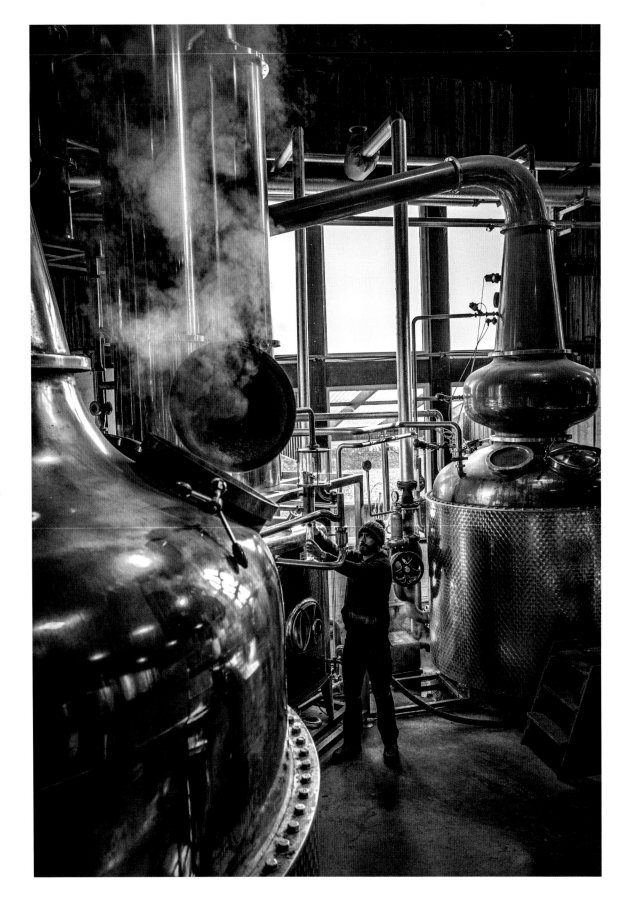

As well as whisky, Arbikie produces other spirits, including Haar Vodka, named for the freezing coastal fog that sweeps in from Lunan Bay and sometimes blankets the distillery.

ARBIKIE DISTILLERY

EST. 2013

THE HIGHLANDS

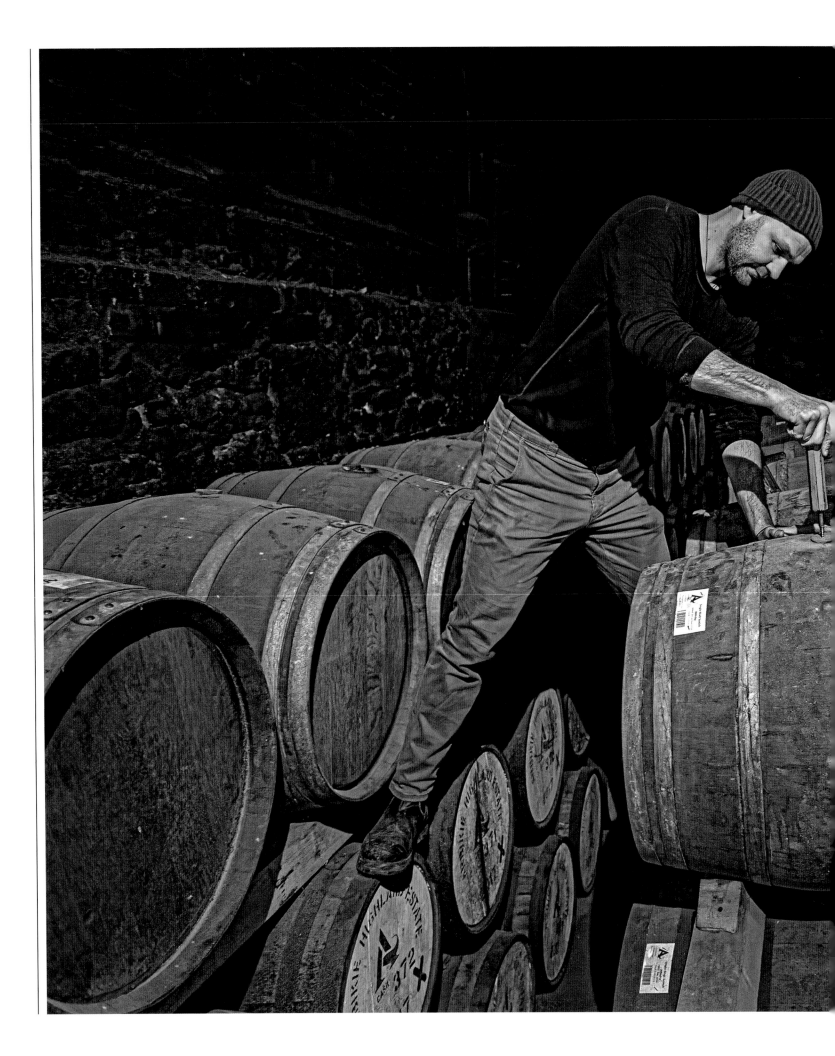

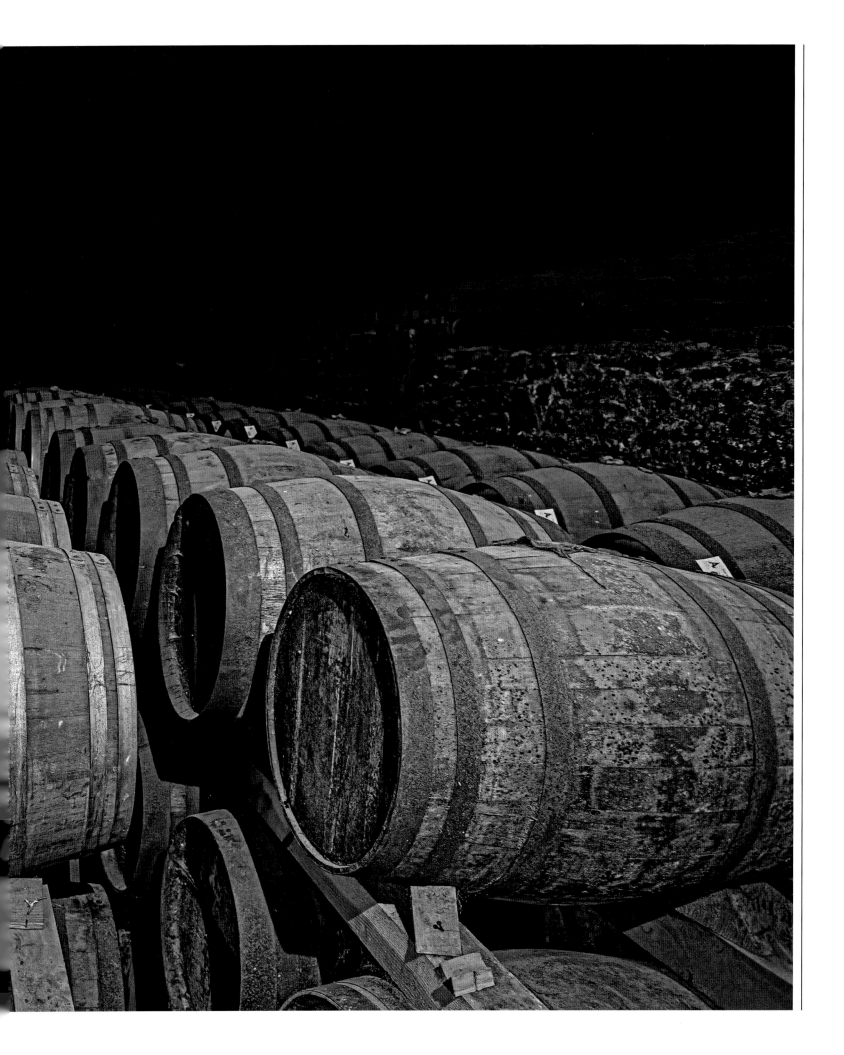

"We're a young distillery, with a youthful outlook. We want to farm in a better way and produce our whisky in a way that's kinder to the environment."

Arbikie Distillery

"Welcome to the sunshine state," says John Stirling with a grin. Yes, that particular orb is shining this morning – albeit fitfully – sort of confirming Stirling's contention that this part of Angus, on Scotland's east coast, is blessed with more rays than other parts of the country. Right now it's giving a mellow cast to the dunes and gentle waves of the distant Lunan Bay, and bathing the environs of Arbikie, Stirling's 2,000-acre farm-to-bottle distillery, in a benevolent light. "We're about producing the best whisky, of course," he says, "but we also want to farm in a better way and be kinder to the environment."

Terroir is a comparatively recent buzzword in whisky circles, but here at Arbikie, set on the Stirling family farm, the sense of place is deeply felt – granular, even. "We've ploughed this land, furrowed it, and run it through our fingers," says Stirling. "We know it intimately. So with the growing interest in provenance – where something's come from, how it's made – well, we've got the story in abundance."

The Arbikie story actually begins in 2013, when John and his brothers David and Iain were enjoying a festive night out in New York. "We decided we would build the distillery, and the more drinks we had the better the idea became," he says. "But in the cold light of day, it actually made sense; we could utilise what we were already growing here, we could go back through my dad's old farm diaries to see what kinds of barley were grown, and we could build in sustainability by ditching artificial chemicals and fertilisers, increasing crop rotation, practising regenerative farming, and even deploying the dung from our Highland cattle. It's about going back to the way that whisky used to be done; tapping into that association between land, farm and distillery."

The Stirlings set about recruiting like minds, including Dr Kirsty Black, Arbikie's manager, who studied plant science at Edinburgh's Heriot-Watt University; she researched long-fallow barley varieties like Diablo and Concerto, and produced Arbikie's climate-positive vodka and gin, a world first, both christened Nadar (Gaelic for "nature"): "They're pea-based," she says, "because peas carbon-capture." Arbikie has also produced the first rye whisky for two hundred years. "There's a very good reason that it's been so long in coming," laughs Stirling. "The whisky's harder to make, and rye only grows well in the dryer east coast climate, but it's good for the soil, and it brings these spicy notes to the palate. We think it's easier drinking for a younger generation, and the cocktail market seems to love it."

Rye whisky is also at its best when young, which is expedient for Arbikie, because their single malt won't be due until 2033. "We wanted to mature it for eighteen years," says Stirling. "It's a statement of intent, if you like, but we wanted to wait until we absolutely know it's ready and not before." (It also gives Christian Solar, Arbikie's enterprising production manager, a chance to make good on his averred intention to "look beyond bourbon casks – why not allow your imagination to play a bit?") In the meantime, there are signs all round of Arbikie's investment in a positive future, from the expansive visitor centre with its views over the rolling hills to the North Sea (and its upright piano, shipped in from the farmhouse courtesy of John's mum, for impromptu dram-inspired singalongs) to the erection of a wind turbine to facilitate the production of green hydrogen. In mid-afternoon, sparrows are flitting and chirruping through the warehouse, a V-formation of geese is honking over the fields (all of which, from Deil's Knap to Gin Shot Hill, will be familiar to Arbikie fans – in a literal expression of *terroir*, they're name-checked on every Arbikie bottle), and the sun is still out (Stirling's further claim – that this region receives less rainfall than Barcelona – will have to be left with the fact-checkers). "The fact that we were all brought up here, and we're tied to the land, gives us our ethos," he says. "Because, if we're passing this on, good stewardship is vital."

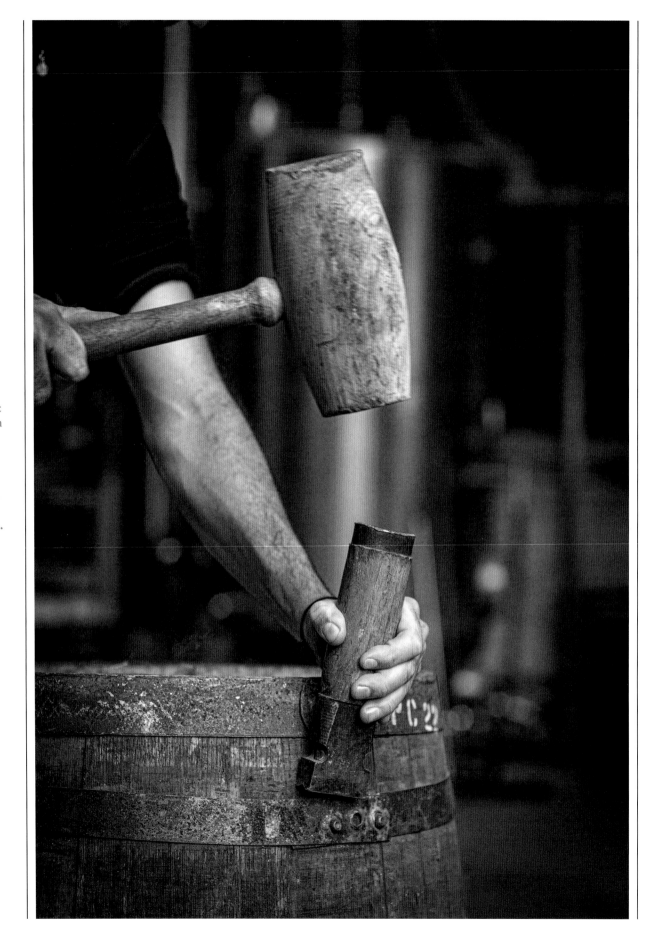

"People are keen on provenance. It happened with food, now it's the same with drink – where it's coming from, how it's made, the story behind it. And we have that story in abundance."

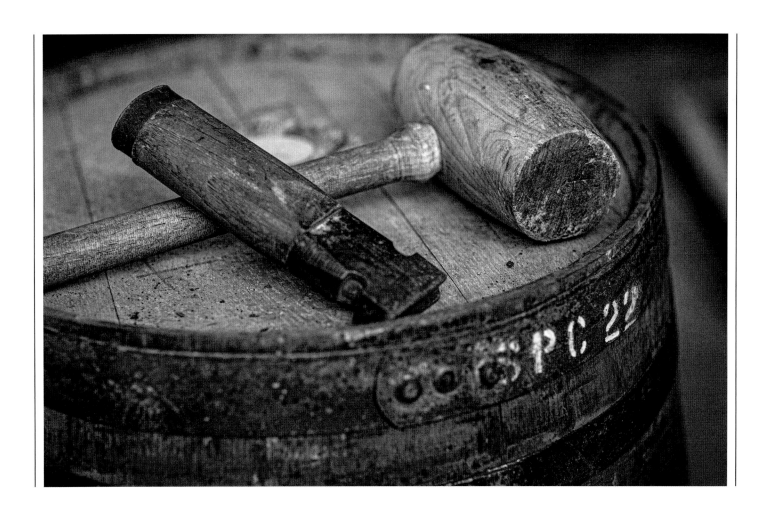

"Every year our whisky will be different – it's naturally wonky, according to what the environment's given us."

Arbikie's rye whisky – the first to be produced in Scotland for 200 years – "is easy drinking for a younger generation, with its spicy notes. It plays well with others, and the cocktail market loves it."

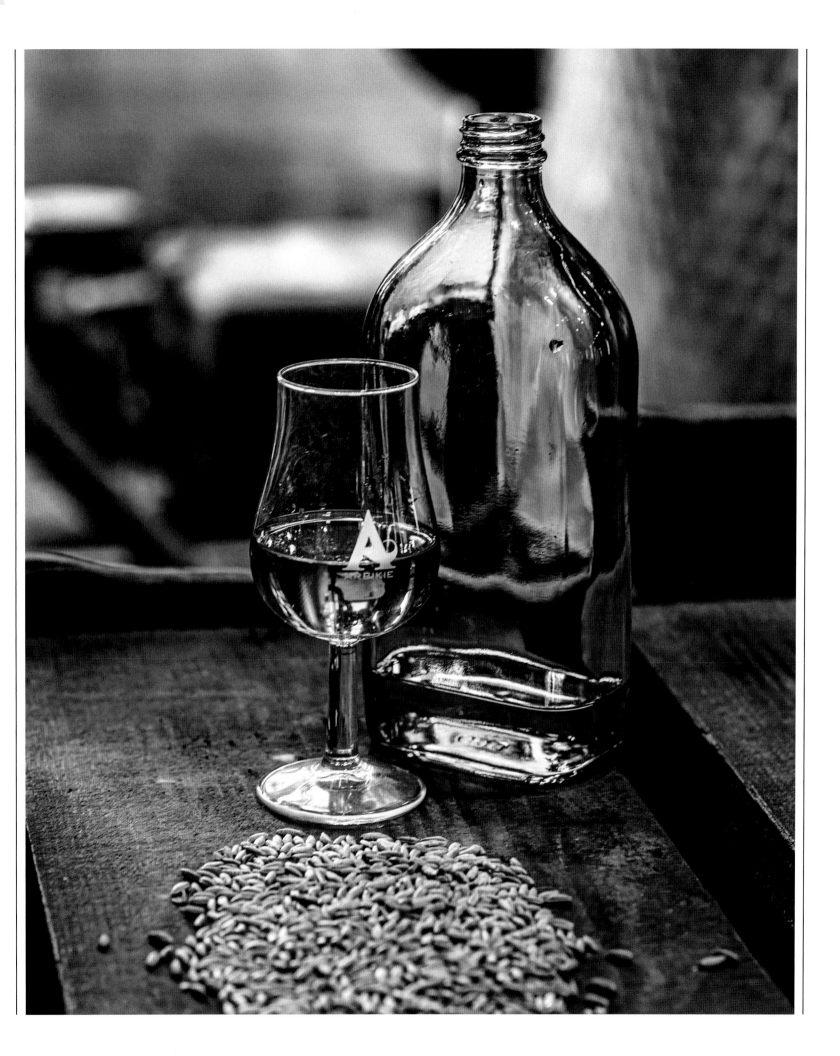

"We know this land intimately, and when you're making a spirit based on that, you understand how important it is."

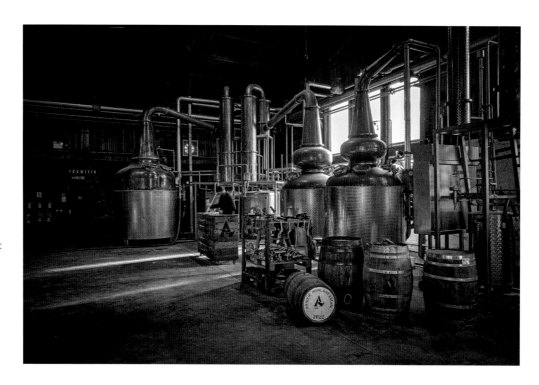

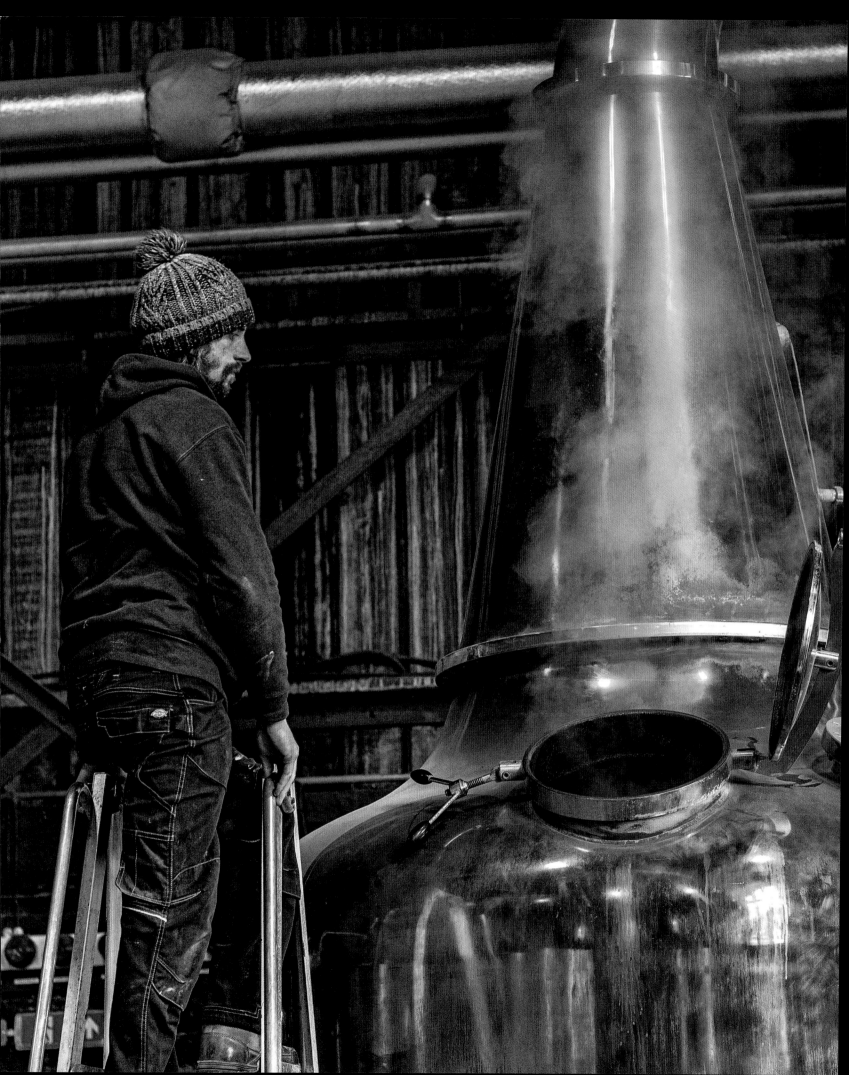

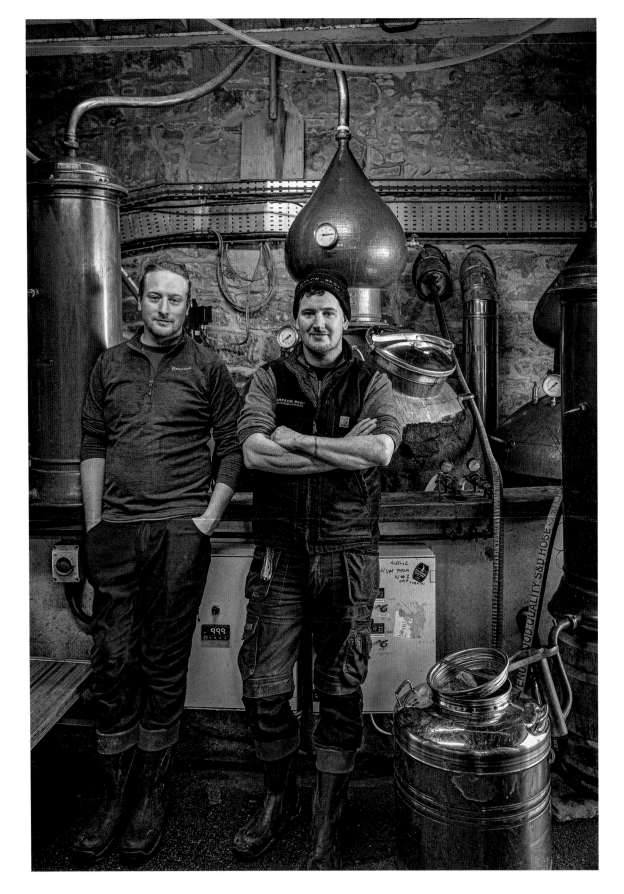

Simon and Phil Thompson in their densely packed distillery, housed in a former Victorian fire station: "You think you know how to distil from reading books, but until you're doing it on a daily basis, you won't have a clue."

DORNOCH
DISTILLERY

EST. 2015

THE HIGHLANDS

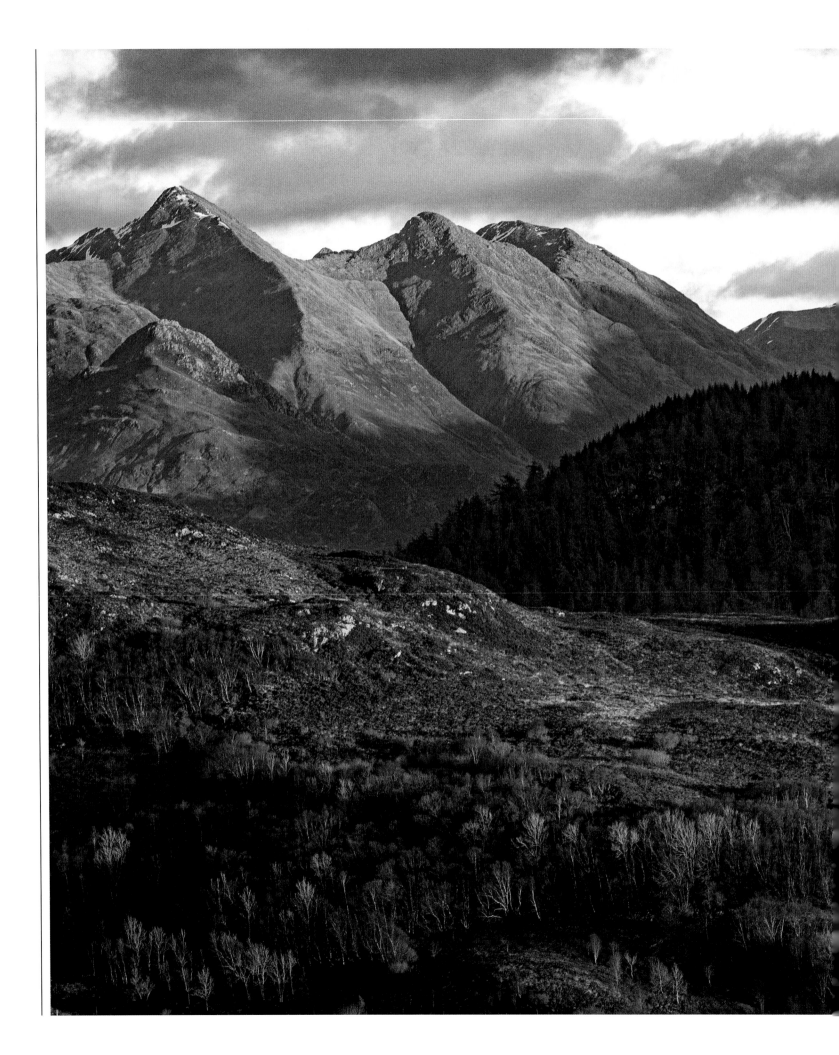

Dornoch Distillery

The words *compact* and *bijou* are brought to vivid life at Dornoch Distillery, undoubtedly Scotland's smallest and certainly its most idiosyncratic. Pipes, hoses and wires criss-cross the space – a repurposed stone-wall fire station at the rear of Dornoch Castle – like rampant spaghetti, while stills hum away on one wall, and mash tuns do their business just over your head on a purpose-built mezzanine. And somewhere in the middle of the mêlée are brothers Philip and Simon Thompson, whose labour of love this all is. "You might think you'd know how to distil by reading books and going round distilleries," says Philip, "but until you're actually doing this on a daily basis, you won't have a clue." They've only had one small explosion, he adds, when a chamber popped out of their direct-fire gas still; he attempts to allay the look of concern on a visitor's face with a breezy "We don't use gas any more."

The brothers, now in their thirties, grew up figuratively, if not literally, steeped in Scotch. Their parents, Colin and Ros, acquired the castle, opposite Dornoch Cathedral, in 2000, and set about turning it into – as a sign on the gate proclaims – "the No. 1 whisky hotel in the world". The brothers began working behind the bar when they were "oh, thirteen, fifteen, something like that", says Philip, "washing dishes and wiping tables".

"We had twenty to thirty whiskies at the beginning," says Simon, "but then we began collecting, going to live auctions all over the country, trying to pick up rarities from the lesser-known or closed-down distilleries."

These discoveries inculcated in the brothers a particular regard for the Scotch produced during the 1960s and 1970s, crediting it with a richer texture, more fruitiness and an abundance of all-important "character". "That can get lost with today's modernised equipment and high-yield yeast strains," says Simon.

"Whisky making is an inefficient process," adds Philip, "but the inefficiencies are what lead to flavour creation."

The pair initially started a bottling company, Thompson Bros, which acquired a cult following both for its adept curation – rescuing the likes of Ardmore 1998 or Cameronbridge Single Grain 1984 from obscurity – and its indie spirit; the labels, many designed by Scottish mural artist Kate Guthrie, featured the trippy likes of Jeff Goldblum about to morph into a fly, or a copper still morphing into a lava lamp. So when planning permission was granted in 2015 to convert the fire station – then being used for junk storage – into a distillery, the brothers sold their apartments and began crowdfunding, raising enough to begin producing test runs the following year. They put their theories into practice, insisting on heritage barley varieties such as Plumage Archer and Maris Otter, and choosing slower yeast strains, leading to fermentation times of up to 216 hours, which may well be the longest in Scotland. "It's a more experimental approach, but for us it's harking back to the golden years of those old distilleries and their singular flavours," says Simon.

They seemed to fulfil their brief with their first original bottling, Dornoch 2017, a 3-year-old single malt matured in a first-fill oloroso cask (maturation takes place in an insulated shipping-style container adjacent to the distillery, packed with earth to mimic the conditions in a dunnage warehouse); it was an instant sell-out, with sultanas, figs, honey, chocolate, pepper and tobacco all being alluded to by those lucky enough to sample it. The Thompsons say that future releases will continue to prize quality over quantity, though their boutique status means the latter is necessarily limited to just 20,000 litres of spirit of a year. That could expand – as could their current team of eight – if their ambitious plans for a £7 million eco-friendly distillery complex and visitor centre on an old gasworks site in the south of the town goes ahead. For Philip, it would be a vote of confidence not only in the new wave of Scotch whisky makers – "It's a really interesting time," he says, "with small guys like us, Nc'nean, Raasay and Torabhaig producing some great hands-on single malts" – but also for Dornoch – a handsome, monied town whose miles of sandy strand and premium golfing facilities are popular with American expats – as a whisky destination in its own right. "We have the spirit, and we have the hotel," he says. "This is a chance to offer stable year-round employment, and have the world come to Dornoch." The Thompson brothers may have started small, but they're definitely thinking big.

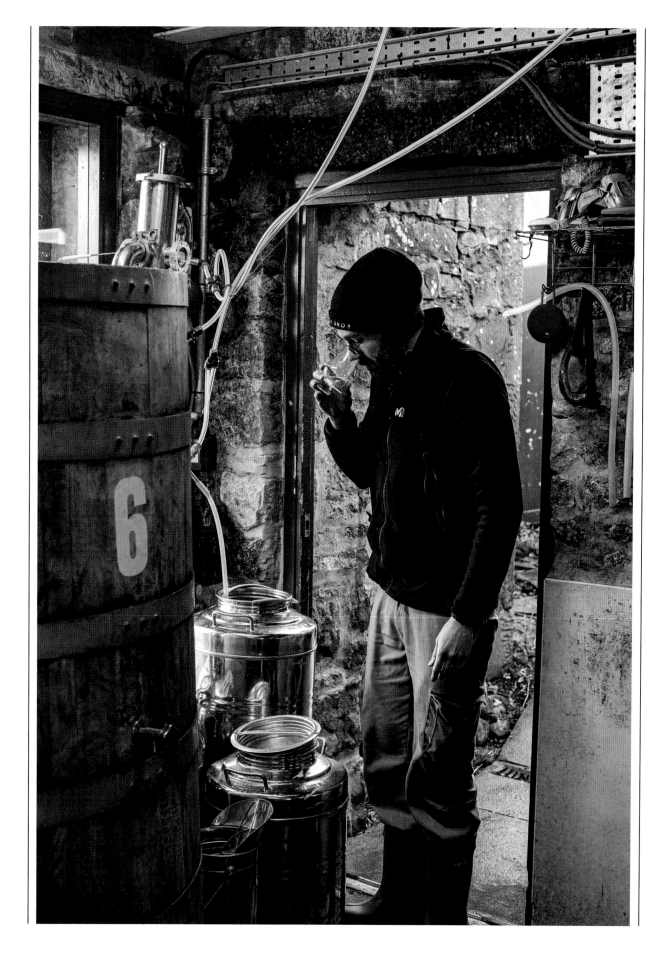

Dornoch produces 300 litres of spirit – just over a hogshead – every week: "That's tiny in Scotch whisky terms, but we're really happy with the quality."

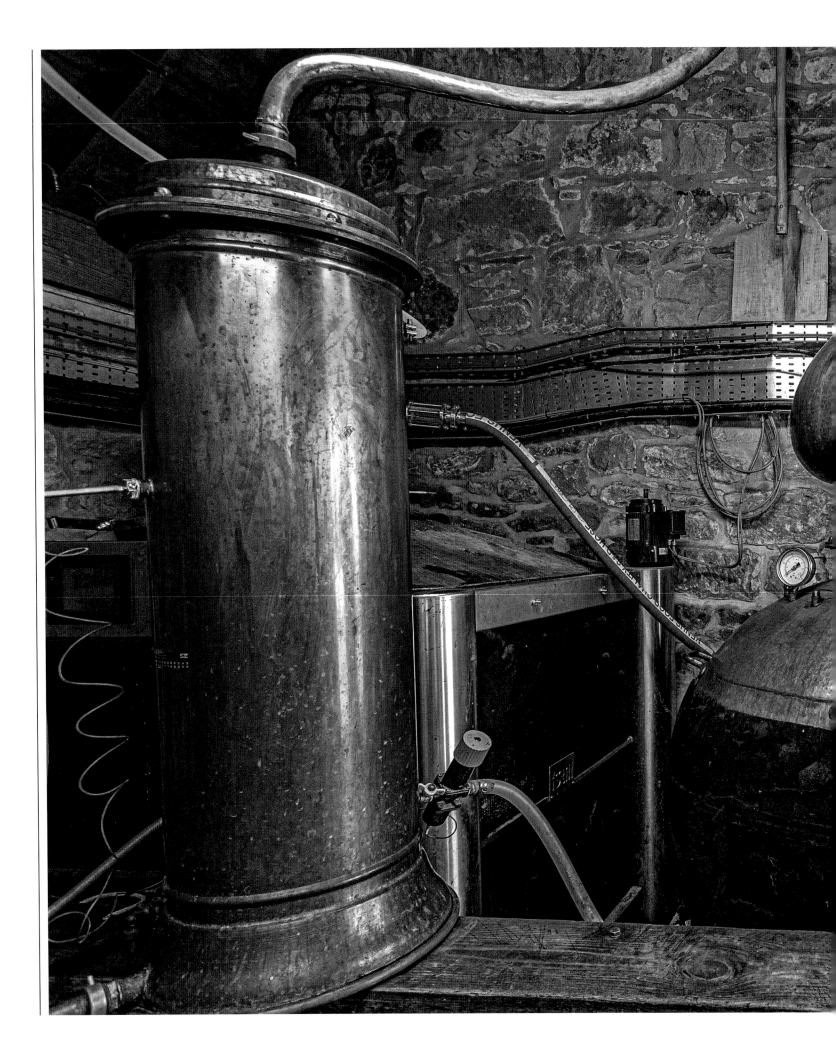

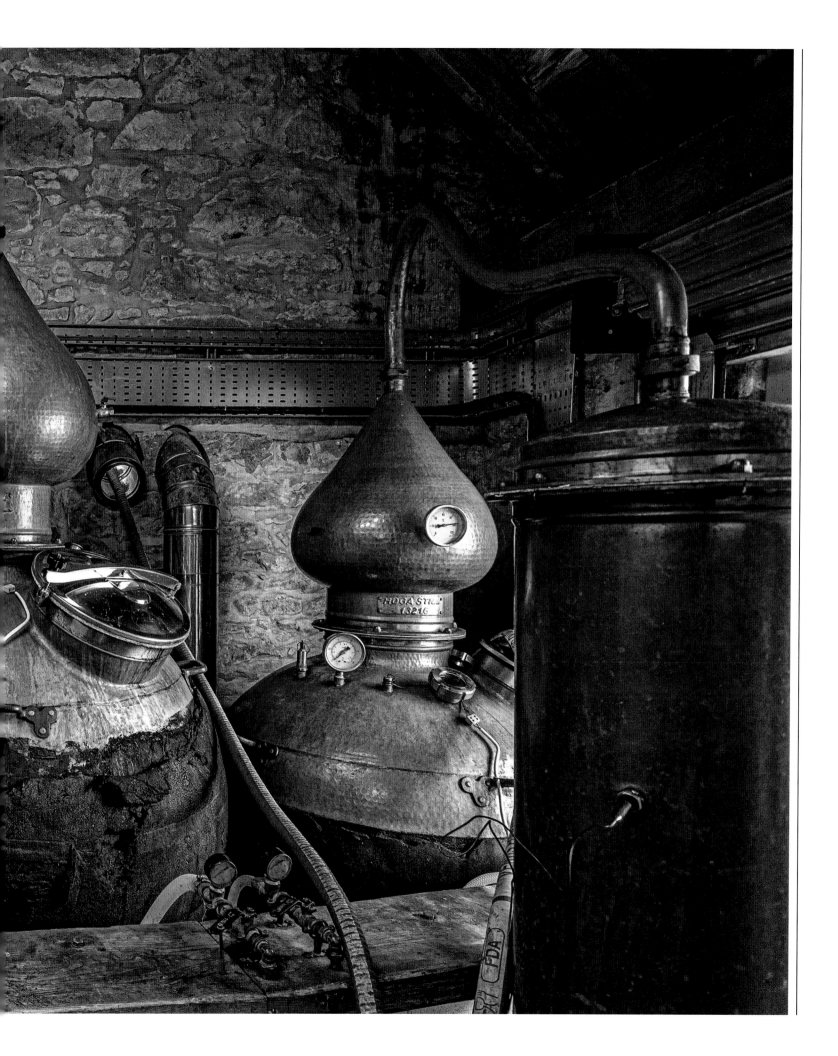

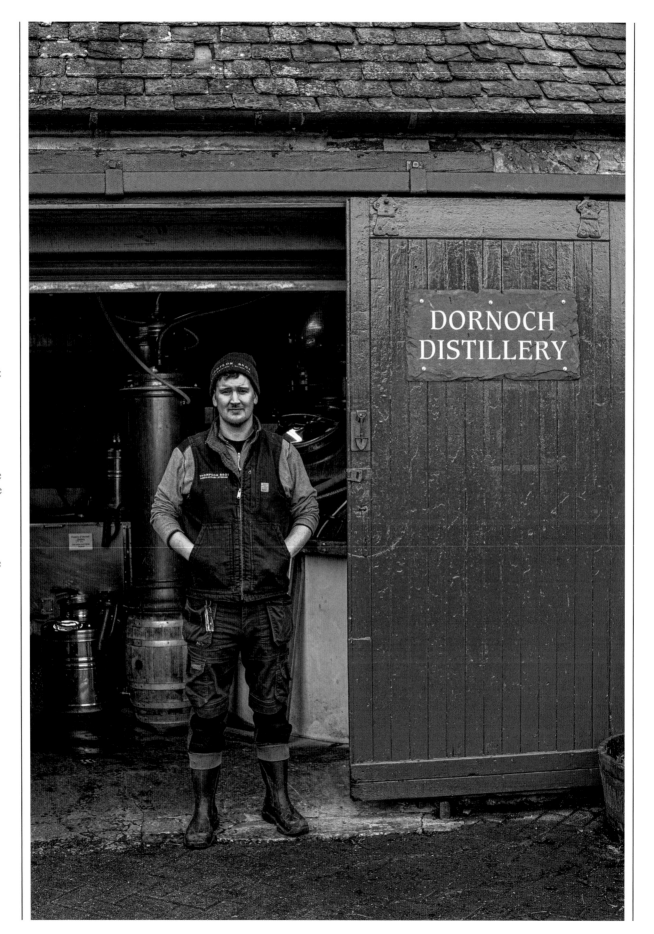

Dornoch released its first single malt, Cask No. 1, in 2020, in a limited edition of 893 bottles. "It's a really interesting time in whisky. There are a bunch of small, independent distilleries producing some great hands-on single malts."

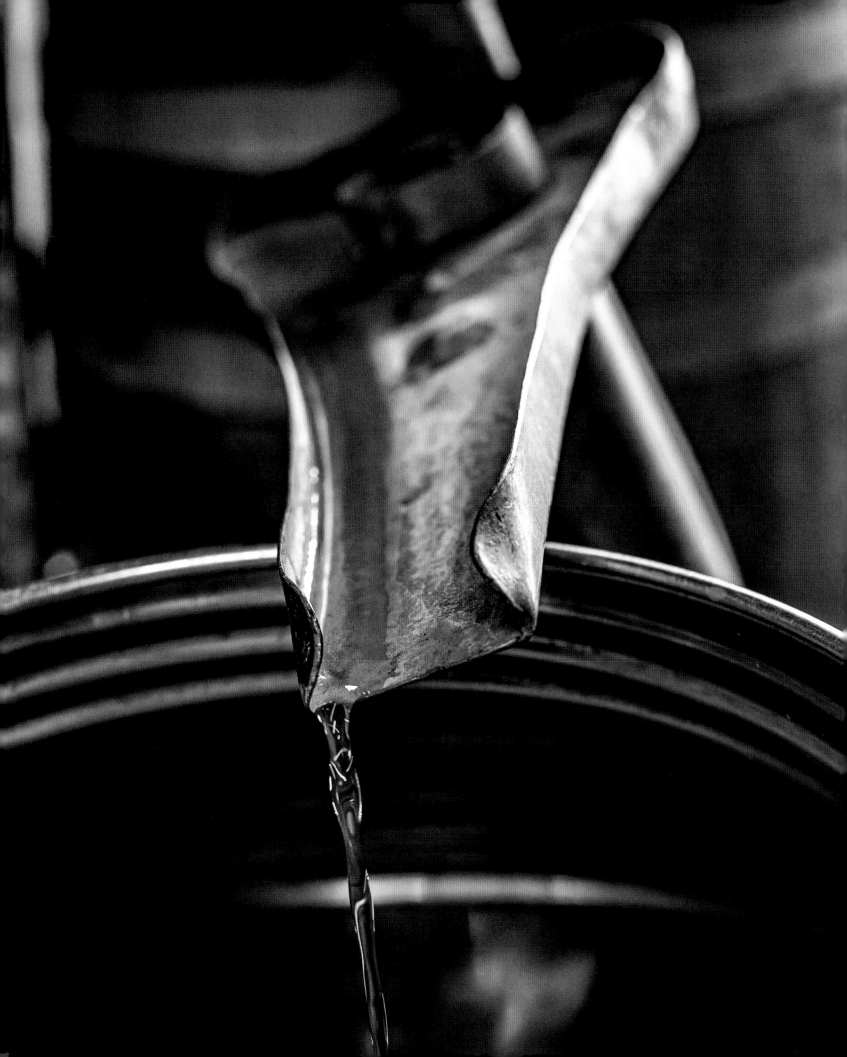

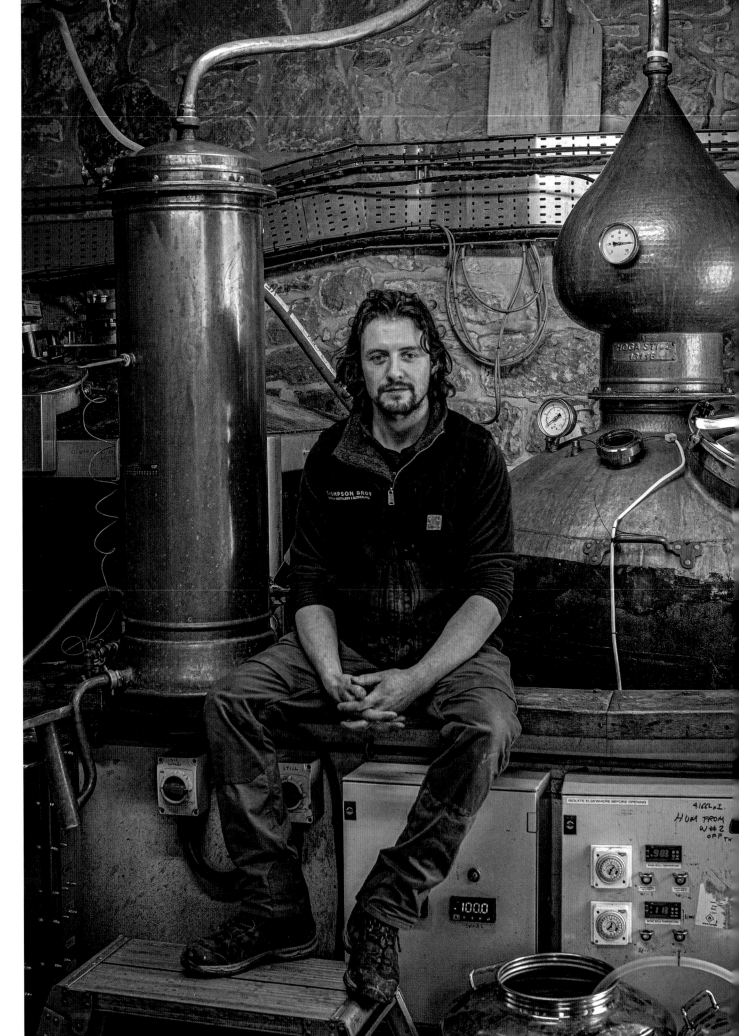

"We want to give people a career choice that isn't necessarily in hospitality."

The brothers'
bottling
company
repackages
cult vintages
with artist-
designed
labels.

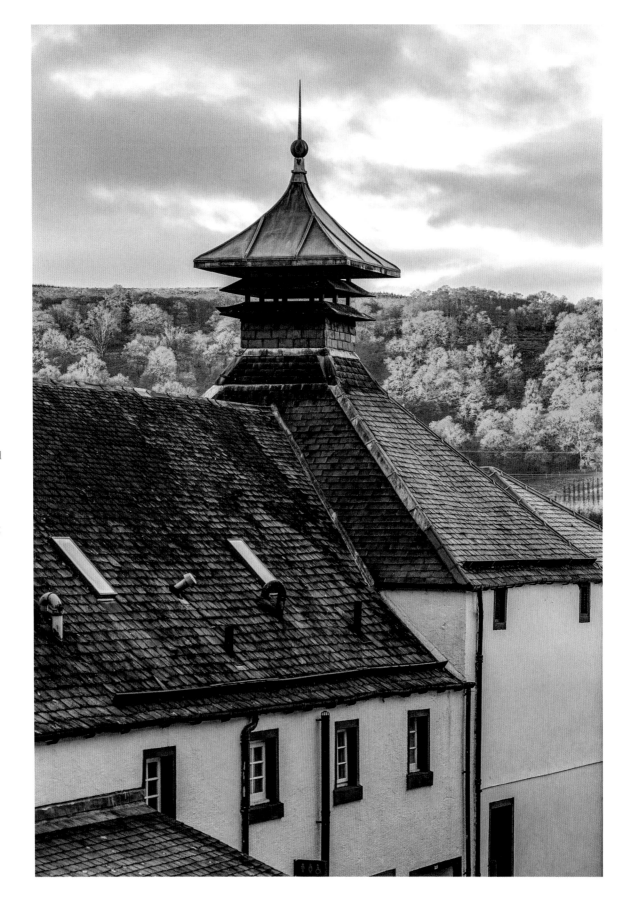

Glengoyne translates as "Glen of the Geese" – every winter, Dumgoyne, the hill behind the distillery, resounds to the honking clamour of the migrating birds.

GLENGOYNE
DISTILLERY

EST. 1833

THE HIGHLANDS

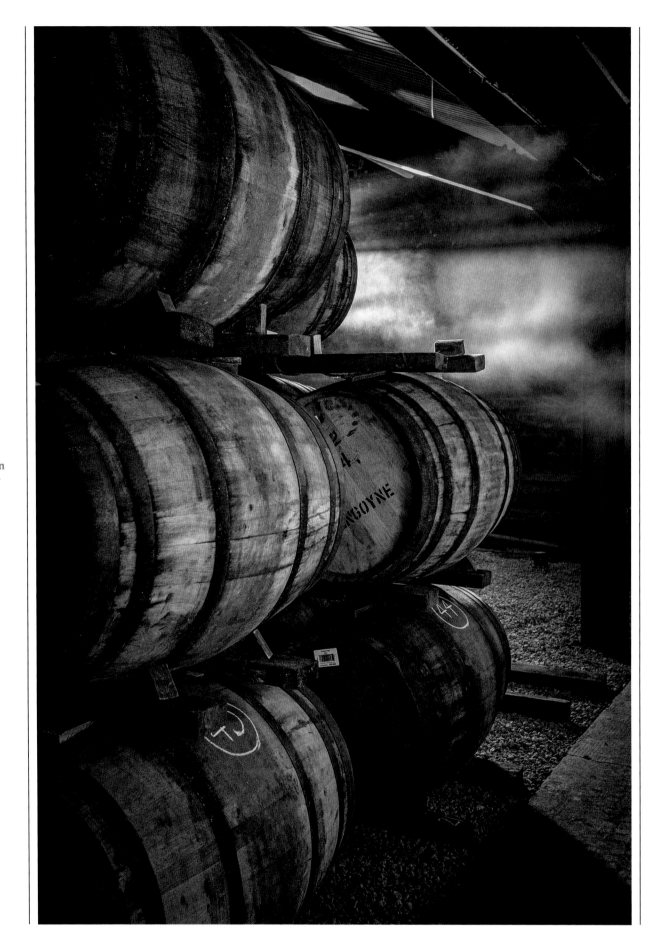

"We've been here for 190 years, and plan to be here for another 190 – at the very least."

Glengoyne Distillery

"'The slowest distillers of the twenty-first century'," laughs the Glengoyne distillery manager Robbie Hughes. "Whoever would be proud of a boast like that?"

Well, Glengoyne would, in its counter-intuitive way, and the evidence is everywhere at its striking site, just fourteen miles north of Glasgow, beneath a sharp promontory named Dumgoyne, the most westerly extrusion of the Campsie Fells (the distillery's name translates as "glen of the geese", owing to the tor's stop-off status for thousands of the migrating birds every winter). "Unhurried Since 1833", reads one sign; "Beautifully Inefficient", says another. Yes, Glengoyne likes to take its time: after a fifty-six-hour fermentation in its Douglas fir or Oregon pine washbacks (prized for their long, knot-free planks), their distillate flows down the lyne arm of the still at around sixteen litres per minute (most distilleries would triple that rate), and it also boasts the slowest distillation from the Spirit Still, at a languorous five litres per minute. However, there's logic in Glengoyne's laxity, according to distillery heritage manager Stuart Hendry. "There's no peat in the area," he says, "and we don't smoke with peat. So we have to work the stills hard in order to build up flavour from the sugars and amino acids in the wash coming into contact with the copper. The longer we can keep it simmering over, the more intense the fruitiness and the richer the flavours." They're greatly aided in their efforts, he adds, by the process known as reflux, where the vapour sent up by the liquid meets the cooler copper interior, turns back into liquid, and rains down to be redistilled: "The more reflux there is, the lighter and more complex the spirit will be."

The final stage in the spirit's leisurely journey is its maturation in ex-oloroso sherry casks; Glengoyne source theirs from a family company in Spain with six generations' experience. "They dry the oak in the sun for three years to get the moisture levels as low as they can," says Hendry. "The sherry then goes in for another three years. So when we talk about our 12-year-old, it's already been eighteen years in the making, from the date that those casks start soaking up the sun's rays." The sun plays a less prominent role in Scotland, of course, but a geographical quirk means that, while Glengoyne's stills are in the Highlands, its warehouses, across the A81, are technically in the Lowlands, leading to all manner of reflux in the minds of *terroir* obsessives; does that make its malt a heathy, honeyed Highland or a light, grassy Lowland? "I think we can claim the best of both," says Hughes, which one taste of the warm, orangey 18-year-old – big, fruity, fresh, sweetly oaked, citrusy, hints of banana and marzipan – comprehensively confirms.

If there's a winningly analogue feel to Glengoyne – the submarine-like metal gangways and gridded floors of the still house, the weights and pulleys for measurement, the chunky wooden thermometers, the vintage touch-tone phones – it's a breath of fresh air in a digital world that prizes authenticity above all else, something Glengoyne has in spades. "We're all about consistency, doing things with great precision, and not cutting any corners," says Hendry. "We've seen an explosion of interest in the processes and detail that goes into the making of single malt in particular, and all of that plays into our hands." The only thing holding them back, he adds, is availability of stock; they're probably in the smallest 10 per cent of distilleries, and they're limited to a million litres a year. "The big brands will make that in a month," says Hughes. "But we can certainly compete in quality. We're not Ford, we're more Aston Martin." And with a growing number of devotees subscribing to the view that – to quote another axiom on the Glengoyne walls – "The Right Way is The Long Way", it seems that slow and steady, in this particular race, is a winner all the way.

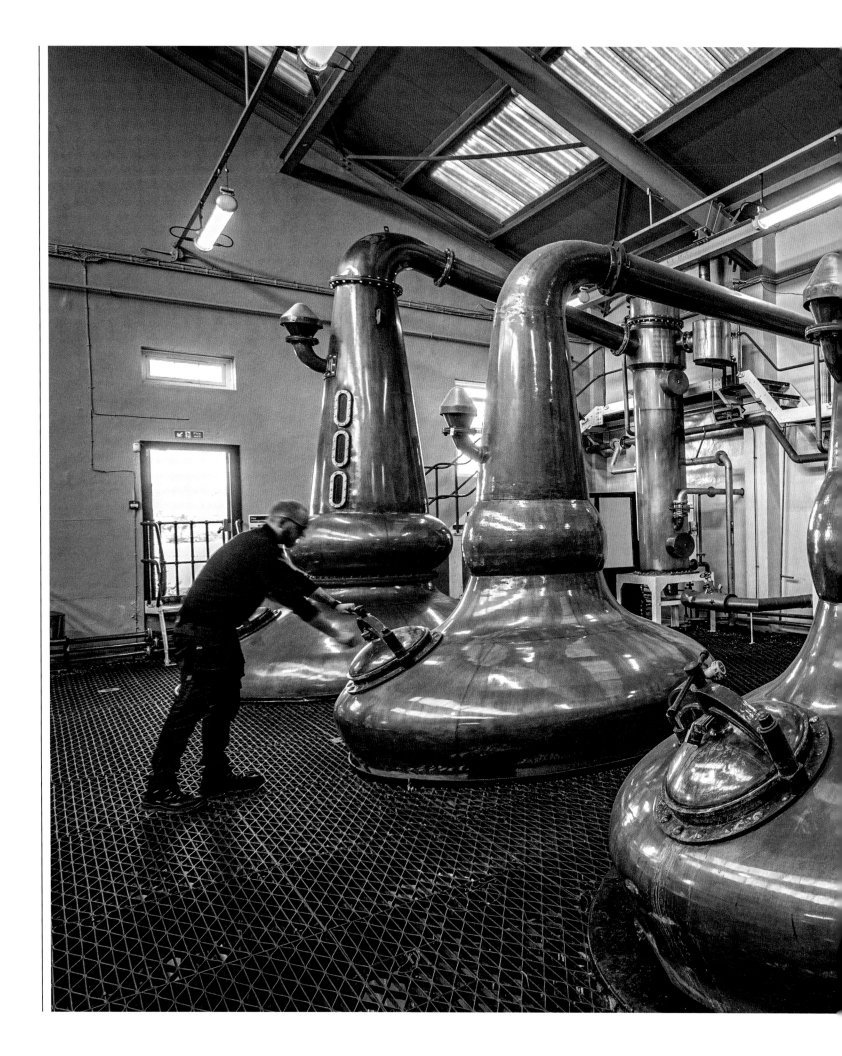

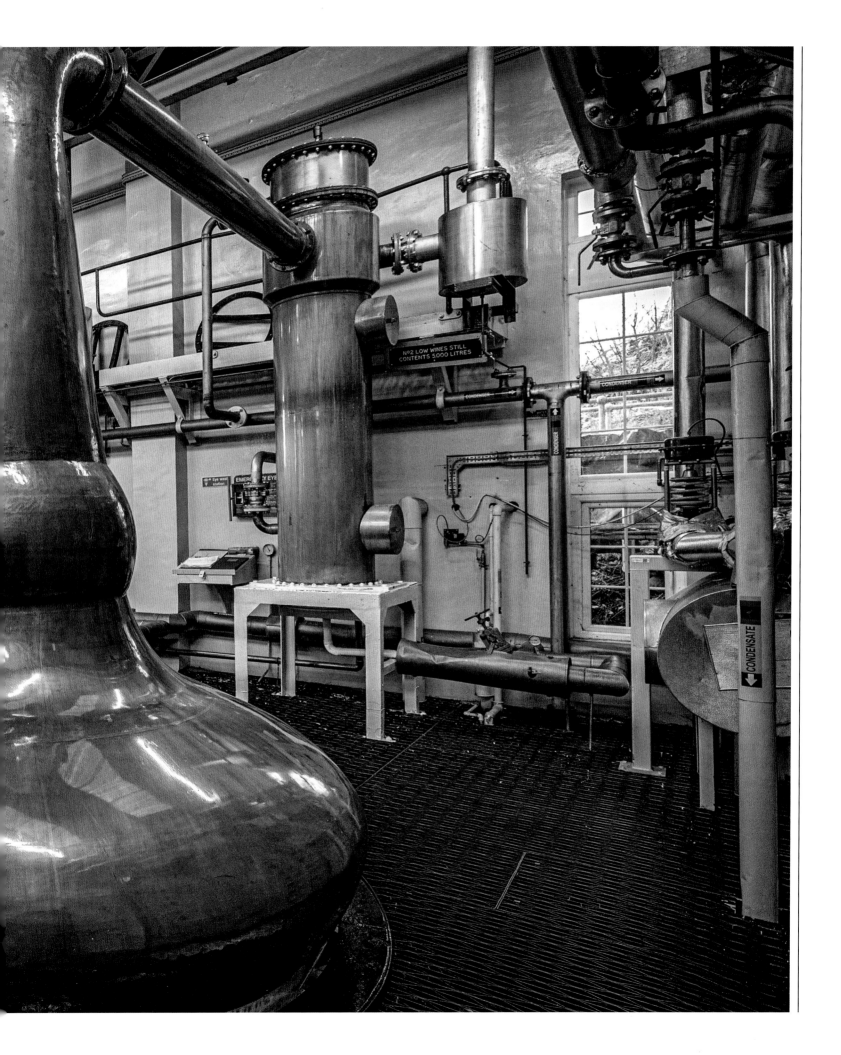

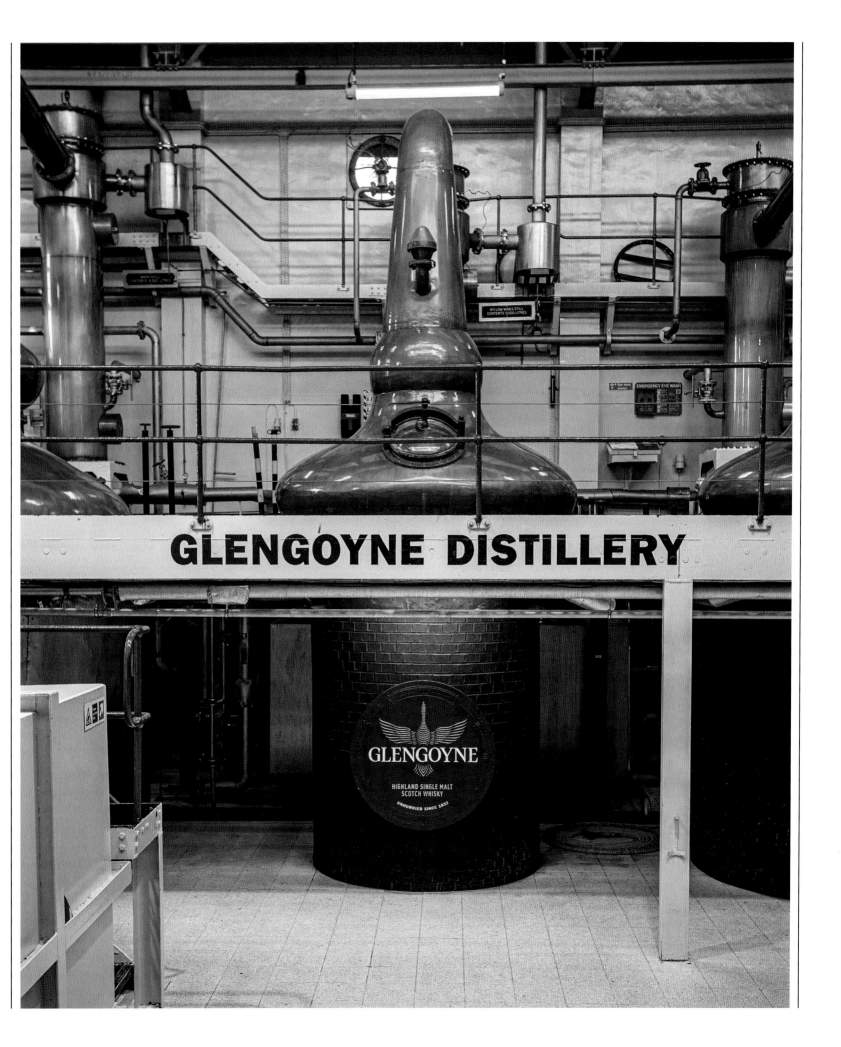

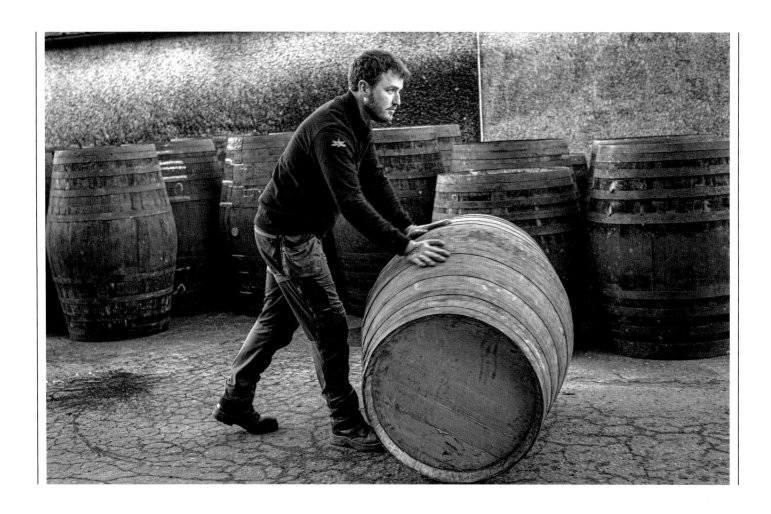

The art of
barrel rolling
is in the
positioning;
if a barrel is
rolled into
the ricks
bung-down,
the chances
of springing
a major leak
are much
increased.

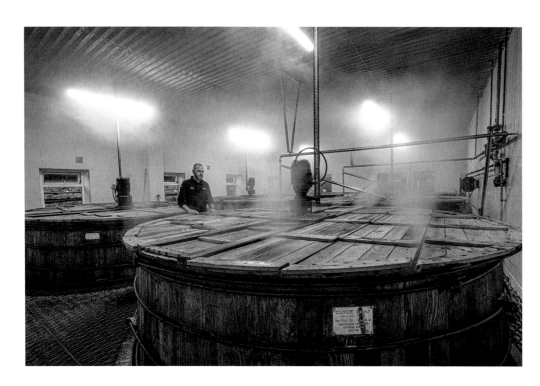

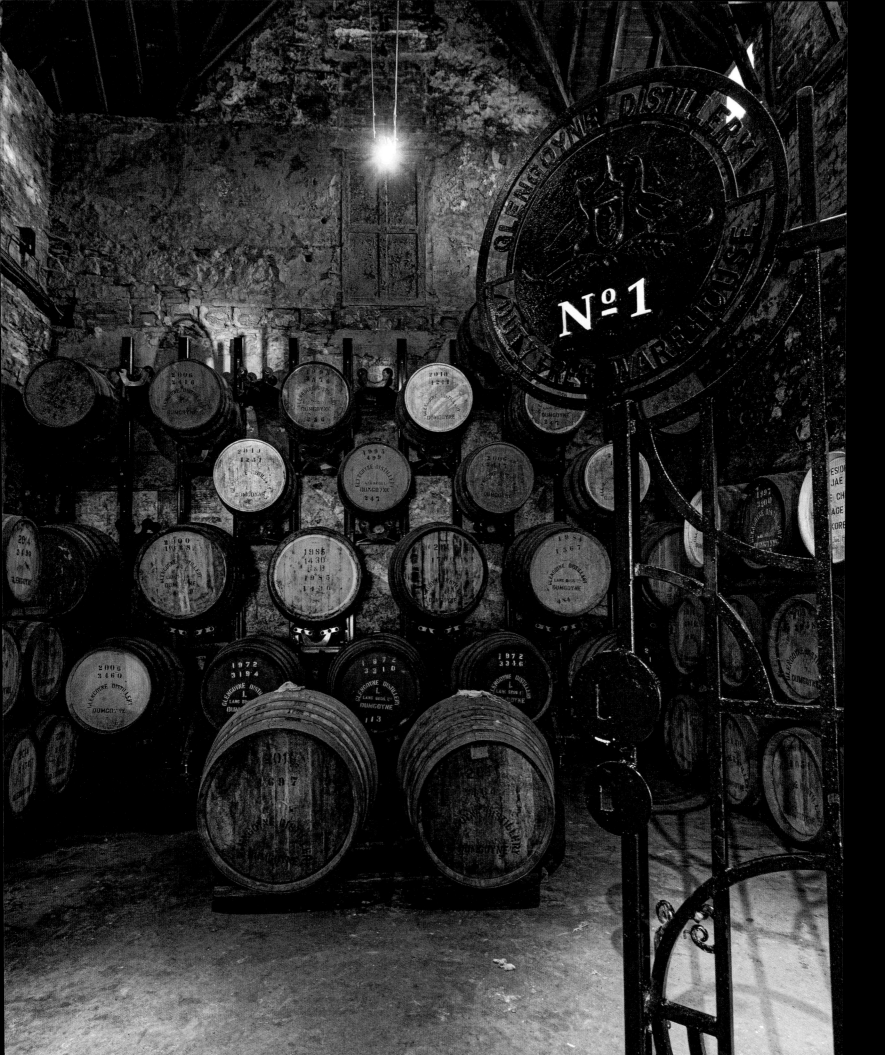

"The world is coming round to our way of thinking, that small-batch, slow-distilled whisky is the way to go. This is our moment in the sun."

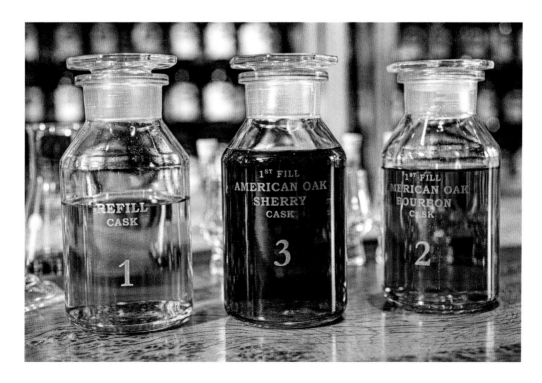

"We build up the flavour by simmering really slowly," says distillery heritage manager Stuart Hendry. "Our sherry casks, with their big, bold dried fruit flavours, add to the fruitiness that we've already brought in."

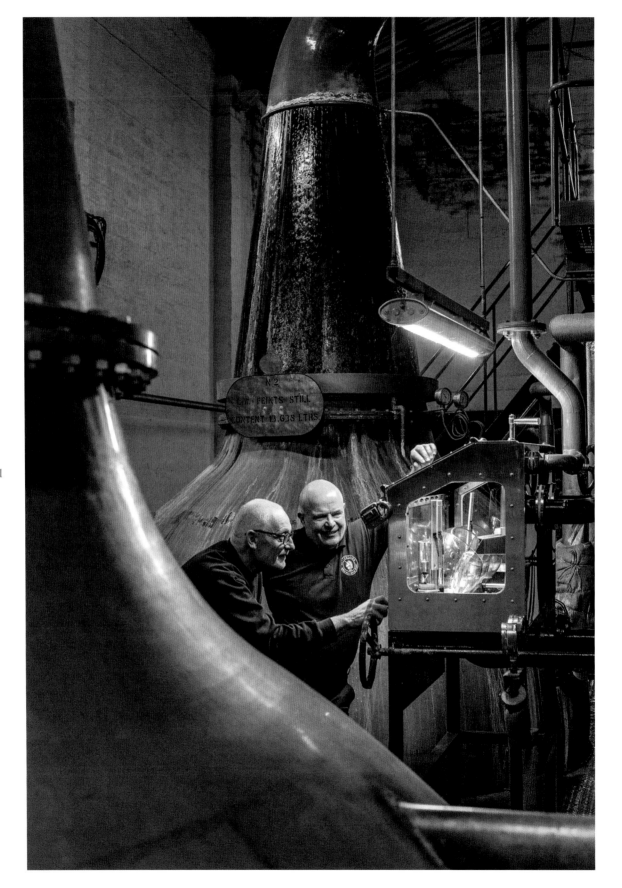

"Whisky is made from water, yeast and malted barley," says Fettercairn manager Stewart Walker (right). "But, for me, there's an essential fourth element in the process, and that's the human factor."

FETTERCAIRN DISTILLERY

EST. 1824

THE HIGHLANDS

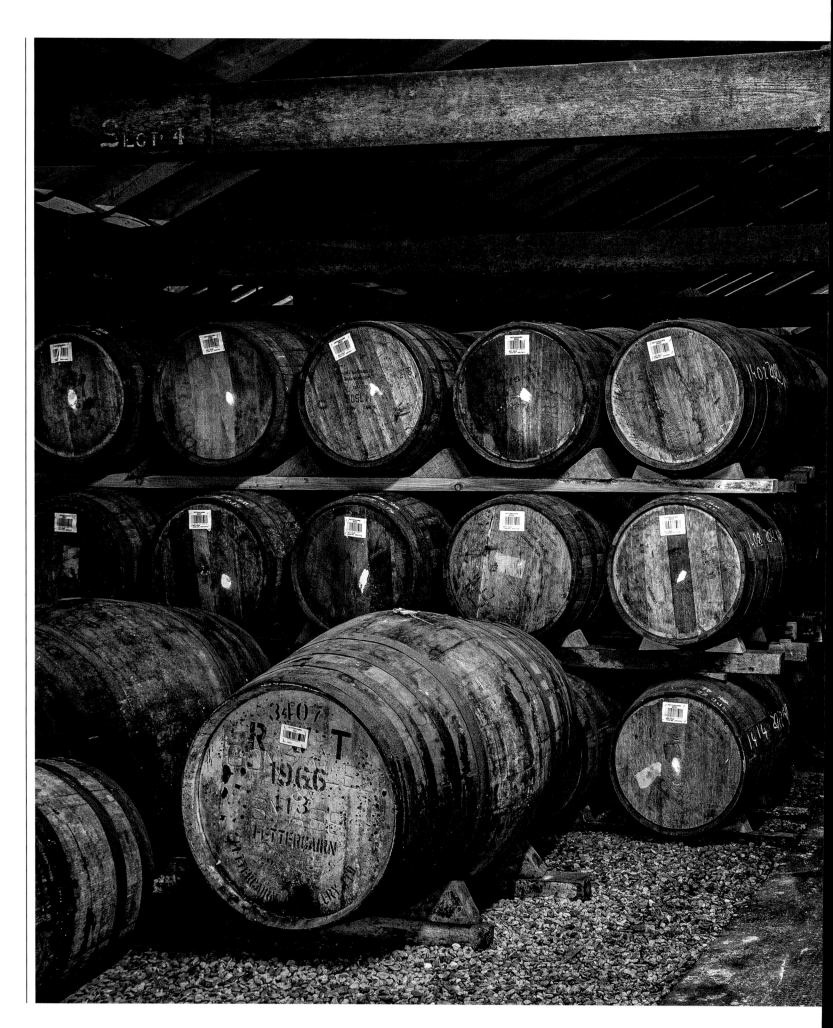

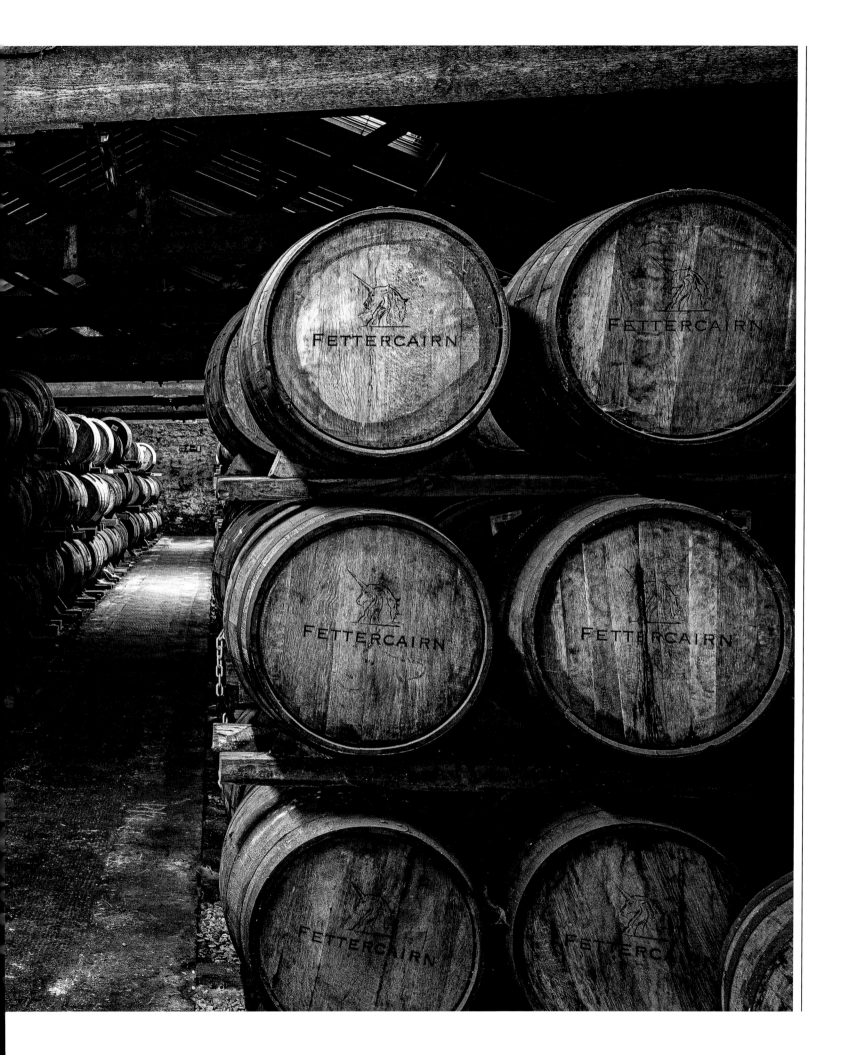

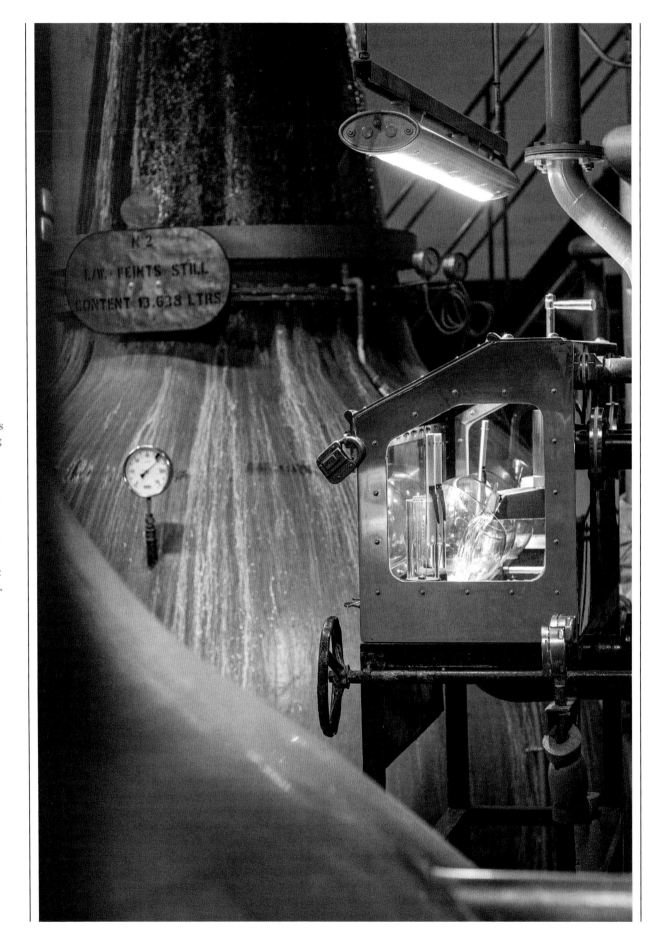

The Fettercairn stills have a distinctive patina, thanks to the cooling ring on the outside, allowing spring water to run down the exterior, and creating reflux, and tropical fruit notes, within.

Fettercairn Distillery

Some distilleries are the beating hearts of their communities, and nowhere is this tendency exemplified more than at Fettercairn, named for the Aberdeenshire village in which it has stood for two hundred years. The signs are, quite literally, everywhere: in the main square, a route indicator signals "All traffic" to the left, with "Distillery" on the right; once directed, you proceed to the end of a street whose nameplate assures you that you're on "Distillery Road".

Stewart Walker used to live in one of the houses on this very road. "The distillery's been part of my life for fifty-plus years," he says. "As a kid, I'd be aware of the guys finishing their shifts, chatting as they went past the front gate every day. But you don't realise the magnitude of the place until you come inside, and it all hits you; the smells, the noise, the beautiful stills…"

Walker is now Fettercairn's manager, having worked here for north of thirty years, and he has a proud, proprietorial air befitting a Distillery Manager of the Year award-winner (2021) as he walks a visitor around the complex of whitewashed buildings, enlarging on everything from the distillery's unicorn logo ("It's Scotland's national emblem – England already had the lion, so we had to go one better"), to the Victorian tumble rake mash tun ("It's a rare survivor – to see it in action is just incredible"). But he saves his richest encomium for Fettercairn's unique feature – the pair of cooling rings fitted to its stills, enabling water to run down their exteriors. "They typify what Fettercairn's all about," he says, "coming at things from a different angle, and bringing ingenuity to bear."

The rings were the brainchild of Alistair Menzies, manager in the 1950s. "He wanted to refine the spirit a wee bit, and the obvious thing would have been to reshape the stills, but that costs money," says Walker. "So he got an engineer called John Twigg to make a copper pipe that went round the head of the still with a small hole bored every twenty-five millimetres, spraying cool spring water over it to create reflux."

Such ad hoc innovation backs up Walker's claim that "people say there are only three ingredients in whisky, but I think there's a fourth element involved, and that's the human factor." The rings have not only left a photogenic patina on the stills; they've also had a marked effect on Fettercairn's flavour profile, according to Walker. "They've brought a tropical fruit note into our trademark light, fresh style," he says. There's mango, pineapple and soft spice coming through in our 12-year-old; if we introduce sherry butts and port pipes into the maturation, I've found notes of guava, blood orange and passion fruit standing out." He grins. "Not the kind of language you'd normally associate with the world of whisky."

As the distillery's two-hundredth anniversary is celebrated, Walker reckons Fettercairn has found its moment. "We flew under the radar for a long time, because most of the whisky we produced was for blends," he says. "Now, our single malt, which we started producing in 2018, is our ultimate statement of intent. We have so much stock of lovely whisky here" – fourteen dunnage warehouses' worth, in fact – "so we can show our scope with our cask types and limited Batch releases. Our story's in place." And he also has one eye on legacy – both his and Fettercairn's. All the barley now used in the distillery's production is grown within a fifty-mile radius of the building, in the rolling Aberdeenshire hills. Its Scottish Oak Programme, developed with Gregg Glass, master blender at Fettercairn's owners Whyte & Mackay, has seen the planting of 13,000 oak saplings on the 8,000-acre Fasque Estate, adjacent to the distillery, to create Fettercairn Forest and expand their existing use of Scottish oak casks ("You get a lovely spiciness from the oak that mellows to a peppery warmth," according to Walker). All of which makes the "Forest to Field to Fettercairn" slogan around the distillery much more than mere window dressing. For Walker, the journey from Distillery Road may have been short, but it has encompassed a lifetime of learning – and it's still ongoing. "I love going into a warehouse and finding casks that surprise you," he says. "Even if you think you know what you're dealing with, there's always a little dram that'll make you go 'wow'. You shut the door, everything goes quiet, and you quite literally summon the spirits, taking the time to nose, and sip, and savour."

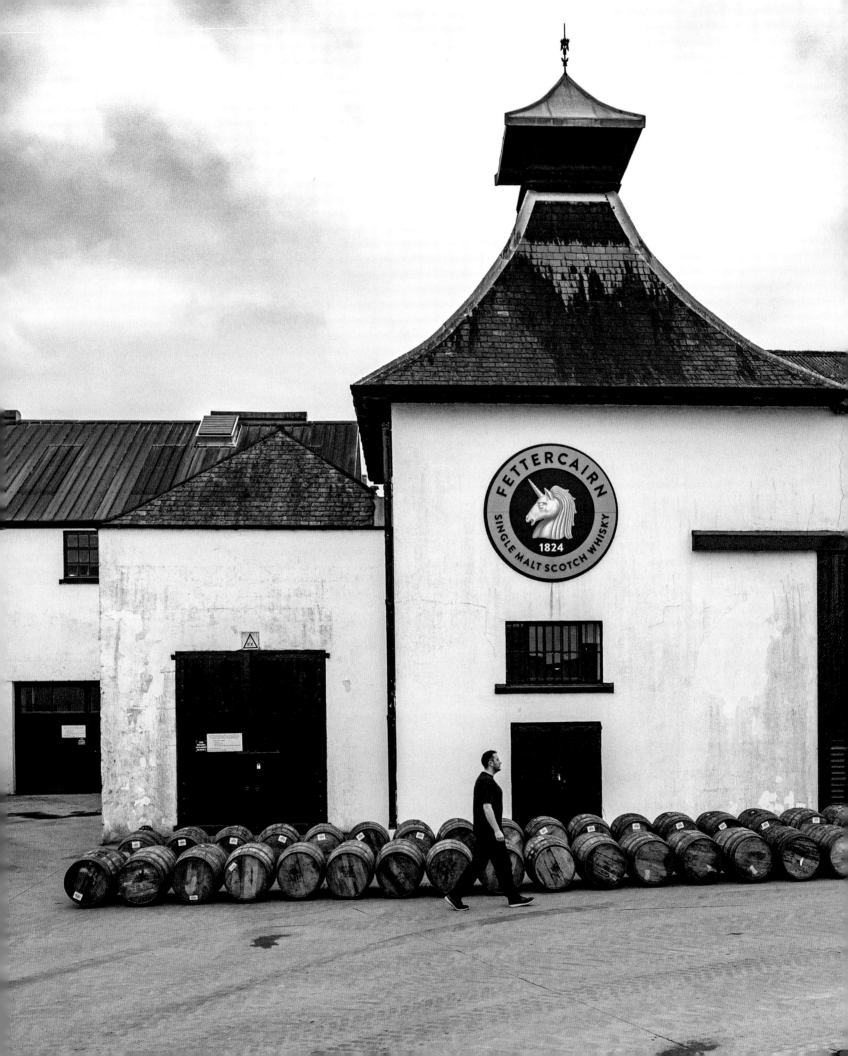

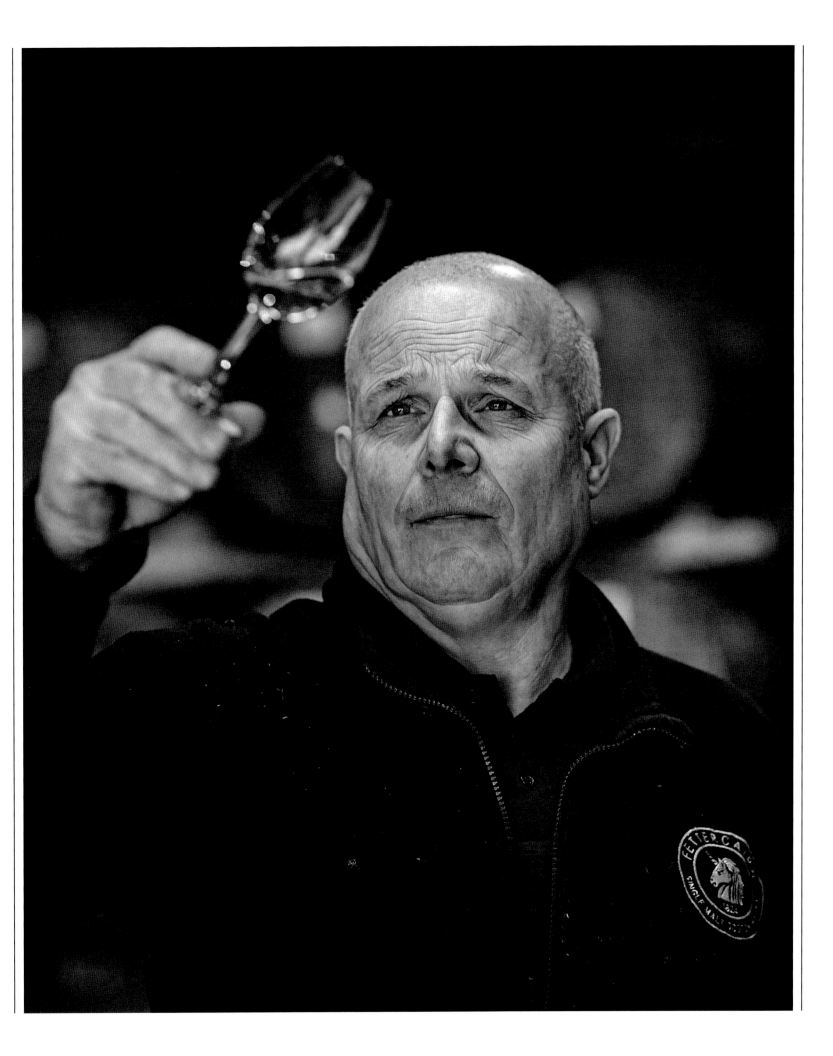

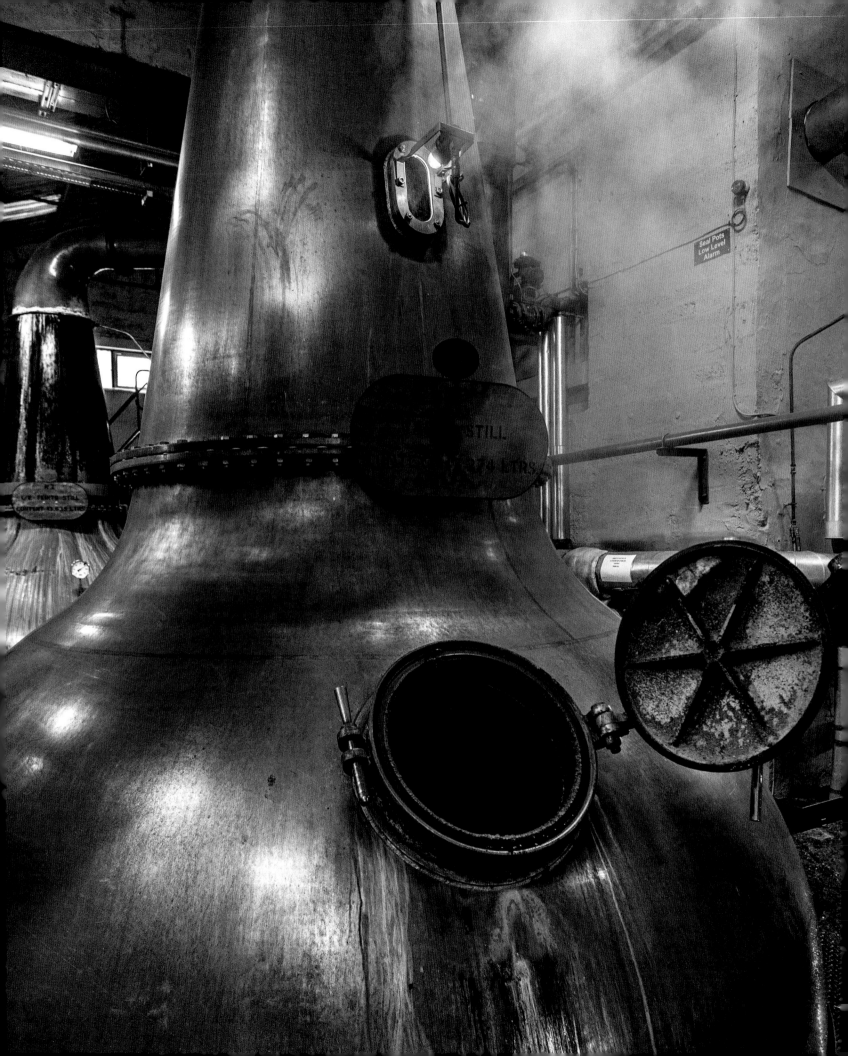

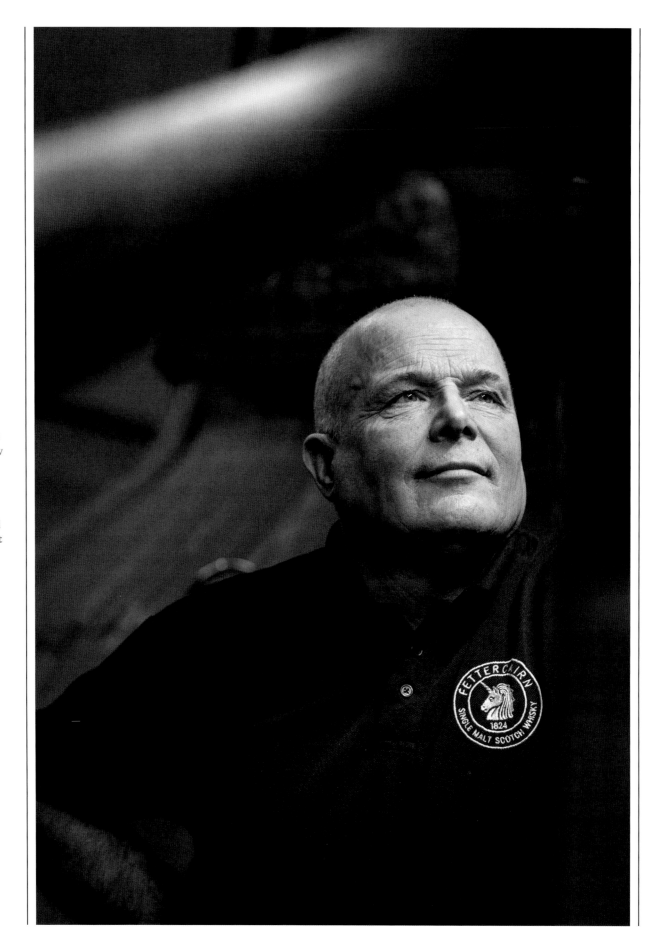

Stewart Walker, Fettercairn's manager, grew up on Distillery Road: "This place has always played a massive part in my life."

Nº 2

L/W. & FEINTS STILL

CONTENT 13,638 LTRS.

"The pride people have in this place, and in the product, is inspiring. It's a special environment to be in; it seeps into you. There's 200 years of history in these walls, and in these stills."

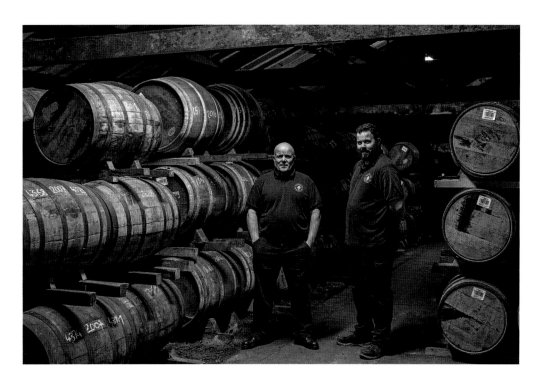

Top: Vintage stencils. Bottom: "We're caretakers, handing the story on to the next generation."

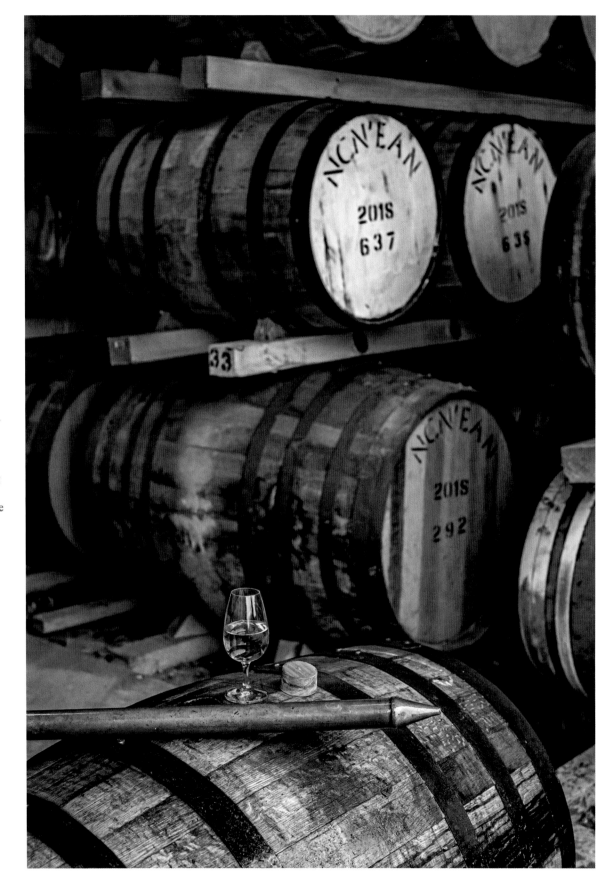

"We want to introduce a new audience to whisky," says Nc'nean's founder Annabel Thomas. "We're not disruptors, we just want to bring some different perspectives, some fresh thinking."

NC'NEAN
DISTILLERY

EST. 2017

THE HIGHLANDS

Nc'Nean Distillery

Even by the stringent standards of the Scottish Highlands, the Morvern Peninsula is stunningly beautiful and stirringly remote. At its westernmost tip – Ardnamurchan to the north, the Isle of Mull to the south – lies the 7,000-acre Drimnin Estate, all rugged coastline, heather moorland, ancient oak and beech spackled with lungwort and lichen, and rich pasture. It's a fittingly Elysian setting for Scotland's first organic, fully sustainable and carbon net zero distillery.

Nc'nean – the name was inspired by the Queen of the Spirits in Gaelic legend, Neachneohain – lies at the end of a twisting drive, where you're greeted enthusiastically by Doug, the sheepdog and "happiness manager"; he undoubtedly has a generous amount to manage. The distillery, in a set of repurposed farm buildings, looks out over the Sound of Mull; pairs of nesting sea eagles occasionally glide over on foraging hunts. "The whole idea was to work with nature rather than against it, because you can't tame it out here," says Annabel Thomas, Nc'nean's founder. That means using organic barley; employing a closed-loop water system which funnels the liquid from a pond to the condensers and back again; operating on renewable energy in the impressive form of a biomass boiler that's fed on woodchips from the estate's managed forests of lodgepole pine, spruce and larch; and using bottles made entirely from recycled glass. Even its (optional) gift tubes are 97 per cent recycled cardboard. It's all helped Nc'nean meet the net zero target for distilleries a full two decades before the Scotch Whisky Association's imposed deadline. "We all feel a sense of purpose," says Amy Stammers, Nc'nean's head of sustainability. "It's all about using what you've got and not imposing yourself. And this is a very bountiful environment."

The comments in the visitors' book – "a meaningful ethos", "good luck to the eco-goddesses" – are certainly on board, but when Thomas, a refugee from management consultancy, had the idea to start the distillery in the early 2010s (her parents own the estate, and she got married on its grounds), she initially found it a harder sell. "I still have the list of the eight hundred potential investors I approached to get the forty-five we ended up with," she grins.

Sustainability was baked into the business plan from the very beginning: "Part of the reason for doing this in the first place was because I felt the industry wasn't going far enough or fast enough in that direction. So we could help pave the way."

It's been a learning curve; the organic barley, sourced in Scotland where possible, is costlier, but, says Thomas, "every grain is infused with more character and I think that comes through", while the boiler, says distillery manager Graham Wood, "took some getting to grips with. There were some long days and evenings in that first year." Thomas worked with the late legendary whisky consultant Jim Swan to help develop Nc'nean's spirit and flavour profile; the resulting single malt, says Wood, was "a bit lighter, more rounded, more far-reaching and easy drinking, to bring new audiences in."

Those audiences, to Thomas's delight, skew younger and more X chromosome, attracted by Nc'nean's eco-commitment, its refreshingly un-precious attitude to its product – "many distilleries are still 'thou shalt not mix' about their single malt, but I think whisky and soda is a forgotten wonder," says Thomas – and even their packaging; the bottles feature embossed foliage rather than the traditional pile-up of antlers and heraldry, and the green tint of the recycled glass makes it more approachable as well as being on message. "But we're not a disruptor," says Thomas. "We're just bringing some different perspectives."

Nc'nean were the proud recipients of the 2023 Icons of Whisky Craft Producer of the Year Award, but they're not resting on their (organic) laurels; Thomas is attempting to carbon-neutralise the distillery's supply chain – "an uphill task, to put it mildly" – and their Aon range of limited-edition single cask bottlings makes use of red wine and Rivesaltes casks, among others. "I feel like what we've created has encapsulated what I wanted it to more than I could have imagined," says Thomas. "Bring in sustainability, banish the stuffiness, experiment, explore textures and mixing." She indicates the tree-shrouded shore below with a sweep of her hand. "And I hope we've distilled just a little flavour of this extraordinary place."

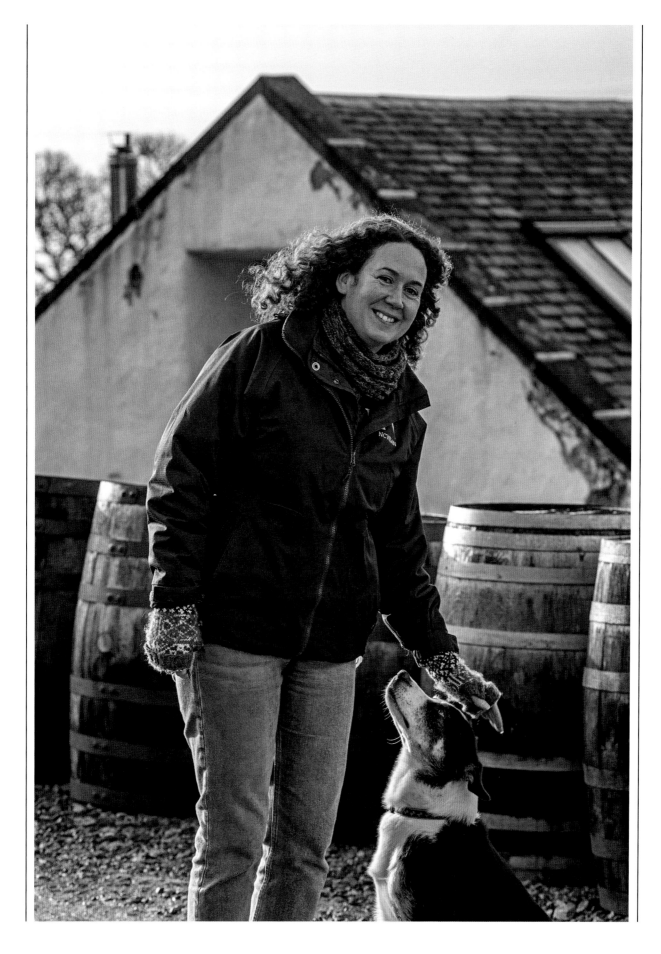

Amy
Stammers,
Head of
Sustainability,
with Doug,
Happiness
Manager:
"We're a young
team, we're all
very close, and
we get to enjoy
whisky. How
cool is that?"

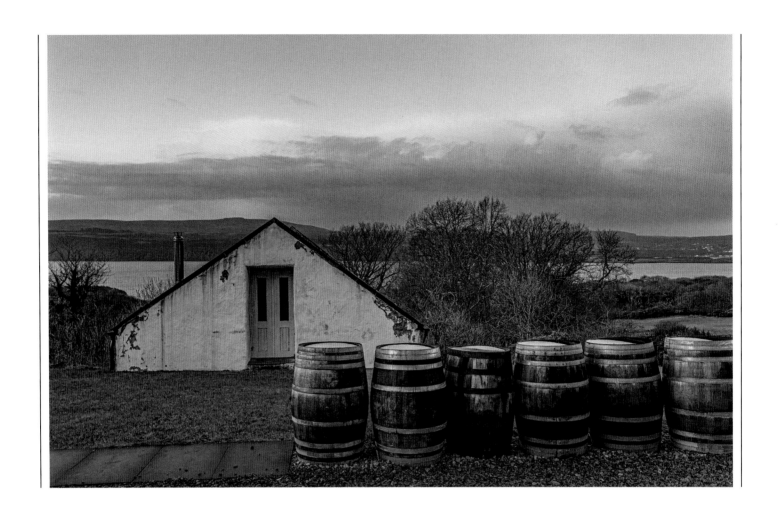

Nc'nean's converted farm buildings hold the still room and bar.

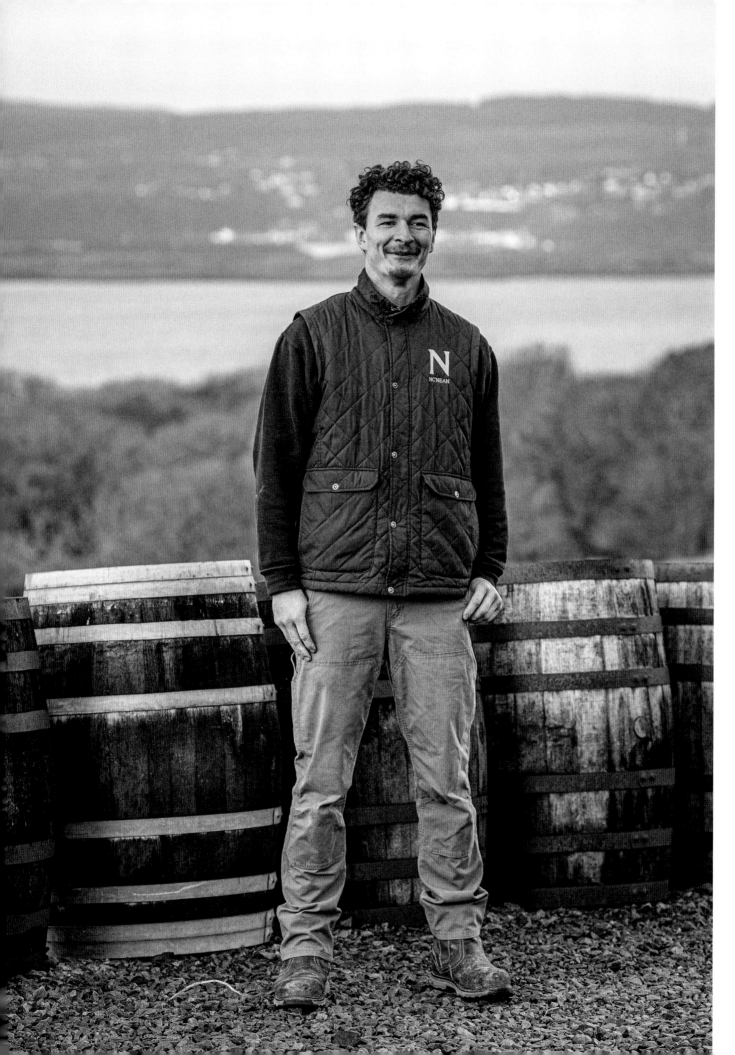

"Because we
started with
a clear
philosophy,
particularly
around
sustainability,
we attracted
people who
felt the same."

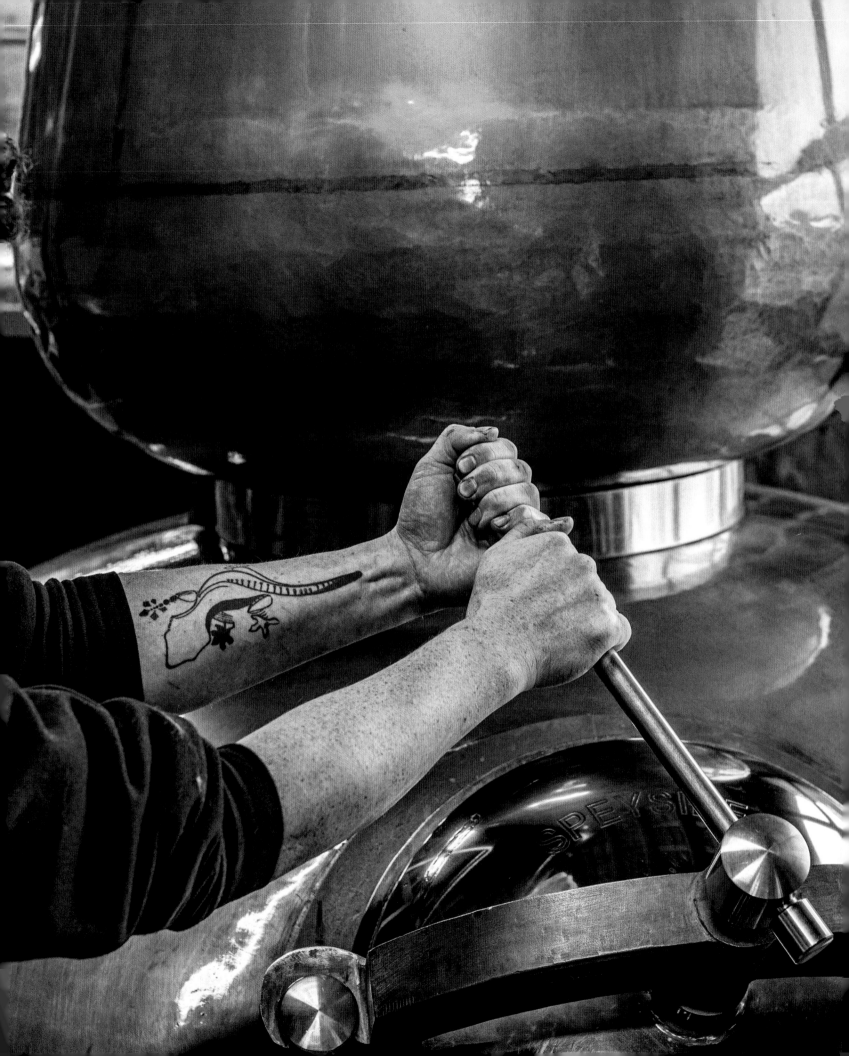

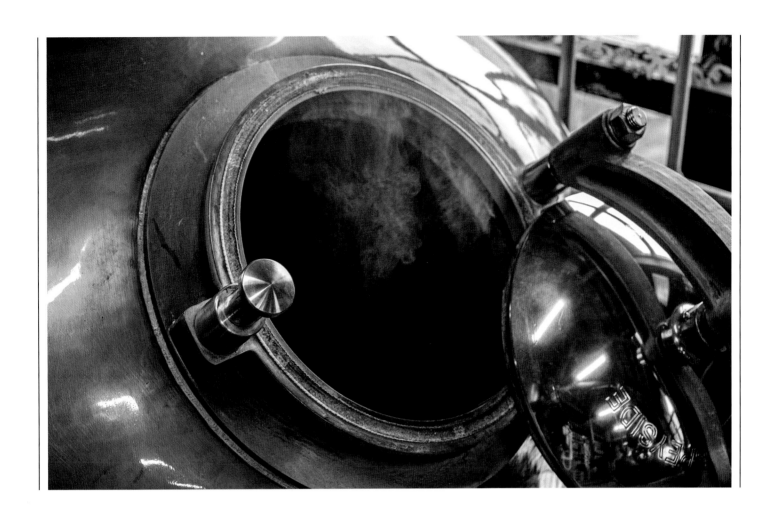

Flaming chips:
Nc'nean's
impressive
biomass boiler.

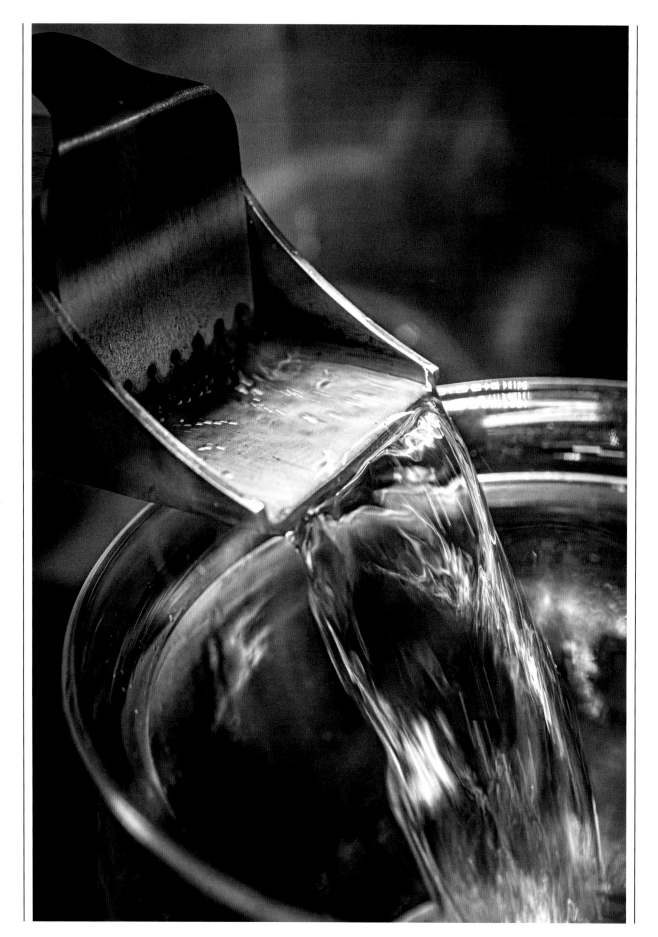

"We're organic, we're sustainable, and we're net zero carbon emissions," says distillery manager Gordon Wood. "We're at the forefront of where the industry's got to be."

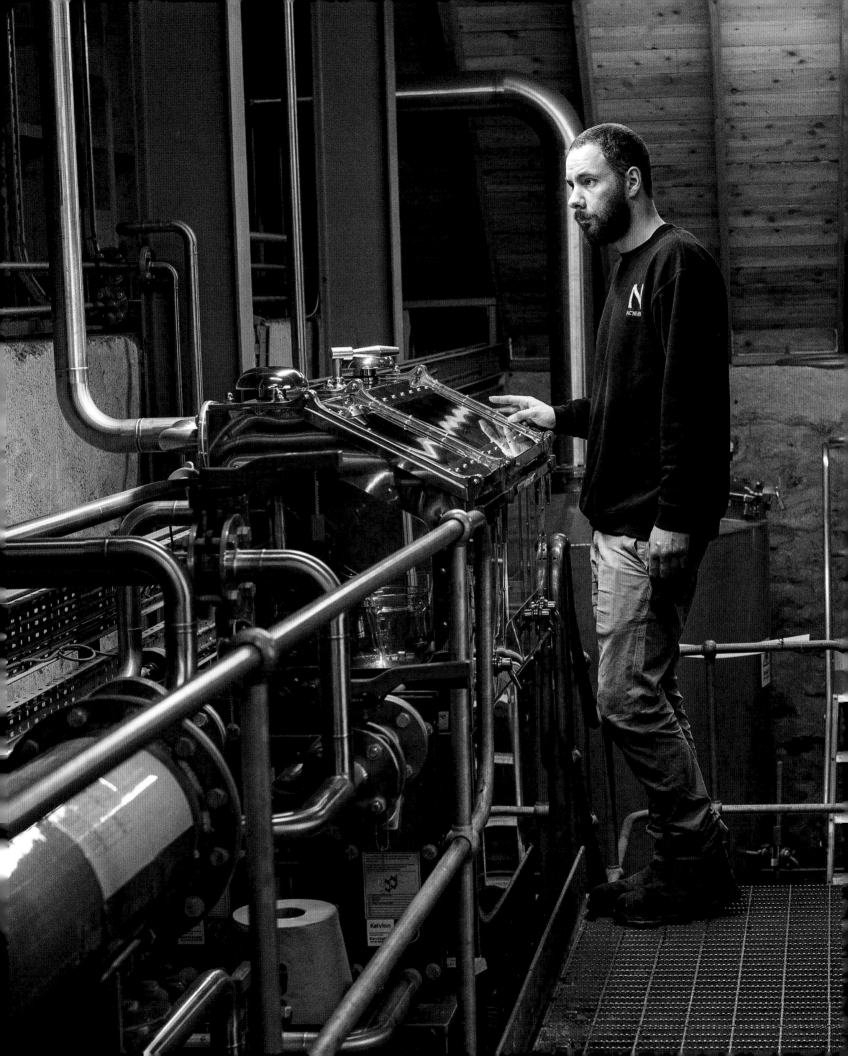

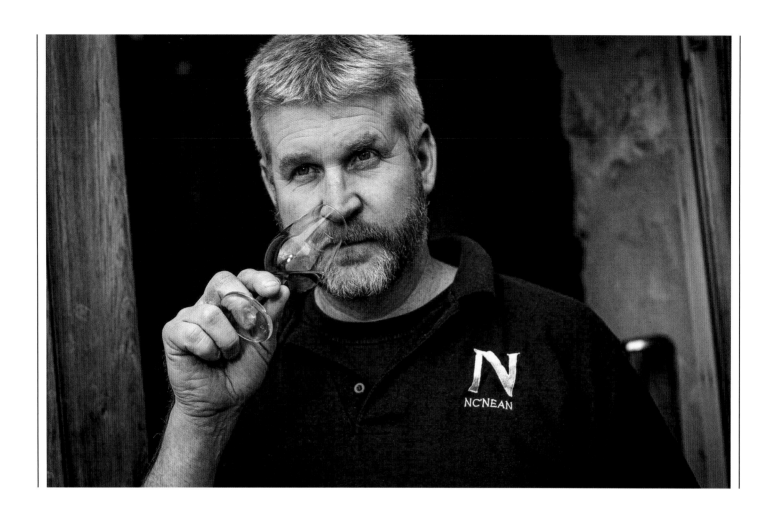

The still room looks over the Sound of Mull: "This place is reflected in the character of what we make."

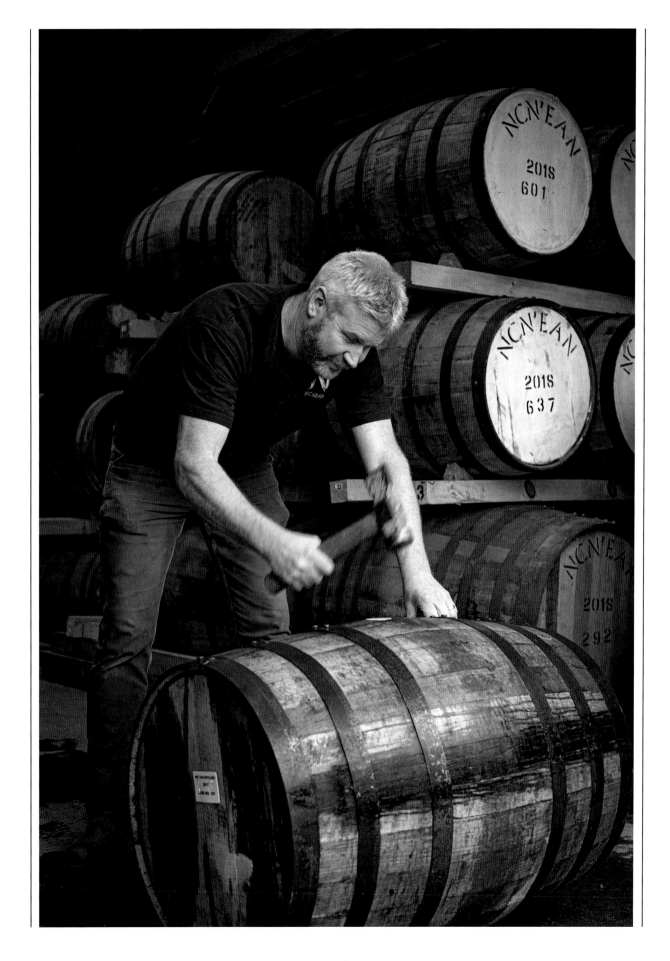

The bung stops here: "We're filling about fifteen casks a week off five mashes," says Gordon Wood.

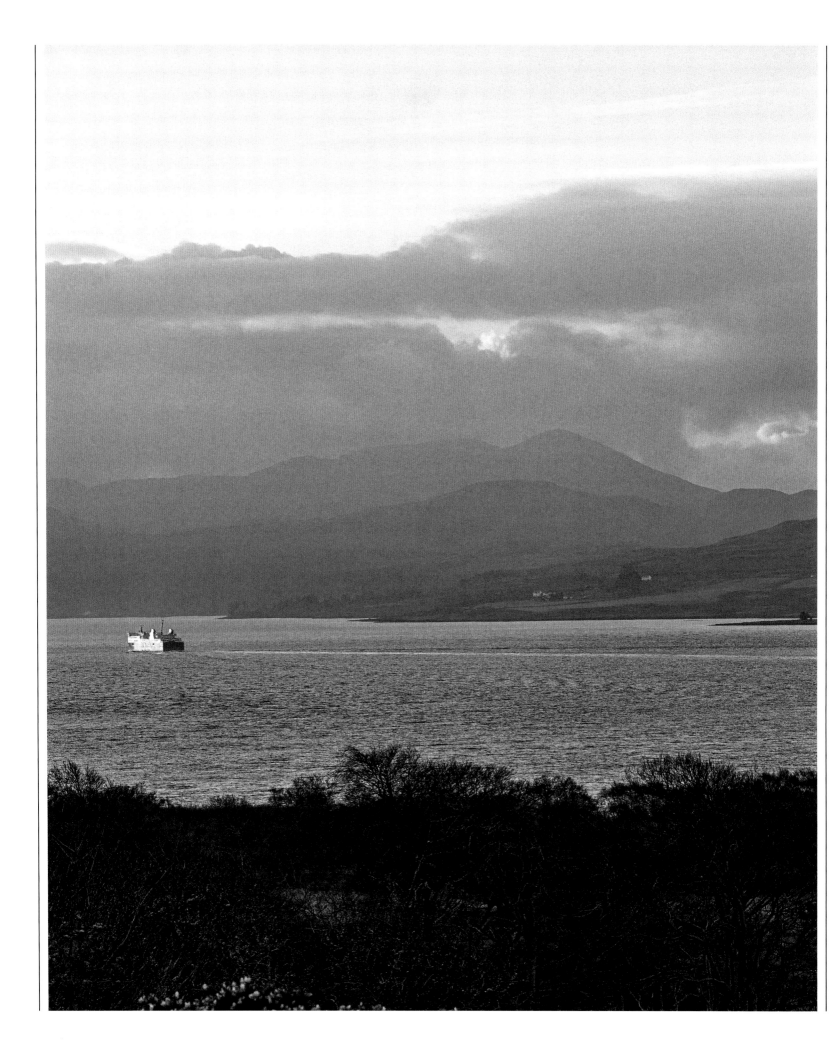

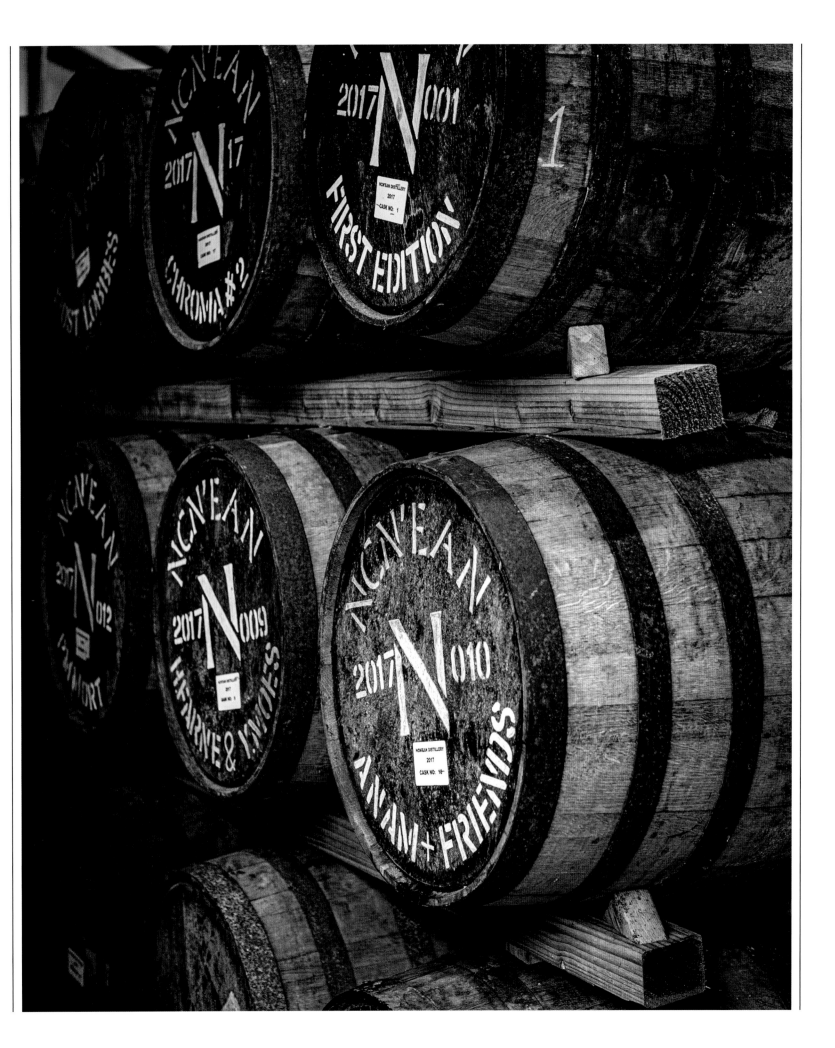

The Isle of Harris distillery aims to bring stable employment to its island community – and to produce a dram as celebrated as its eponymous tweed.

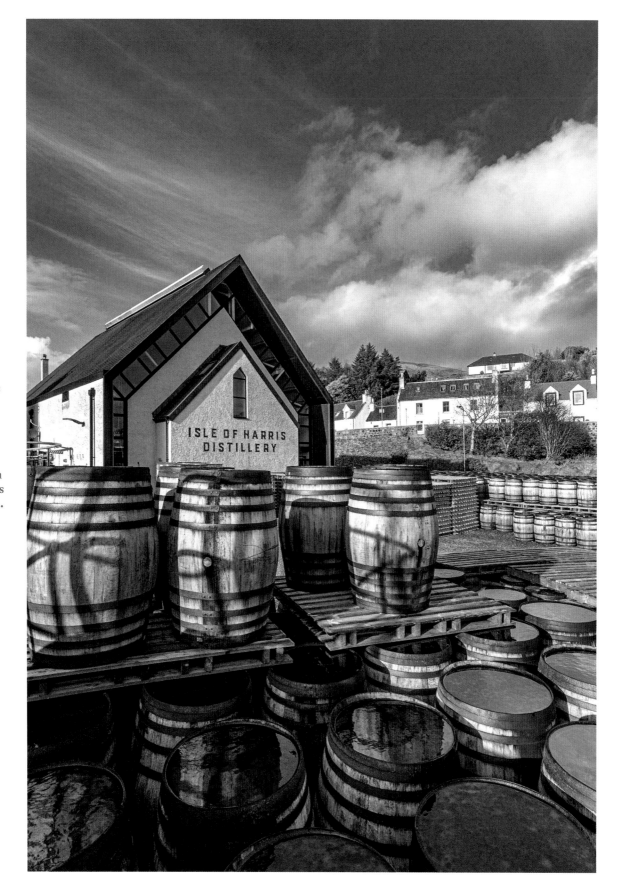

ISLE OF HARRIS DISTILLERY

EST. 2015

THE ISLANDS

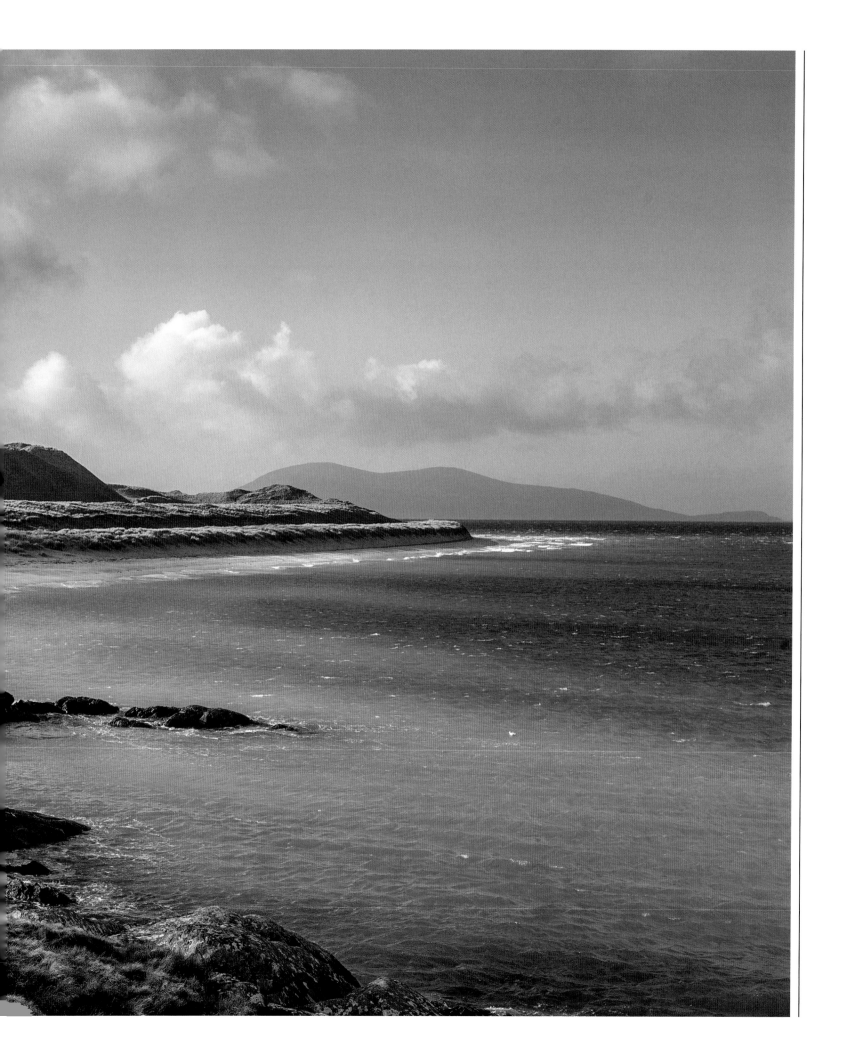

Isle of Harris Distillery

As beginnings go, they don't get much more auspicious. On 24 September 2015 the doors to the Isle of Harris distillery were thrown open for the first time. An inaugural fire was lit in the building's hearth, and three generations of Hearaich – the Gaelic word for the island's natives – each placed a block of peat on the blaze to mark the occasion. This ceremony was quickly followed by the largest ceilidh the island had ever seen, with hundreds of islanders enjoying, if not a bona fide rave, then a night of music, dancing and song in the cask warehouse, as the inaugural island spirit flowed.

No wonder Isle of Harris calls itself "The Social Distillery". But it's about more than banging nights out; it was envisioned as a catalyst for positive change in this outer Hebridean community whose numbers had halved to fewer than two thousand in the past half century, with a remit to help arrest the exodus of the island's best and brightest, bring stable employment and, not incidentally, make the island known for something other than tweed (though, in a nod to its illustrious forbear, the distillery boasts an official Harris Tweed jacket among its merch).

The vision can largely be credited to Anderson "Burr" Bakewell, an American-born former musicologist – he spent a large part of his career engaged in the Sisyphean task of trying to save the world's traditional music from being inundated by the tsunami of Western pop – and organic farmer; he saw the small island of Scarp, off the Harris coast, as a kind of spiritual retreat after getting to know it in the 1960s, when a few families still inhabited its grassy hills. Eventually the island was abandoned, and Bakewell was determined that Harris shouldn't suffer the same fate: "This area has given me a great deal, and I saw an opportunity to put something back."

That something now sits resplendent on the main north-south road through Tarbert, the island's capital. The distillery practices outreach, of course – all Harris's cows are fed on its draff, and work experience placements are offered to students every summer. But within its striking barn-like buildings are forty permanent staff, including seven distillers, with works by local artists adorning the walls and the visitor centre playing host to book readings. The distillery's premier spirit, the award-winning Isle of Harris Gin, boasts sugar kelp, sustainably harvested by a local diver from the seas of the Outer Hebrides, among its botanicals; the countdown is now on for the release of The Hearach, the distillery's first single malt, currently maturing in ex-bourbon and ex-oloroso casks on the shores of Loch an Siar in the nearby village of Ardhasaig. "It'll be lightly peated, complex, full of character and with great balance," says Simon Erlanger, the distillery's manager. There will also be a more heavily peated expression, with the peat cut by hand at Cleite Mhòr, an area of South Harris. But, stresses Erlanger, it'll only start flowing when it's good and ready: "Life takes time," he says, "as every islander understands." In the meantime, the social distillery is bringing Harris that bit closer with weekly storytelling sessions on its online journal, covering everything from sea eagle sightings to holding the perfect ceilidh (something they are eminently qualified to discuss). They are also lighting that peat fire every day – a beacon of hope for, if not a vote of confidence in, Harris's future. "We're part of the island story now," says Erlanger, "and we have a chance to take it forward."

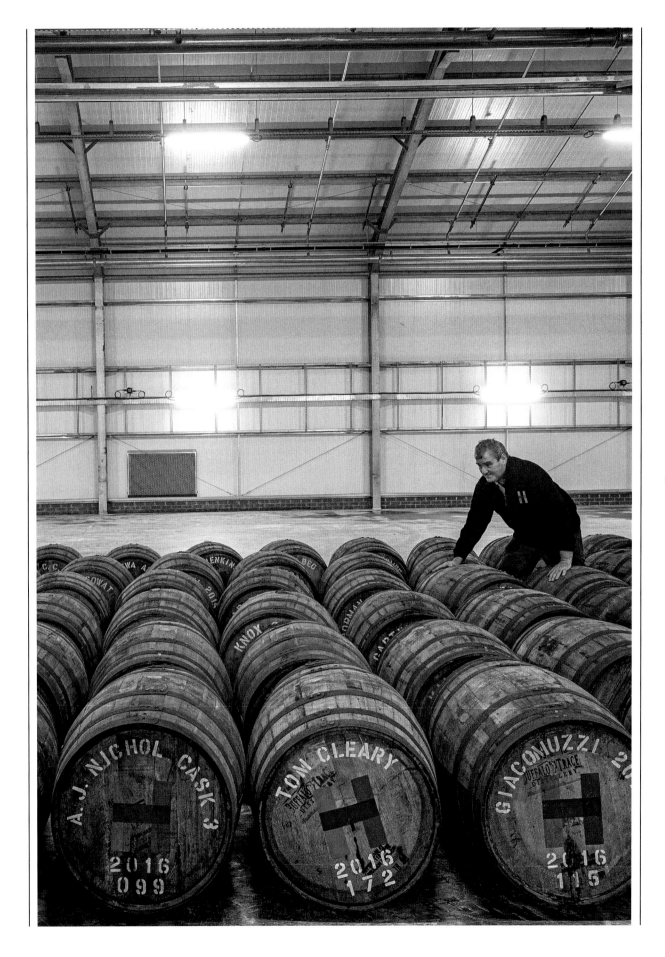

Reserved casks maturing in the warehouse on the shores of Loch an Siar.

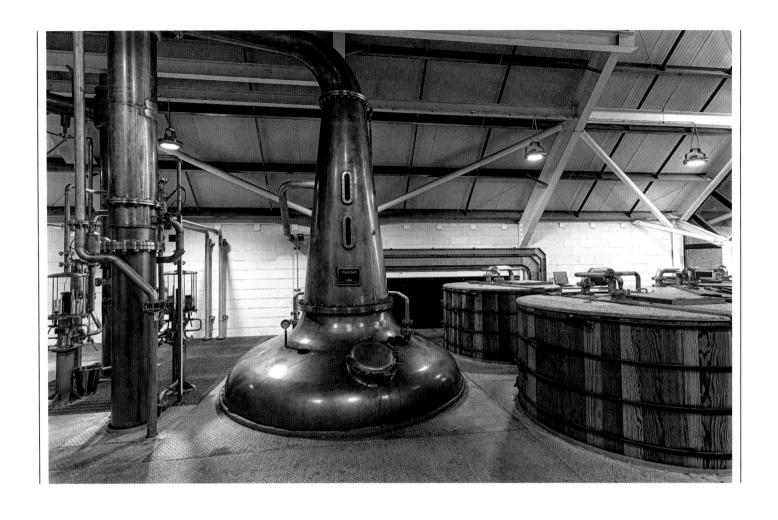

Harris's first
single malt
will only start
flowing when
it's good and
ready: "Life
takes time, as
every islander
understands."

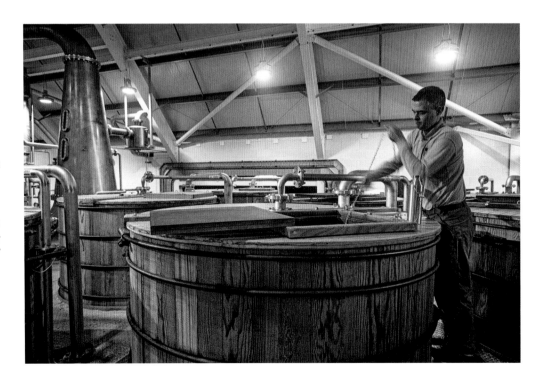

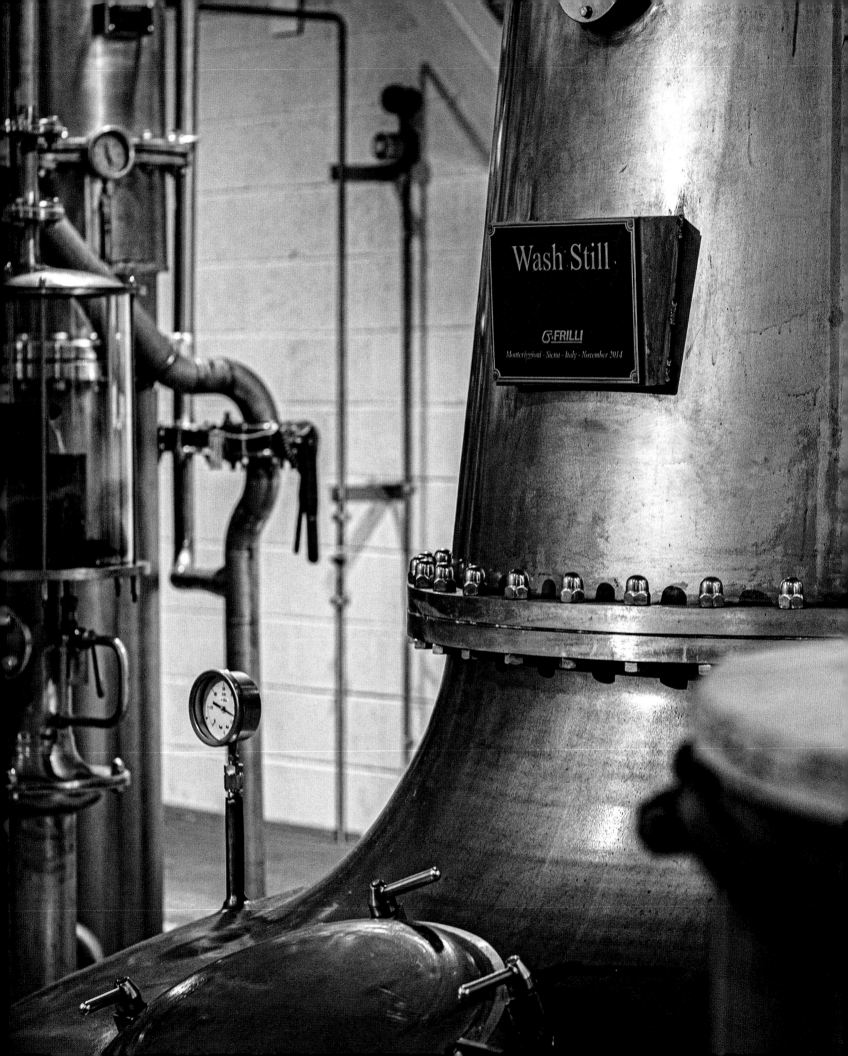

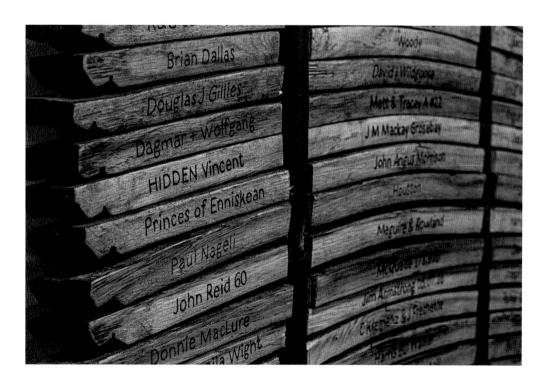

Top: Mike Donald, Harris's chief storyteller. Bottom: Staves engraved with the names of some of the 1916 people who've signed up to receive Harris's first single malt, The Hearach.

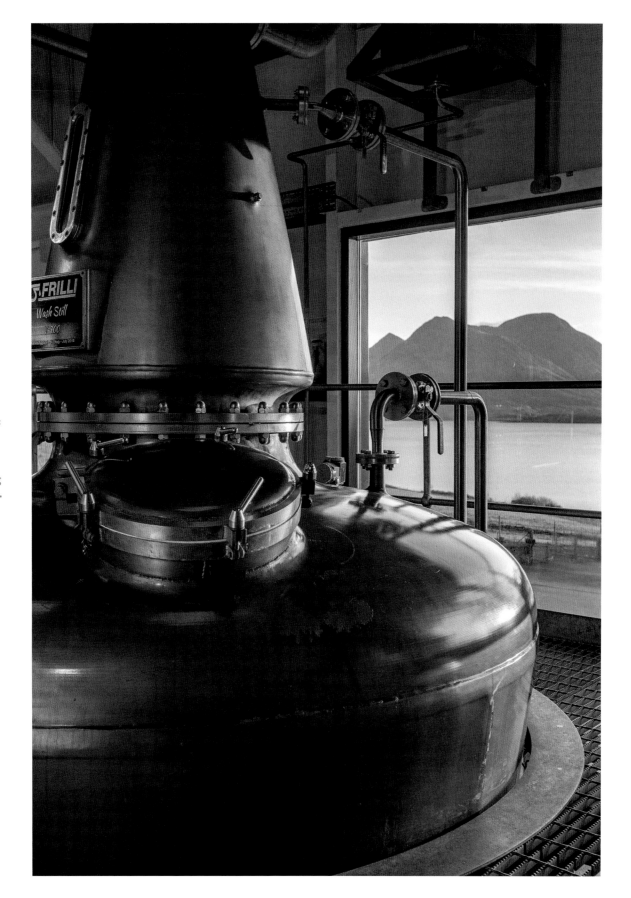

Isle of Raasay's still room looks out across the sound to the Cuillins, Skye's brooding mountain range.

ISLE OF RAASAY DISTILLERY

EST. 2014

THE ISLANDS

"Whisky has emotional associations," says Norman Gillies, Isle of Raasay's manager. "So by putting Raasay in a bottle, we can recall this beautiful place to people's minds, wherever they are in the world".

Isle of Raasay Distillery

Ralph Waldo Emerson's famous quote, "The journey is the destination," is given new impetus on the twenty-five-minute ferry ride from Skye to Raasay, if only because, on a gentle, sun-kissed morning, the serene, glorious passage across the Sound of Raasay – to the piping of oystercatchers and the occasional rasp of a golden eagle, high on a therm – matches the majesty of the place to which one is borne.

The name Raasay is thought to come from the Old Norse for "Island of the roe deer" – appropriately enough, as the 280 head of *Capreolus capreolus* on this Hebridean jewel, just fourteen miles long and three miles wide, is almost double that of its human population. The latter has been bolstered, however, by the island's newest attraction, opened in 2017. The Isle of Raasay distillery is the second building you encounter as you make your way from the jetty, just after the imposing Victorian pile of the Raasay House Hotel; tucked into the lee of a hill, its glass-fronted, gold-clad visitor centre and still room (complete with handsome Italian-made stills, courtesy of Frilli in Tuscany) boasts spectacular views across the sound to Glamaig, the foremost peak of Skye's Cuillin mountain range. "Not bad, is it?" says Norman Gillies, the distillery manager. "People who make the pilgrimage here tend not to forget it."

Particularly if they leave with "Raasay in a bottle". The distillery's spirit, with water filtered through Jurassic sandstone into its own well, Tobar na Ba Bàine (The Well of the Pale Cow), comes in peated and unpeated varieties, with maturation in American chinkapin oak casks (caramel, honey and dark fruit notes), Bordeaux red wine casks (spicy, cinnamon, sandalwood) and American rye whiskey casks (peppery, butterscotch). Each decanter-like bottle has Raasay fossils and rocks moulded into the glass. "It's a whisky that's designed to be good when young and drunk when young," says Gillies. "Our production set-up is designed to give us lots of variability; we have cooling jackets on our washbacks so that we can change our fermentation times, and lyne arms that put reflux back into the still. But all our drams are approachable, and not polarising in any way."

The same might be said about the tall, bearded, amiable Gillies, a Raasay native who left to study engineering on the mainland and returned to helm the distillery and its thirty-strong team, which has not only helped buck the trend of population decline on islands such as Raasay, but also skewed it younger. The distillery's future plans – accommodation at the Victorian Borodale House, adjacent to the visitor centre; the growing and malting of Raasay barley; a possible grain store and maltings ("that's the dream", says Gillies, "to create jobs here, and to keep them here") – should not only embed it within the community, but help spread the Raasay name far and wide. "The best thing about working here is the sense of possibility," says Gillies. "We're in twenty-six countries now, and it's amazing to think that you could end up in some far-flung corner of the world and you'll encounter our whisky."

Meanwhile, in this particular far-flung corner of the world, a trip in the distillery's Land Rover Defender over the island's rugged hills reveals more stunning vistas; is that a dolphin gambolling in the Inner Sound? (No – it turns out to be a submarine on manoeuvres from the nearby testing base, but seems no less exotic for that.) Is that the bay where Queen Elizabeth II once sunbathed? (Yes – she was partial to private picnics on the secluded, sandy beach of Inbhir, with HMY *Britannia* moored offshore.) Raasay's terrain has long made the heart soar – now it has a spirit to match.

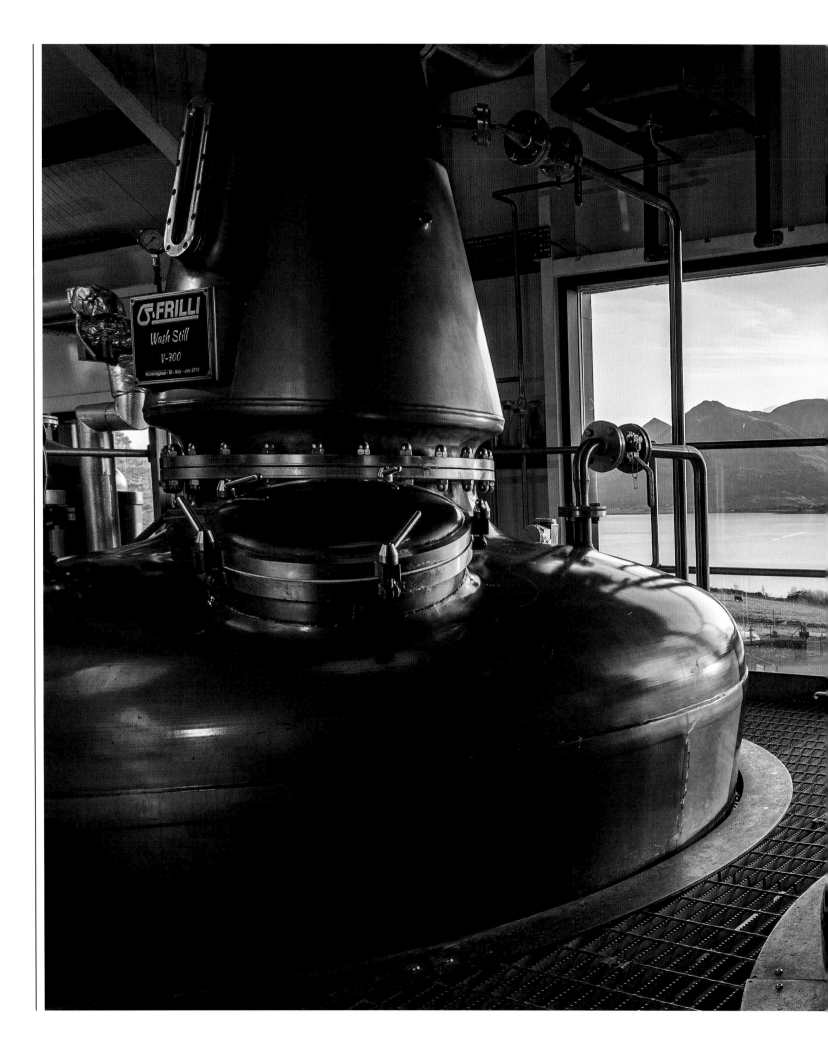

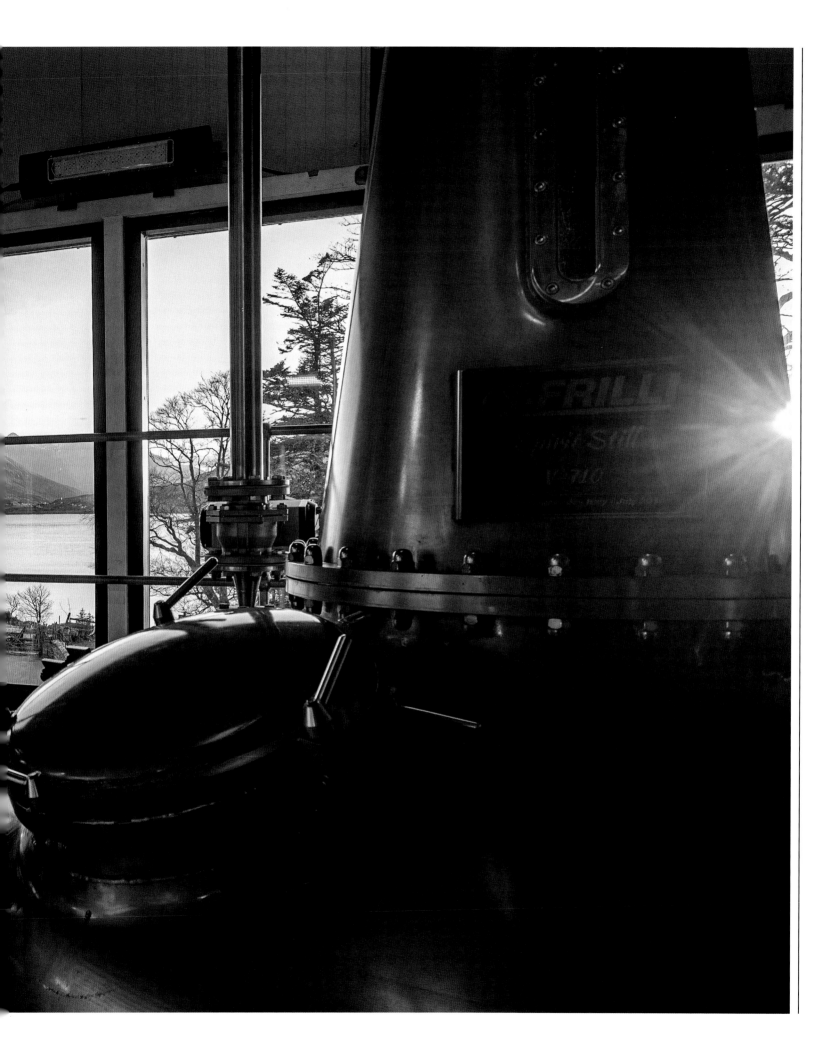

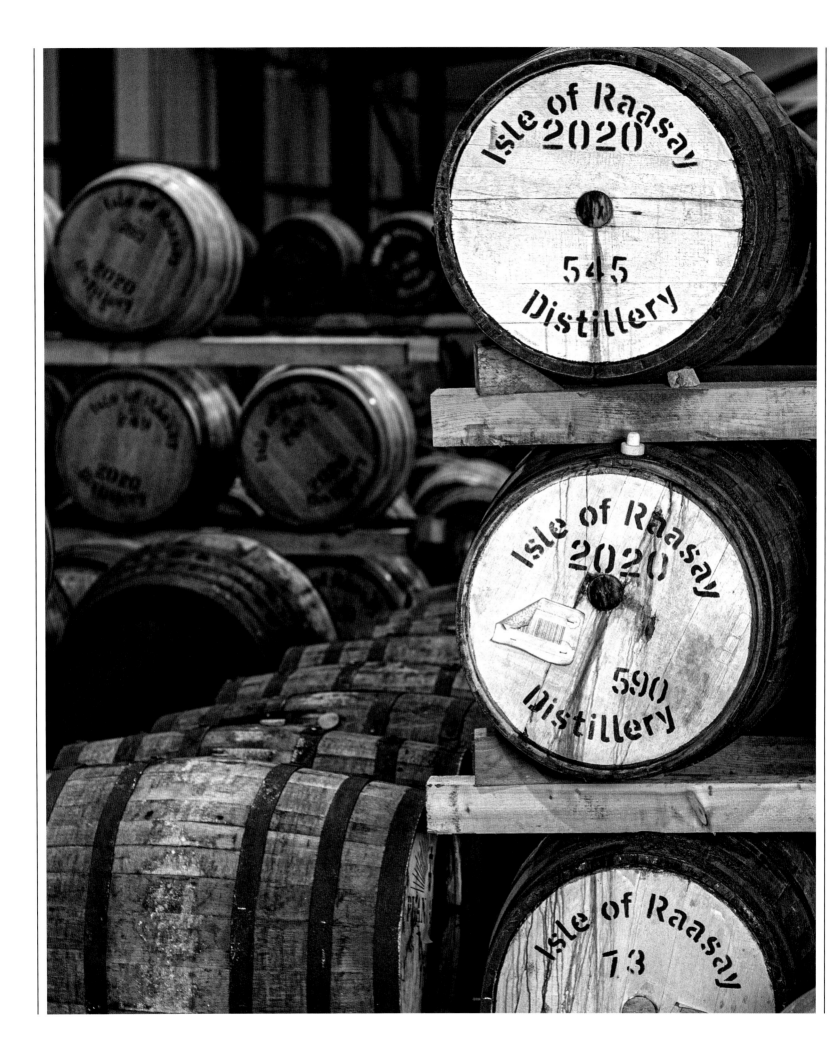

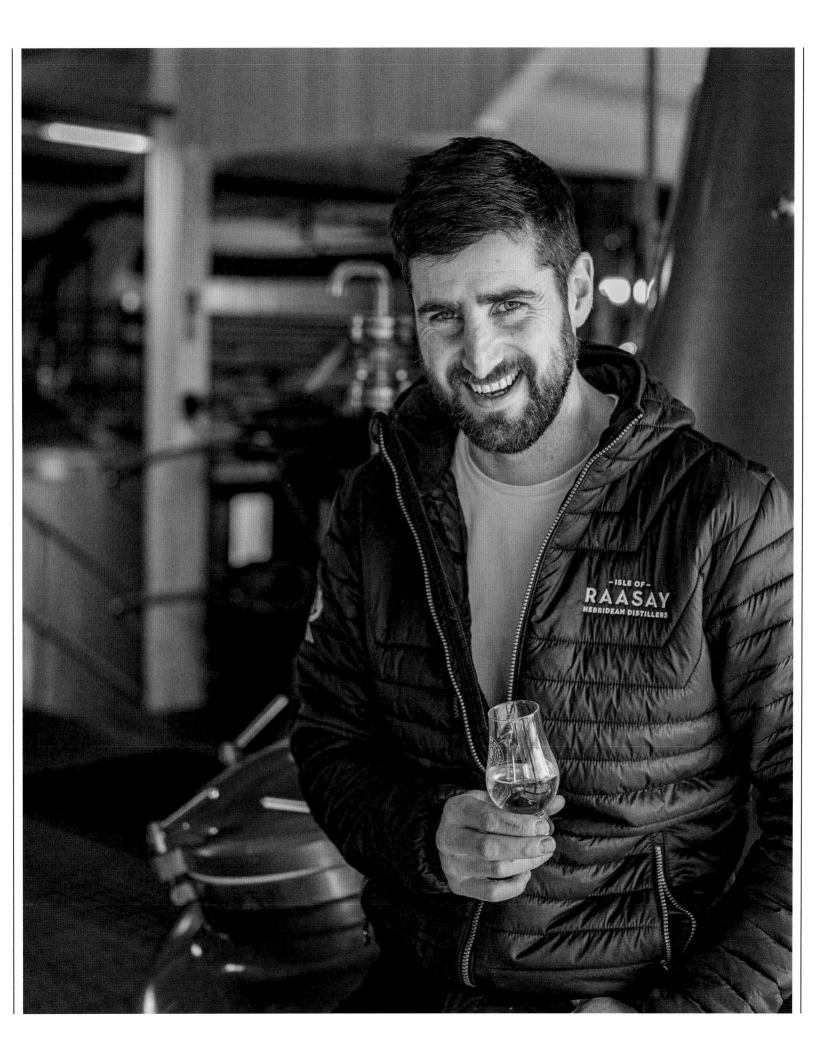

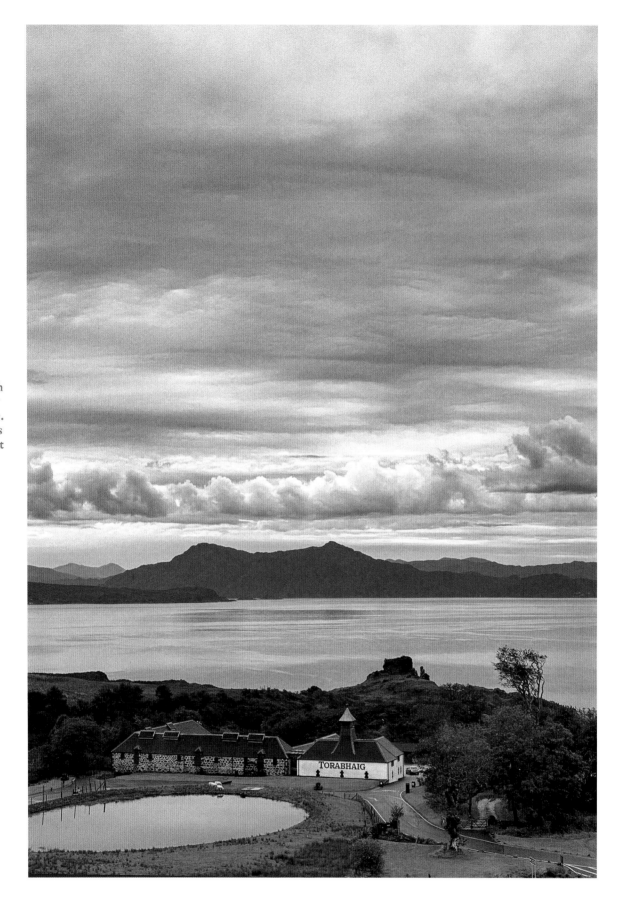

Torabhaig is only the second ever licensed single malt Scotch whisky distillery on the Isle of Skye. "The building was dormant for about fifty years," says manager Neil Macleod Mathieson, "and we've done it justice by bringing it back to life."

TORABHAIG DISTILLERY

EST. 2017

THE ISLANDS

ALT MILLED LOG TORABHAIG DISTILLERY

PERIOD __20__ _____ WEEK NO ____

DATE	LOAD NO	BIN NO	MASH NO	VARIETY	GRIST SAMPLE		COMMENTS
					YES	NO	
24/07/17	8	2	1				
25/7/17	8	2	2	CONCERTO	✓		
25/7/17	8	2	3	Concerto	✓		
26/7/17	8	2	4	" "	✓		
26/7/17	8	2	5	Concerto	✓		RECHARGED TOP 1 5mm 2 11mm BOTTOM 1 1 5 0.55
27/7/17	8/4	2/1	6	" "	✓		
28/7/17	9	1	7	Concerto	✓		
28/7/17	9	1	8	"	✓		
24/7/17	9	1	9	" "	✓		
			10	" "	✓		

Journeyman distiller Iona Macphie takes a sample using a grist sieve box, more commonly known as a shuggle box, so that the mill can be adjusted when needed.

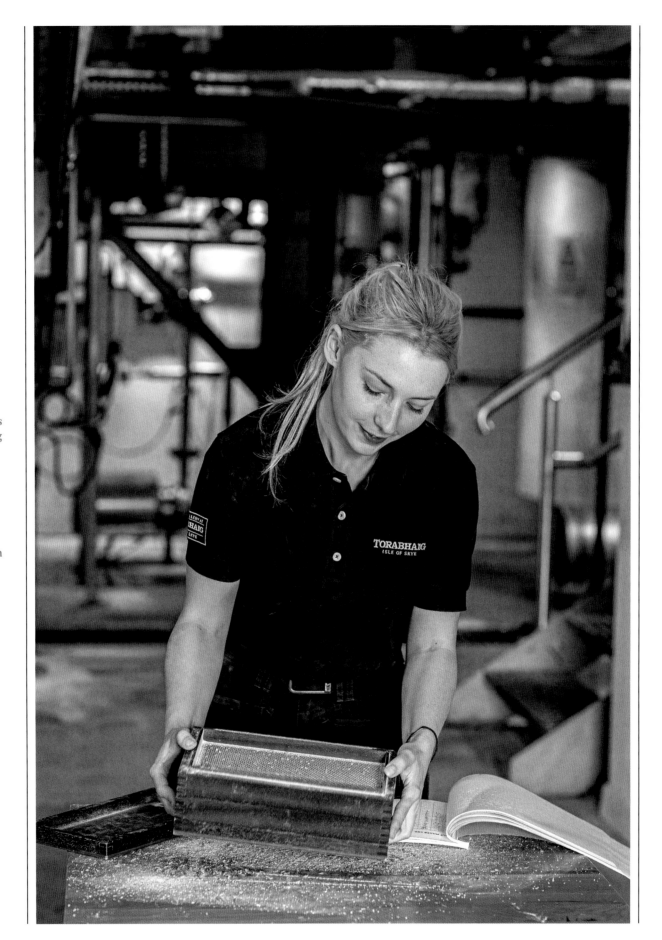

Torabhaig Distillery

"I think we have the most beautiful distillery in Scotland and the best outlook on Skye," says Neil Macleod Mathieson. It's not that he doesn't have some skin in this particular game, being the manager of Torabhaig, only the second ever licensed single malt Scotch distillery on one of the Highlands' premier destinations. But as the sun rises over the pagoda roof, with all the attendant splendour of the new day – exulting larksong, the gentle plash of waves on the Sound of Sleat, the rays illuminating the distant peak of Ladhar Bheinn to the west – it's hard not to have some sympathy with his claim.

The story of how Torabhaig came to sit in this plum spot on Skye's southern shore is pretty remarkable in itself. It was the brainchild of Sir Iain Noble, a merchant banker and laird of Skye's Eilean Iarmain Estate. He obtained planning permission to convert a listed 1820s farmstead near the hamlet of Sleat, but passed away before work could begin. Enter Mossburn Distillers, who took up the mantle. "The buildings had been lying dormant for about fifty years," says Mathieson, who's also Mossburn's CEO, "there were trees growing through them, and no windows or doors." They began a painstaking reboot of the complex, some of whose stones were originally plundered from the derelict fifteenth-century Castle Camus on the shore of the sound (the castle was once fought over by Skye's two principal clans, the MacLeods – Mathieson's antecedents – and the Macdonalds; it stands on the site of an Iron Age fort known as Dun Torabhaig). "The law mandated that we couldn't build any higher than the apex of the roof," says Mathieson, "so the stills had to be made to fit, and in a sense we had to squash our flavour profile into the fabric of the building."

That flavour profile – rich, smooth, with a fragrant, heathery, lavender-like peat, as savoured in releases like Caisteal Chamuis and Cnoc Na Moine – is fed both by the Allt Breacach and the Allt Gleann, the burns that supply Torabhaig with the purest island spring water, and the gracefully diminutive stills,

custom-built to fit the long, narrow still room (and named, in tribute, Sir Iain and Lady Noble; the latter, still running the estate, has given Torabhaig her unalloyed blessing). Maturation in oloroso sherry casks and finishing in first-fill bourbon casks also play their part in producing a lighter, less smoky spirit than Skye is generally known for. "I'm not an enormous fan of very heavy peat," says Mathieson, "and we're an open book about what we make and how we make it – we give analysis of phenols and cask types on our labels. We distil at around 140PPM, and we call that full peat if anyone asks." He smiles wryly. "It's high enough for us."

As well as bolstering Skye's reputation for singular Scotch, Torabhaig is doing its community bit by offering full-time, as opposed to seasonal, job opportunities. Alongside its single malt and blends, it has invited its nine young distillers the chance to create their own Speciality Journeyman's Drams, coming up with their own recipes and seeing the process through to cask and bottle. Leading the charge are Iona Macphie and Niall Culbertson; Macphie has gone for "an unpeated, strong, deep-flavoured chocolate malt with a low cut point", while Culbertson has opted for a maritime-inspired expression. "My dad was a fisherman and I'd go out on the boat with him when he checked his lobster pots in the sound," he says. "I chose a crystal malt that's been wet-roasted, with sweet caramelly flavours, and a brown malt that's a traditional ingredient in Scottish ales, and I wanted to finish in a rum cask, because I've always been a rum drinker, and that's traditionally the sailor's tipple." Every step has been a learning process, he adds, "but we all hope that people get something of our character, and that of the island, when they eventually taste them. It's amazing to think you've created something unique." But then again, in a place like Torabhaig, "shaped by Skye", as its labels proudly attest, and "striving to see beyond the obvious", according to Mathieson, it's easy to believe that the everyday and the prodigious go hand in hand.

"There's room in the market for a gentle, well-managed peat style," says Torabhaig manager Neil Macleod Mathieson. "People are hungry for detail, and we've got nothing to hide, no secret recipes."

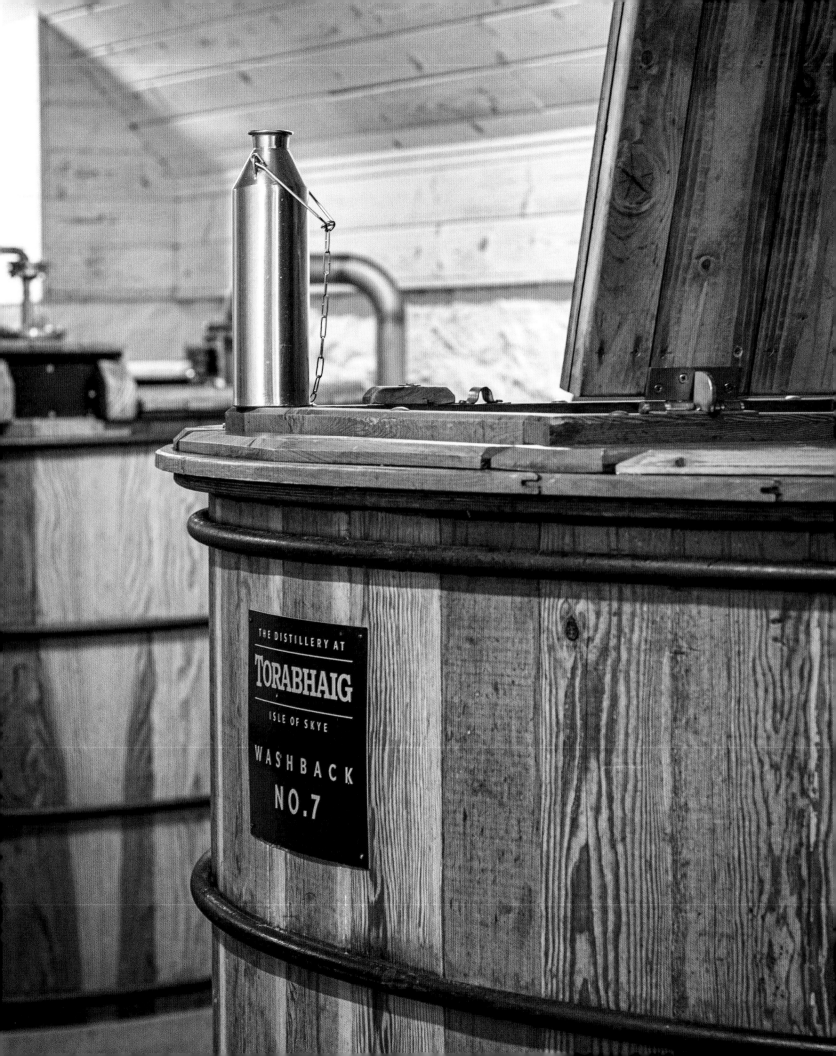

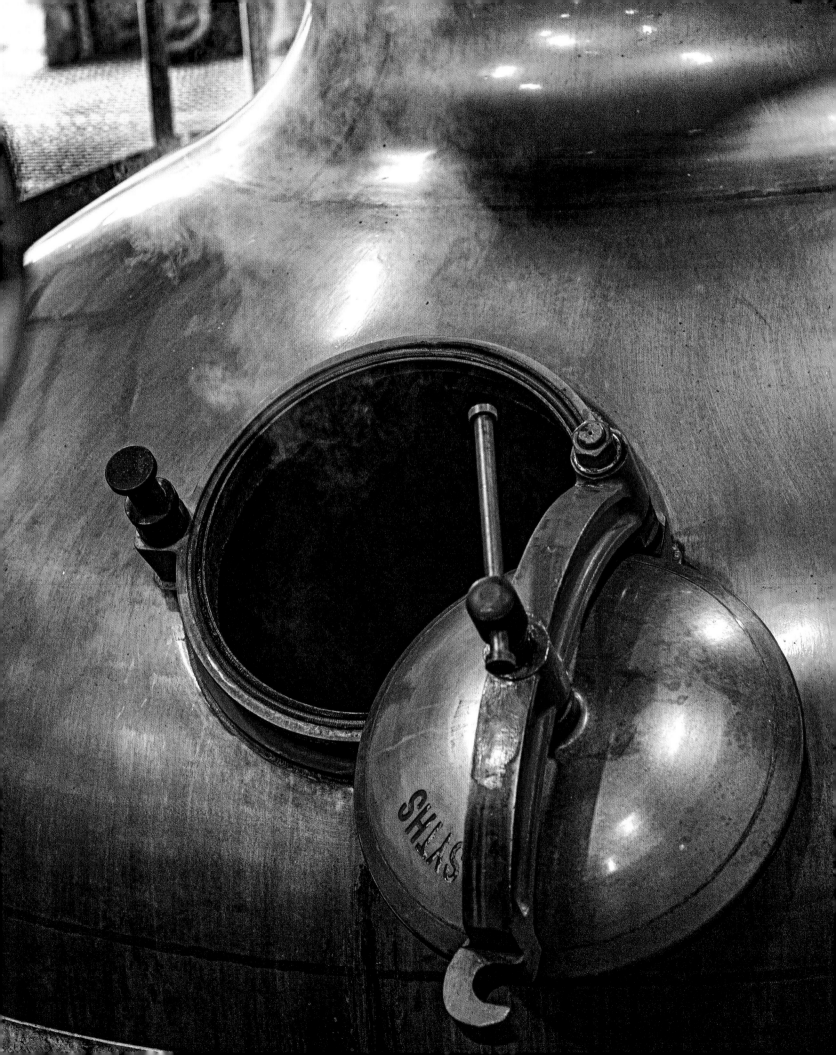

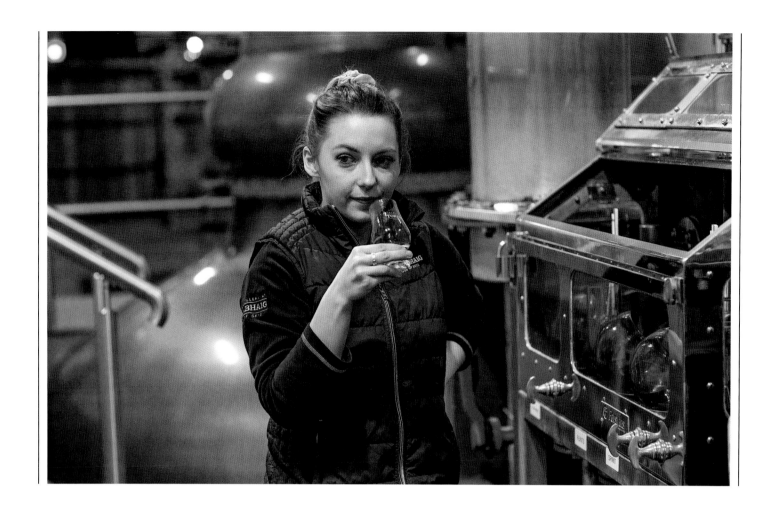

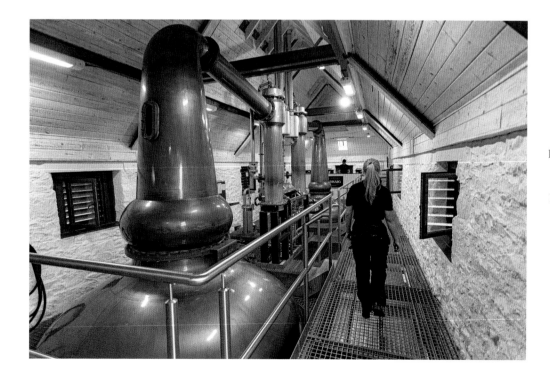

Torabhaig's listed-building status meant that the stills had to be built to fit its existing dimensions.

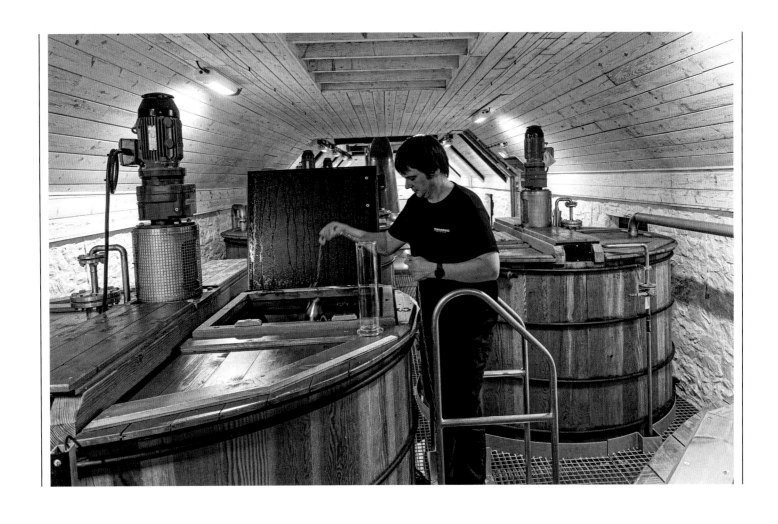

"We are
whisky makers
for whisky
people."

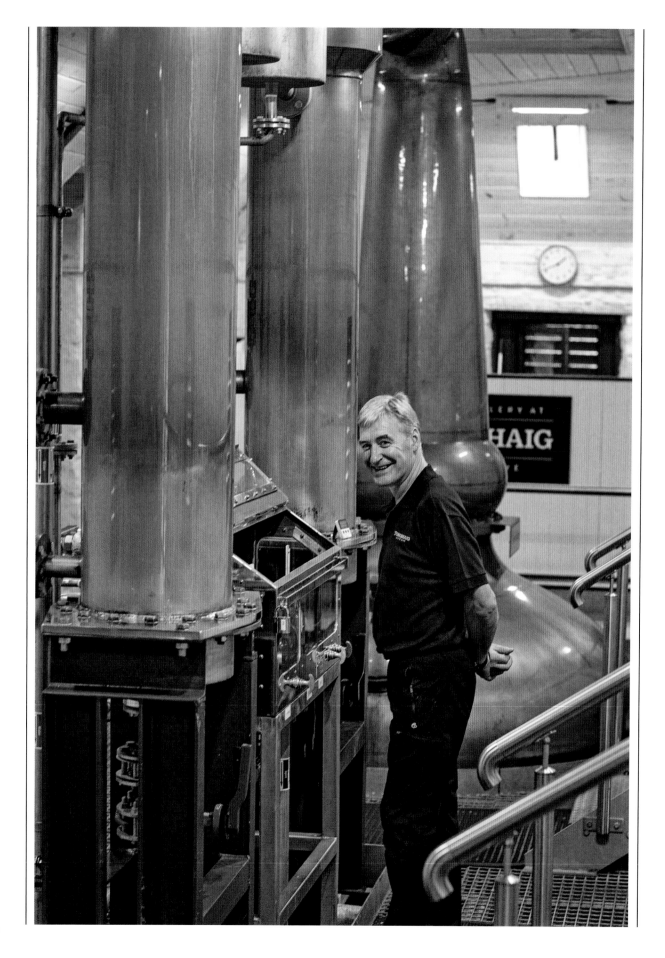

Torabhaig's stills are named Sir Iain and Lady Noble, in honour of the distillery's founders.

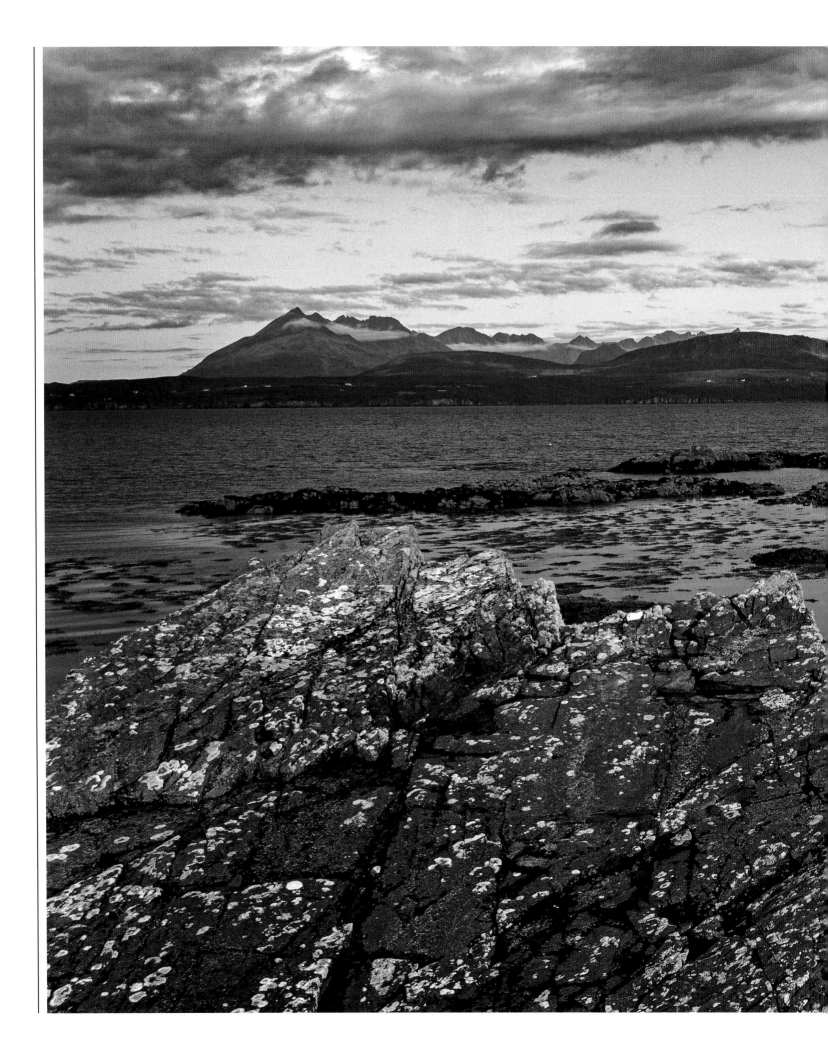

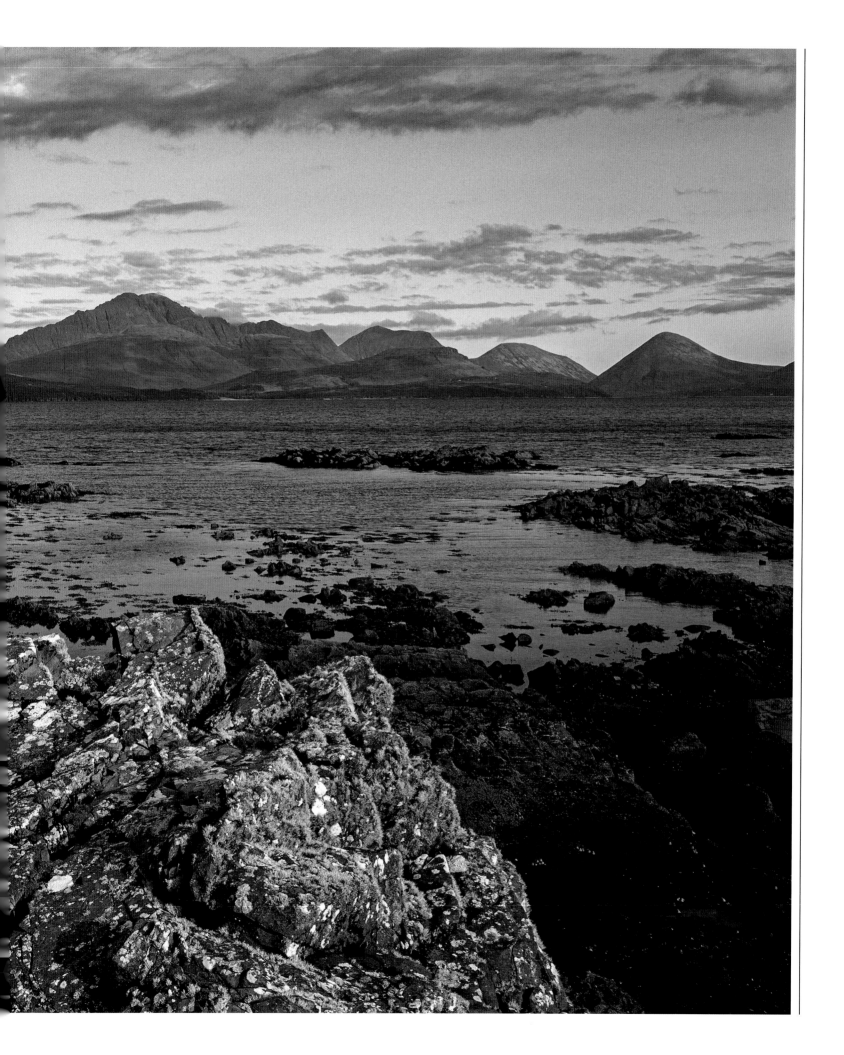

With its
boisterous open
days and funky
bottlings, Ardbeg
has a kind of
steampunk spirit.

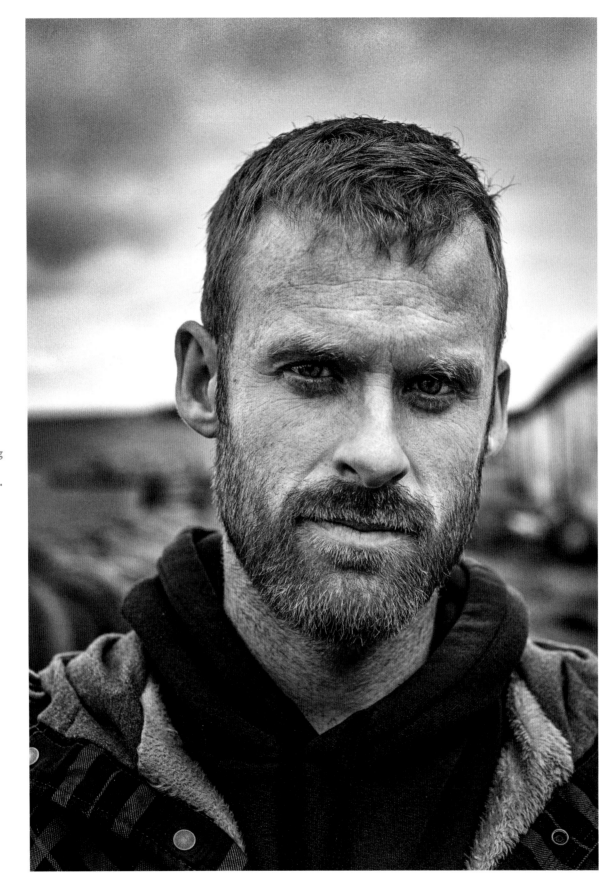

ARDBEG
DISTILLERY

EST. 1815

ISLE OF ISLAY

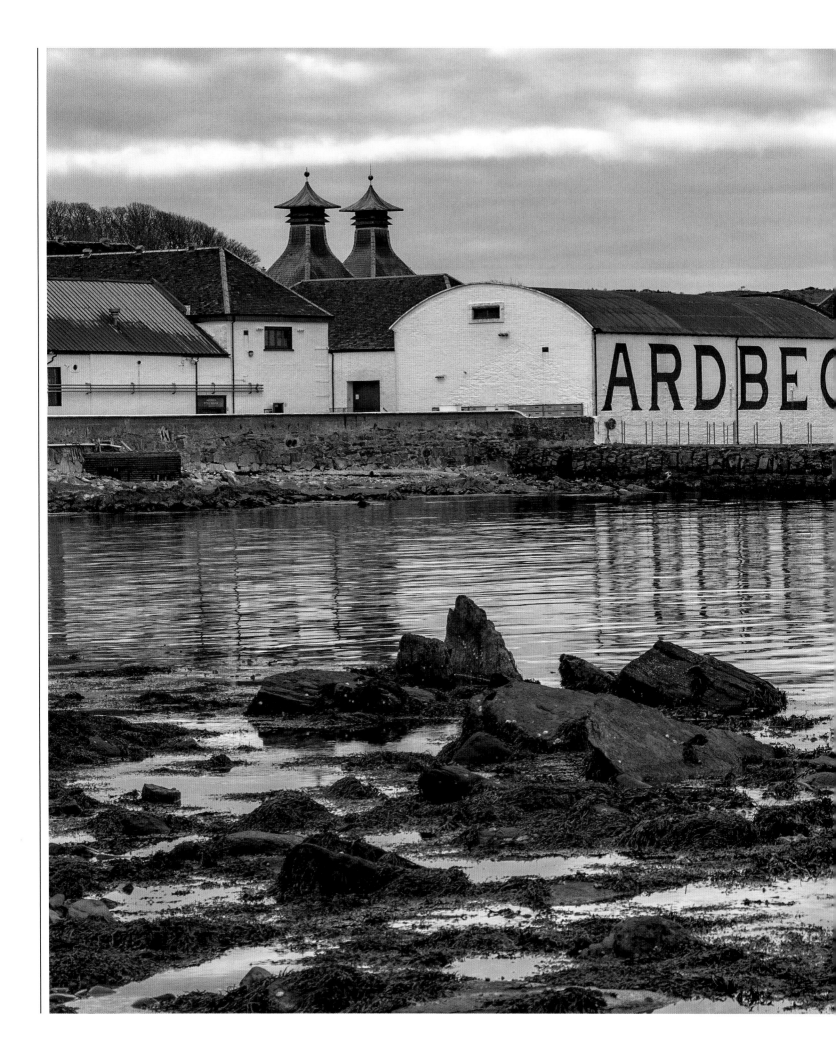

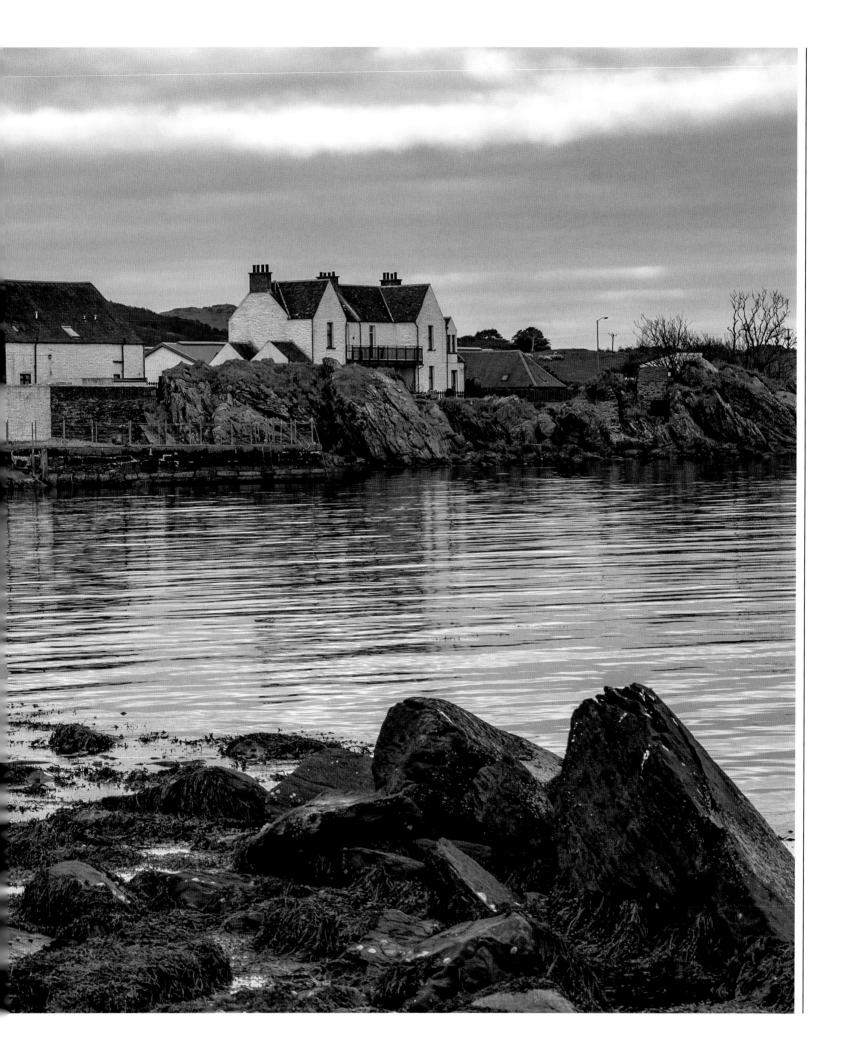

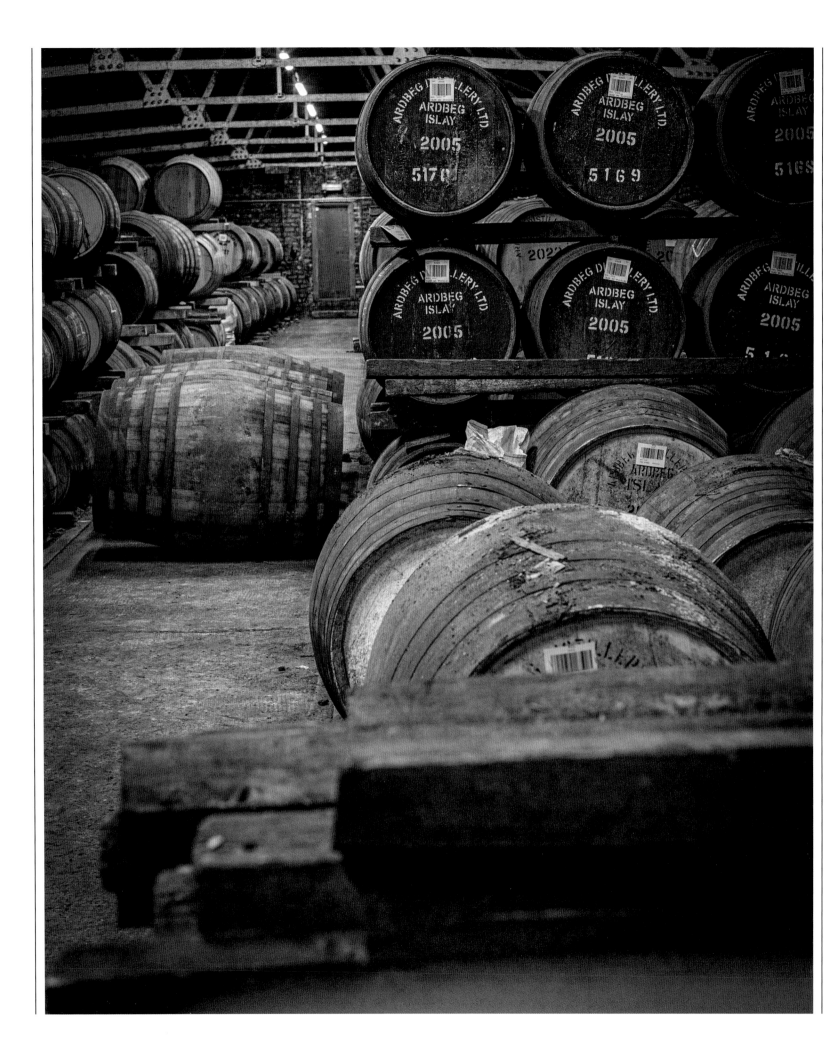

Ardbeg Distillery

You may remember a 1997 earworm by the indie collective Chumbawamba called "Tubthumping" and its nagging refrain: "I get knocked down, but I get up again, you're never gonna keep me down." It could be the anthem for the Ardbeg distillery, both in its sentiments – the building was shuttered through the 1980s, and has changed hands many times in its two-hundred-year-plus history, before its eventual acquisition by LVMH Moët Hennessy Louis Vuitton in 2004 – but also in its scrappy steampunk-style delivery. Because there's something quite iconoclastic about Ardbeg, from its willingness to experiment – its "flavour wheel" encompasses everything from "tarry rope" to "tea-chests" via "custard powder" – to its cult-like following among its worldwide network of 160,000 "committee members", some of whom have its logo, a heavily curlicued *A* that's equal parts Gaelic and Gothic, tattooed about their persons.

"What should the word 'Ardbeg' conjure up in the aficionado's mind?" ponders Colin Gordon, Ardbeg's manager, amidst the lunchtime bustle of the visitor centre, with its communal table resting on peat-shovel legs. "Well, we're in a beautiful place, right by the sea" – the distillery is on the south coast of Islay, with views to the Mull of Kintyre and, on a clear day, the shores of Northern Ireland – "and we're a funky, innovative brand. There's a spirit of playfulness here, a creative, almost underground element that people respond to."

Ardbeg has long had a reputation for producing, in Gordon's words, "the ultimate Islay malt" (in July 2022, the distillery sold a 1975 cask to a private collector for a record-breaking £16 million). "Our spirit stills have a purifier, which encourages lots of reflux and copper contact." Their award-winning 10-year-old single malt, developed with master blender Dr Bill Lumsden, with, according to Gordon, its "amazing balance of smoky, tarry, sooty notes with incredible citrus, herbal, fruity notes", is, to further the music analogy, its greatest hit, its "Stairway to Heaven", its "Bohemian Rhapsody". But when Gordon invokes the spirit of play, he's referring to limited releases like Fermutation (the result of a boiler breakdown and an enforced three-week washback stint; instead of dumping the spirit, "we distilled it, and thirteen years later we had a really funky whisky"), or Ardbeg's decision, in 2011, to send twenty vials of its spirit and wood particles to the International Space Station to study the effect of near-zero gravity on flavour (the result: the cosmic sample displayed hints of "smouldering wood" and "rubbery smoke", which have since been channelled into we-have-lift-off expressions named Supernova and Hypernova).

But the distillery's funkadelic vibe is given freest rein on the annual Ardbeg Day, held on the last Saturday of Islay's Festival of Music and Malt. There are themed releases to coincide with the celebration, from 2021's Scorch (matured in a heavily charred "dragon cask" – Gordon gamely donned *Game of Thrones*-style chainmail and cape) to 2022's Punktured (created with "extreme" roasted black malt, "like biting on a spiky ball" – Gordon gamely donned *Aladdin Sane*-style lightning make-up). Heavy Vapours, 2023's release, is the first ever to be made without the purifier's involvement, with resultant notes of coal dust and cardamom. "All the Ardbeg committee members can have an input into the releases," says Gordon. "People love the engagement and the closeness to the brand."

With that engagement comes a desire to drill down into the fine detail of what's fermenting in Ardbeg's shiny new still house and its dunnage warehouses. "Information is paramount these days," says Gordon. "People want to know: Which casks? Which barley? Which yeast? What maturation time? Which is fine, but for me there comes a point where I just say, well, do you like the whisky? Do you enjoy drinking it? How does it make you feel? I think in the best-case scenario you hit that balance between information and intuition. I mean, single cask whisky is a great thing, but you never know how it's going to taste, and that's part of the magic." From down and out to floating in space, Ardbeg's spirit has proved irrepressible; they'll surely continue to boldly go where few distilleries have ventured before.

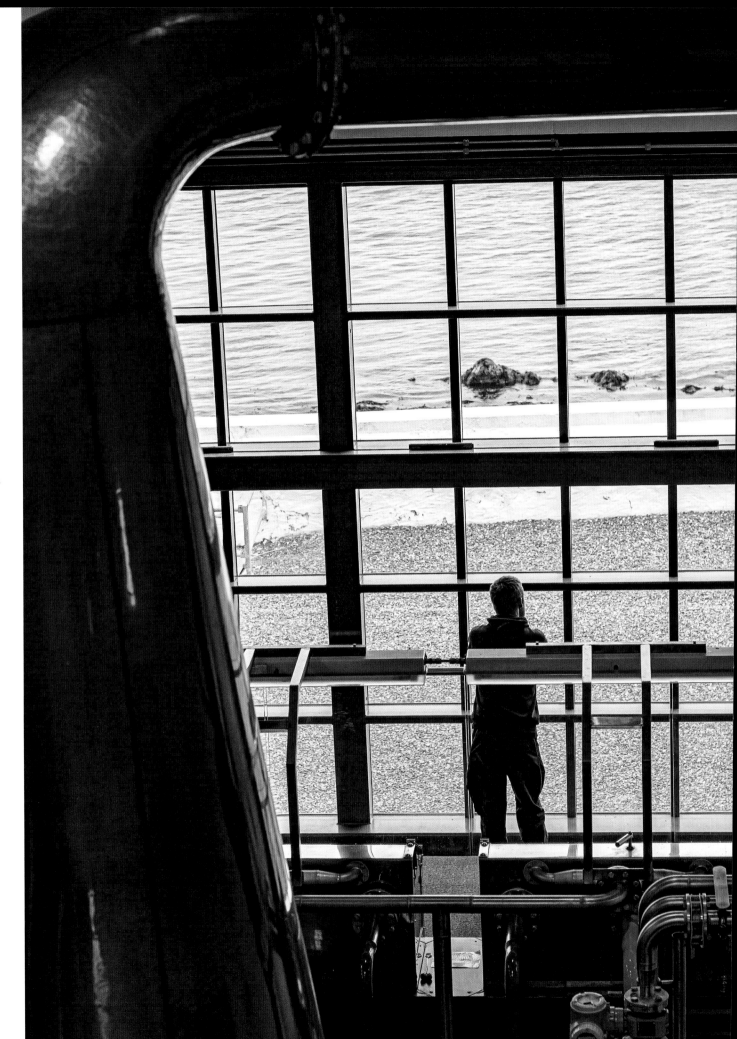

Ardbeg's brand new still house looks out towards the Mull of Kintyre and, on a clear day, the shores of Northern Ireland.

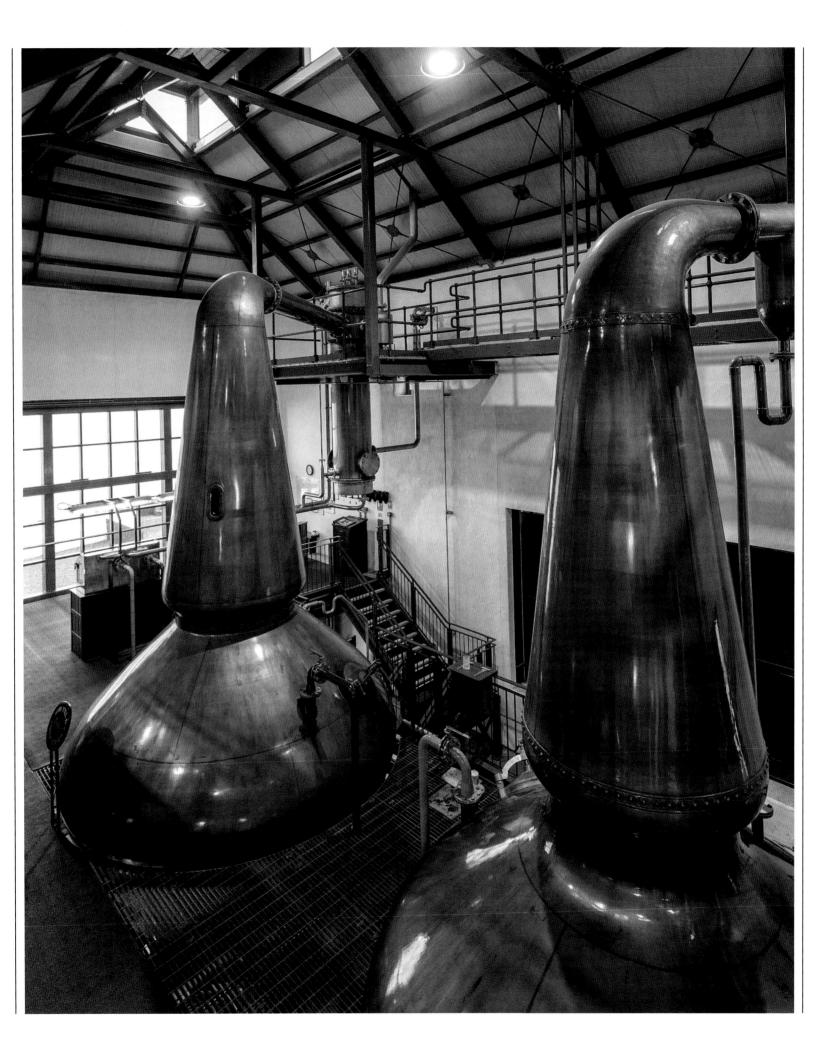

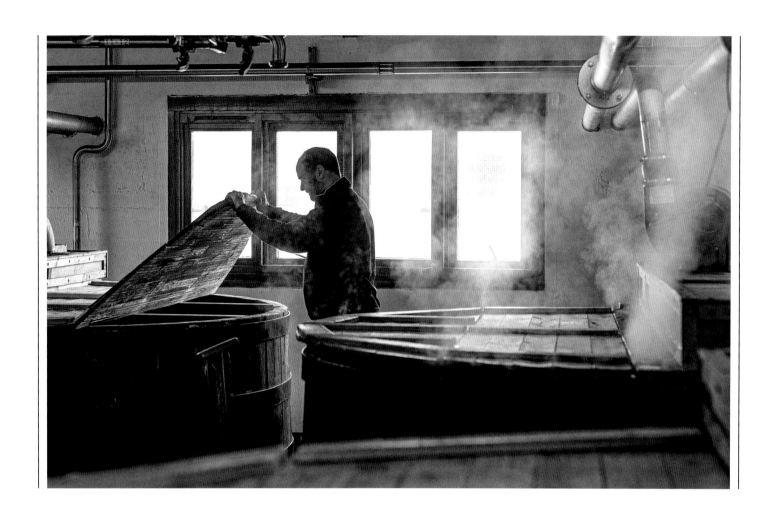

"We can get pretty out there with regard to fermentation times."

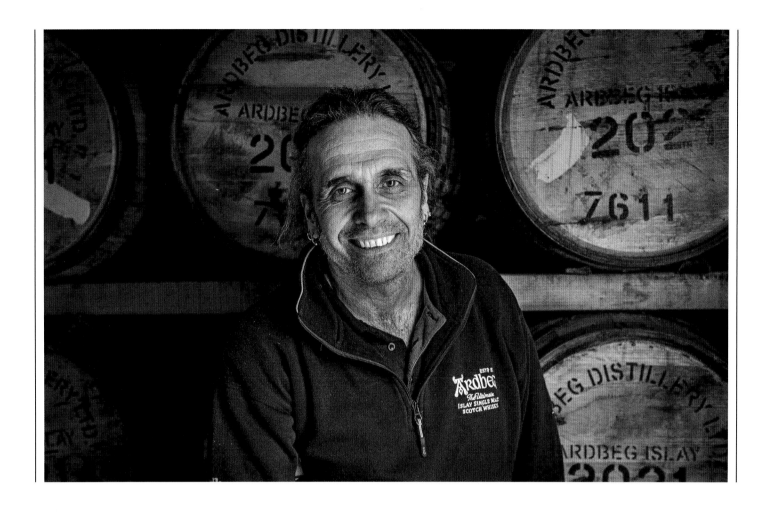

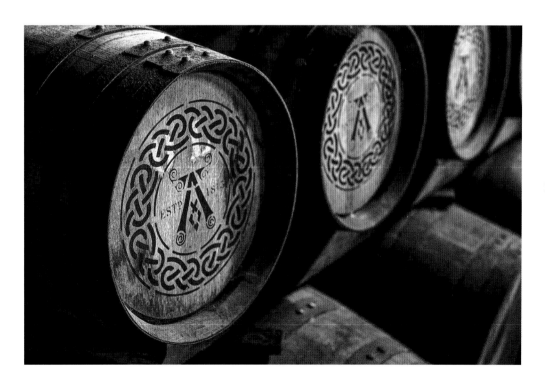

Ardbeg aficionados have been known to have the brand's logo tattooed on their biceps.

A mercurial spirit: "Maturation gives you 60 to 70 per cent of the flavour."

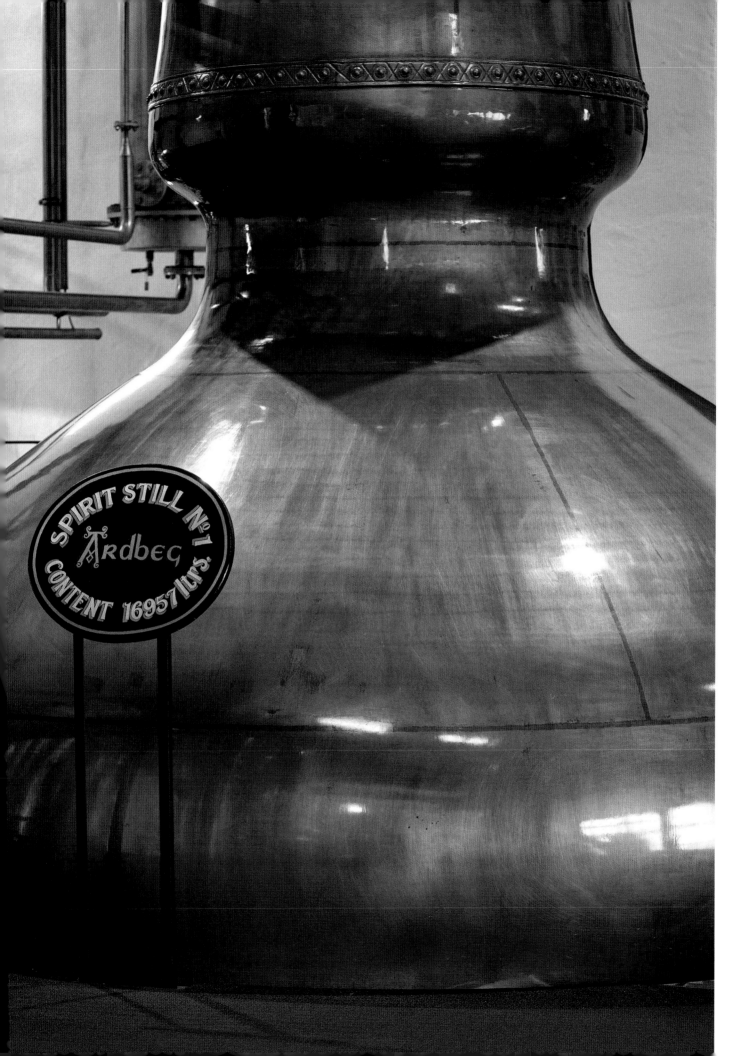

Heavy vapours; Ardbeg's "flavour wheel" encompasses everything from "tarry rope" and "tea-chests" to "custard powder". "We're using the purifier," says manager Colin Gordon, "encouraging lots of reflux and copper contact."

The distillery produces the unpeated Bruichladdich, the heavily peated Port Charlotte, and the "ludicrously peated" Octomore – "We're asking, how far can we push it?" says manager Allan Logan.

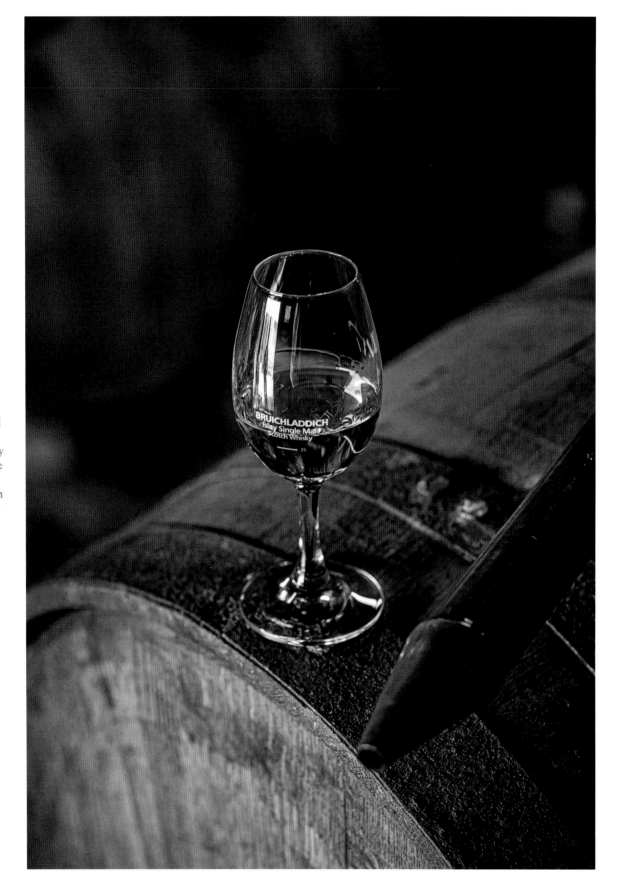

BRUICHLADDICH DISTILLERY

EST. 1881

ISLE OF ISLAY

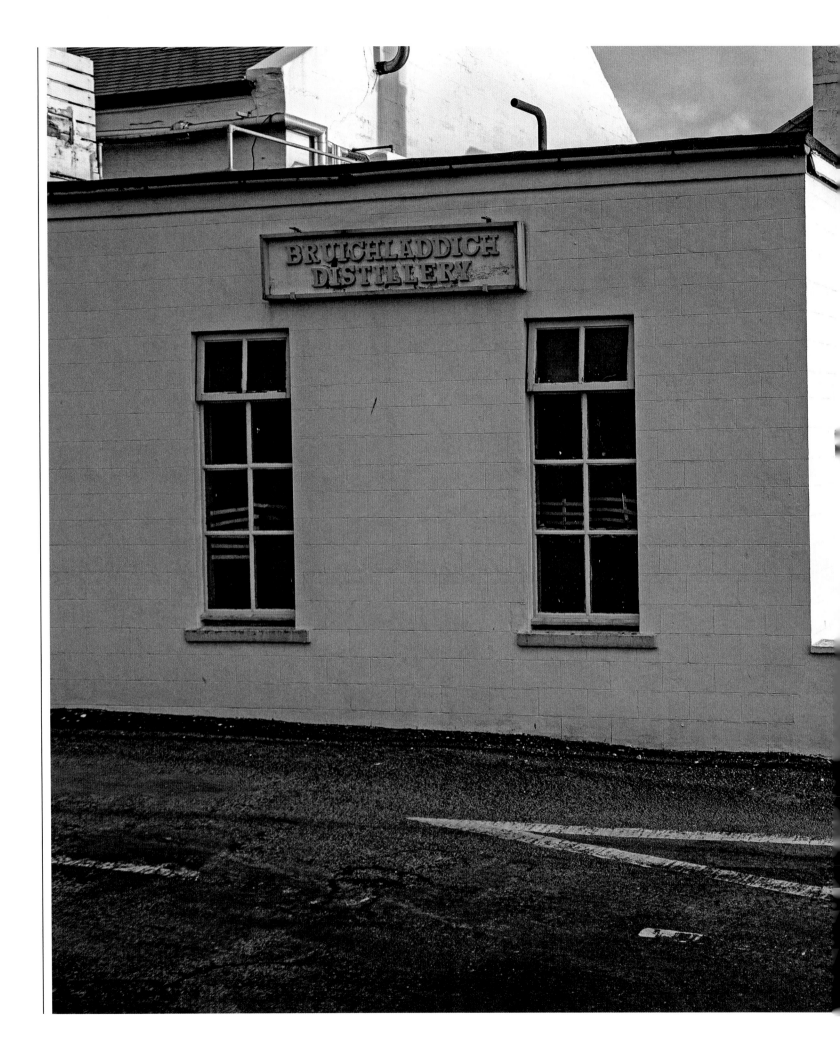

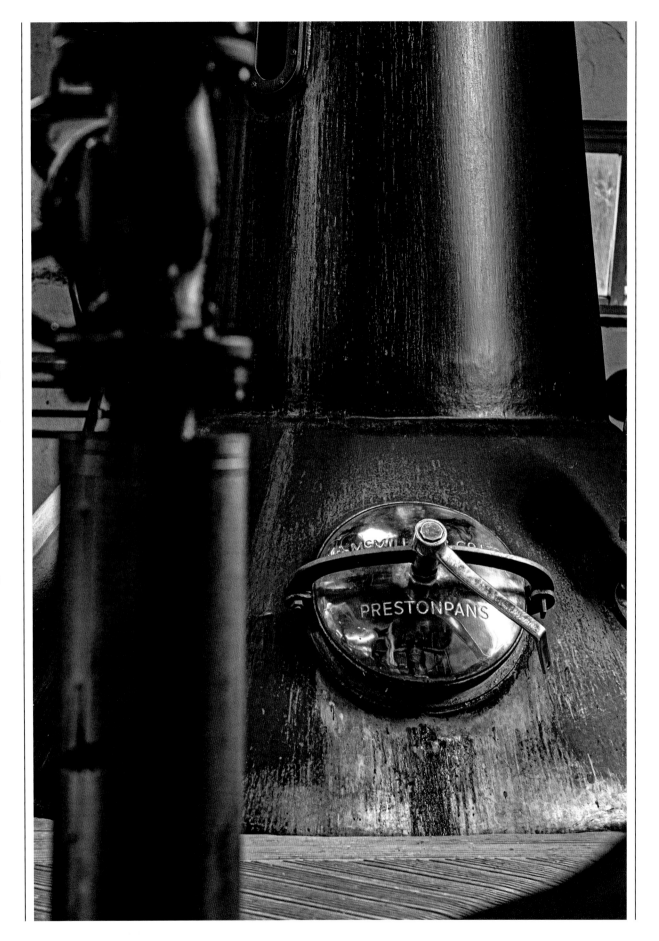

Bruichladdich changed hands eight times between the late 1930s and the 1990s, before being mothballed in 1994 and reopening in 2001. It's now owned by Rémy Cointreau – but the venerable Victorian stills remain.

Bruichladdich Distillery

Even by the fiercely independent standards of most distilleries, Bruichladdich – perched on the shore of Loch Indaal, on the westernmost rim of Islay – has a reputation for doggedly going its own way. "Progressive, pioneering, provocateurs" is a slogan that seems to have been baked into its ethos from the very start in 1881, when it was built by the Harvey brothers, the progressives in a dynastic whisky family, who fitted it with uniquely tall, narrow-necked stills for the production of a very pure and original spirit. "We've always been outliers," says Allan Logan, Bruichladdich's current manager. "And proud of it."

On a clear, sunny morning, the light is bouncing off Bruichladdich's whitewashed walls and casting shadows that are almost Greek fishing village in their pin-sharp clarity. Taking in the bustle of activity – the hum of the bottling plant (the only one on Islay), the trucks negotiating the bends of the large central courtyard – it's hard to believe this place was effectively mothballed as recently as 1994 and only reopened, thanks to private investment, in 2001. "It was a new lease of life," says Logan, who joined at that time. "We had a clean slate to set about building a single malt brand. The idea was to focus on craft, push boundaries, break convention and establish different taste profiles, and also to be more transparent in our values – how we're making it, and why it tastes like it does, which was quite an alien concept back in 2001."

Bruichladdich's core range, developed with Scotch guru Jim McEwan, comprises three single malts: the unpeated Bruichladdich; the heavily peated Port Charlotte; and Octomore, described by its cheerleaders as "ludicrously peated". Was this a chance to be progressive – or even provocative – with Islay Scotch's reputation as the meatiest and peatiest? "We are pushing the parameters of smoking levels," concedes Logan, "and the phenols are high. You might think you would have to steel yourself to taste it, but it's not like that – the balance comes through in the spirit; there's

power but also a lot of complex flavours. Suddenly it's like something you've never tasted before."

Bruichladdich is certainly not afraid to experiment. Head distiller Adam Hannett compares himself to a chef "with a larder full of amazing ingredients", which range from the wealth of different barleys grown in regional trials across Scotland to find the optimum area/flavour match, to the wealth of casks sourced from 280 different suppliers. He describes his job as "integrity plus passion plus fun", with the latter surely coming from projects like a world-first biodynamic single malt, a just-released rye whisky, and the limited Black Art releases, which, as their name suggests, are free-hand concoctions whose recipes and maturation particulars are known only to Hannett himself. "It's thinking about the reputation that Islay whisky has, and taking that story forward," he says, "using all the nuances at our disposal to create more thought-provoking whiskies."

Islay, in Logan's words, "seeps into everything". Bruichladdich matures 100 per cent of its whisky on the island, so, through decades of ageing, "it gets to breathe in the salty seaside air as the wood expands and contracts." And the distillery gives back, supporting the Islay Energy Trust, a community-owned charity that supports renewable energy initiatives, providing career opportunities to keep young people on the island and funding bursaries. "It's the heart of the place," says Mary McGregor, whose farm backs onto the distillery (the McGregors are one of its barley suppliers) and who acts as visitor centre den mother and private client manager. "Life around here was a lot less vibrant through all those years of closure." Bruichladdich's future might now seem assured – the distillery was bought by Rémy Cointreau in 2012 for £58 million – but its pugnacious spirit still endures. Just type its unofficial Gaelic motto – "Clachan a Choin" – into Google translate, and you'll see that they're fulfilling the "provocateurs" portion of their brief every bit as zealously as the rest.

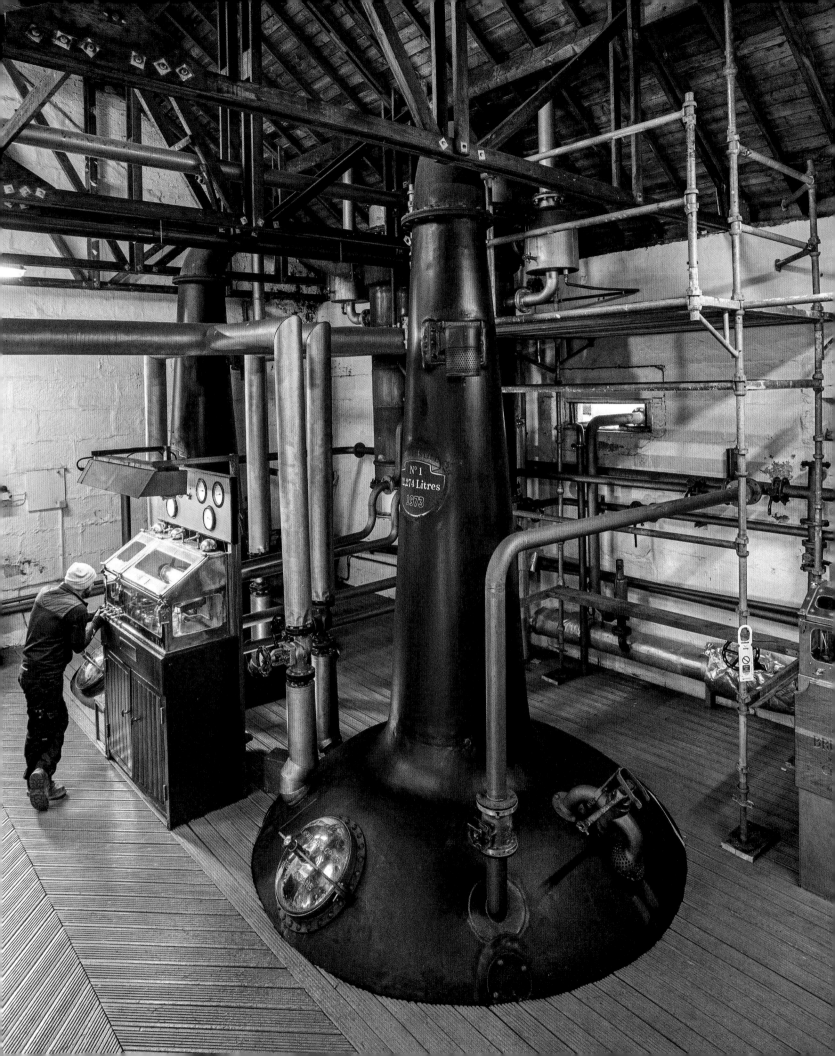

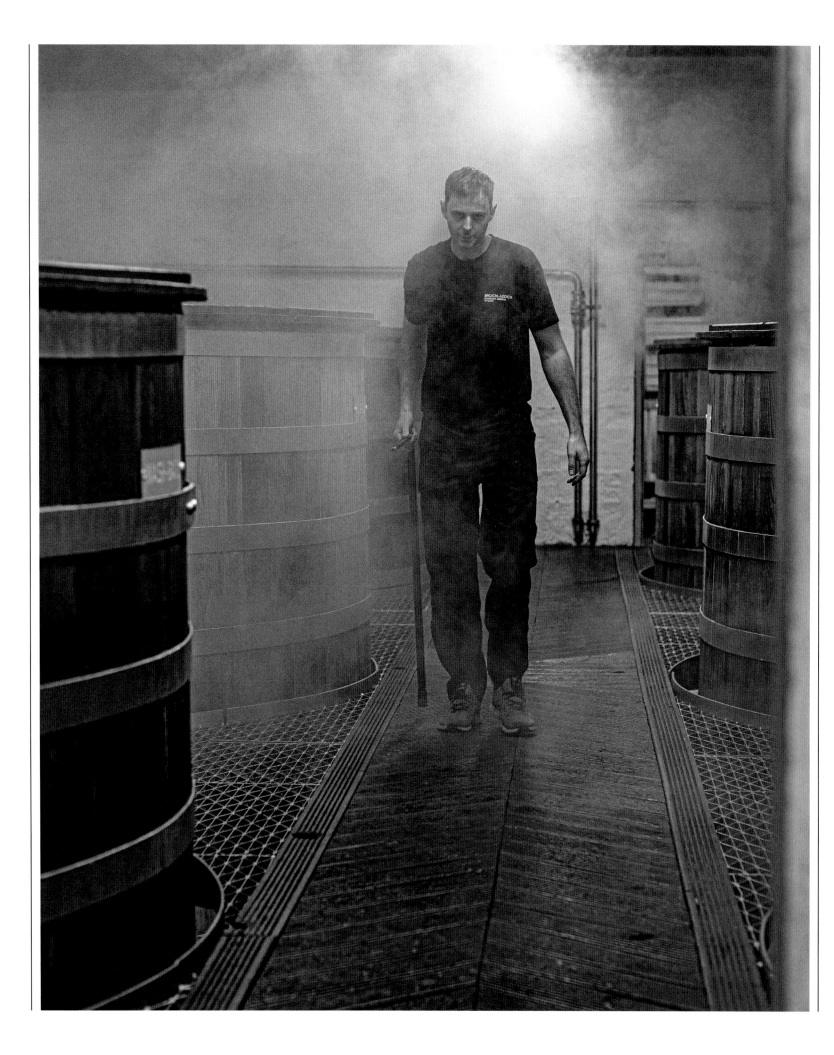

Taking the temperature: the distillery has won awards for environmental leadership in business.

"Progressive, pioneering, provocateurs," says manager Allan Logan, "those are the Bruichladdich buzzwords."

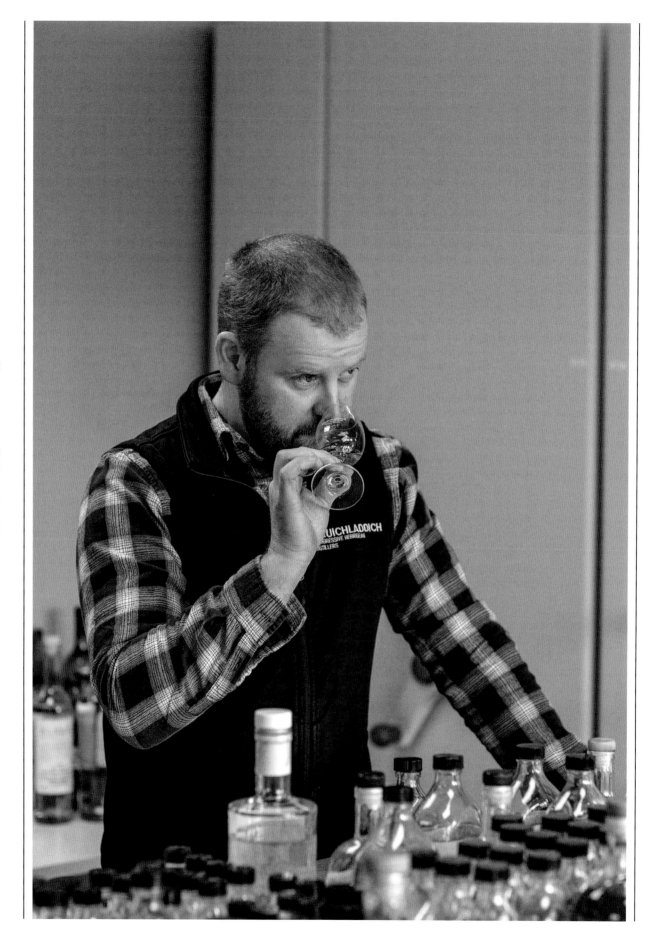

"It's like being a chef, with a larder full of amazing ingredients," says head distiller Adam Hannett, "and it's about exploring that variety, using the nuances to create more thought-provoking whiskies."

"Think about
the reputation
Islay whisky
has – being
part of that is
something to
be proud of."

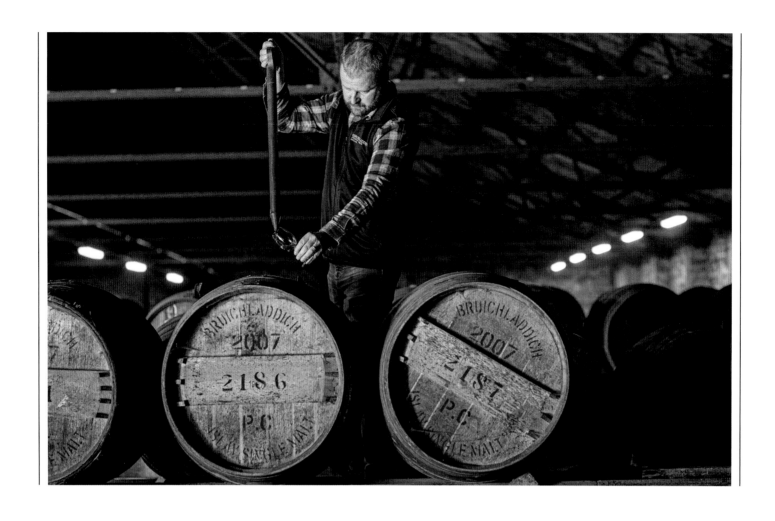

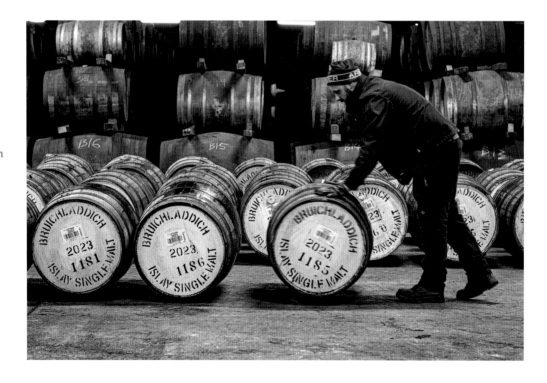

Bruichladdich has utilised casks from nearly 300 different sources.

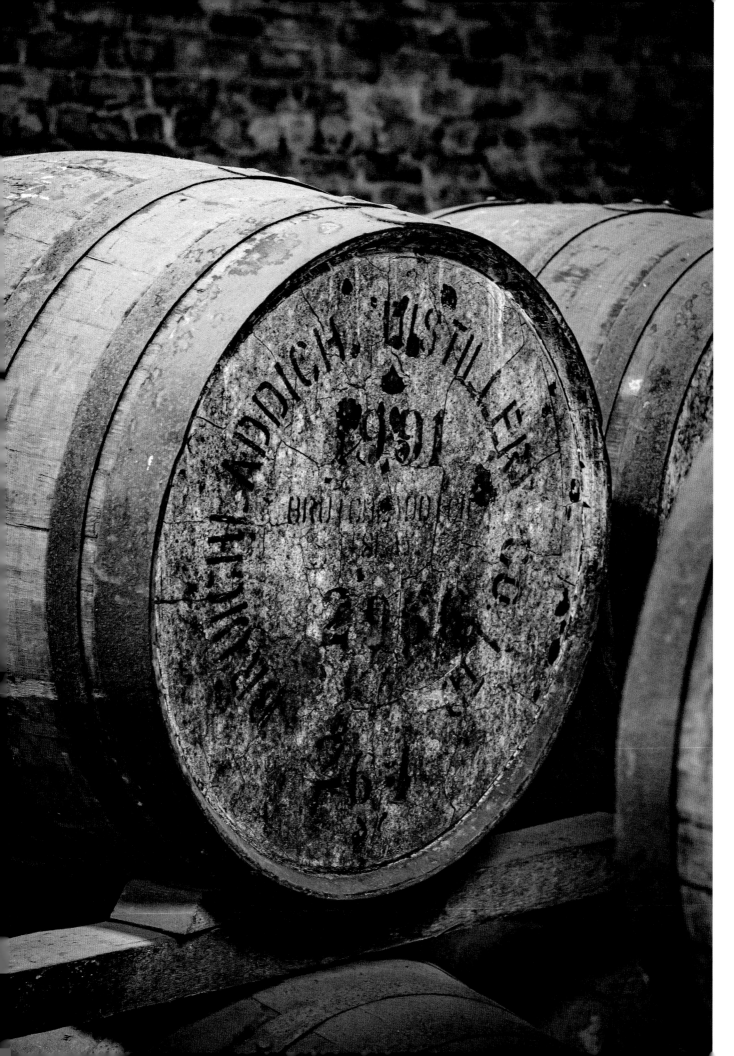

"Islay seeps into everything we do," says manager Allan Logan. "The spirit has decades of ageing, living and breathing in the salty, fresh Islay air as the wood expands and contracts."

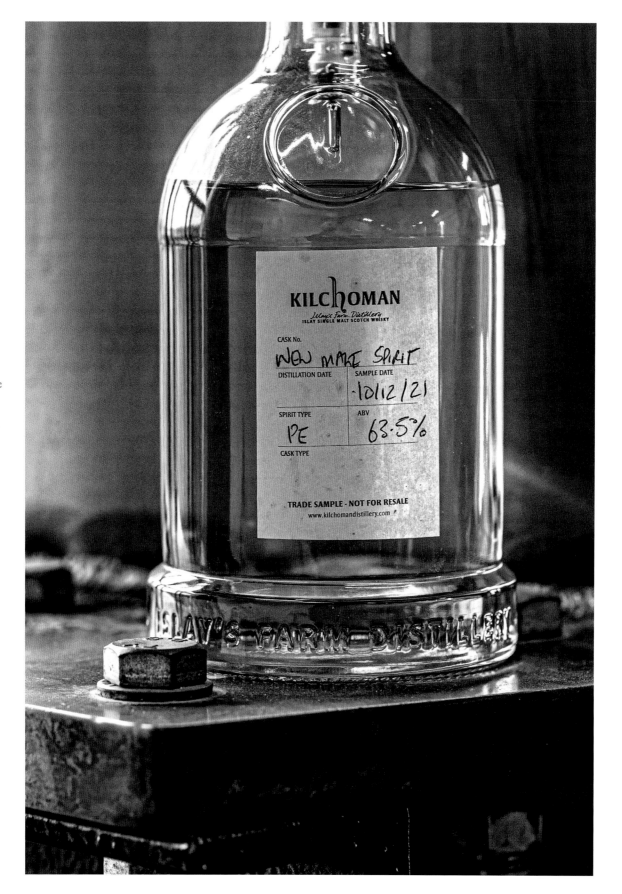

"Being an island distillery is unique and different," says Kilchoman founder Anthony Wills, "and I had people knocking the door down from day one, saying we'd like your Islay single malt."

KILCHOMAN DISTILLERY

EST. 2005

ISLE OF ISLAY

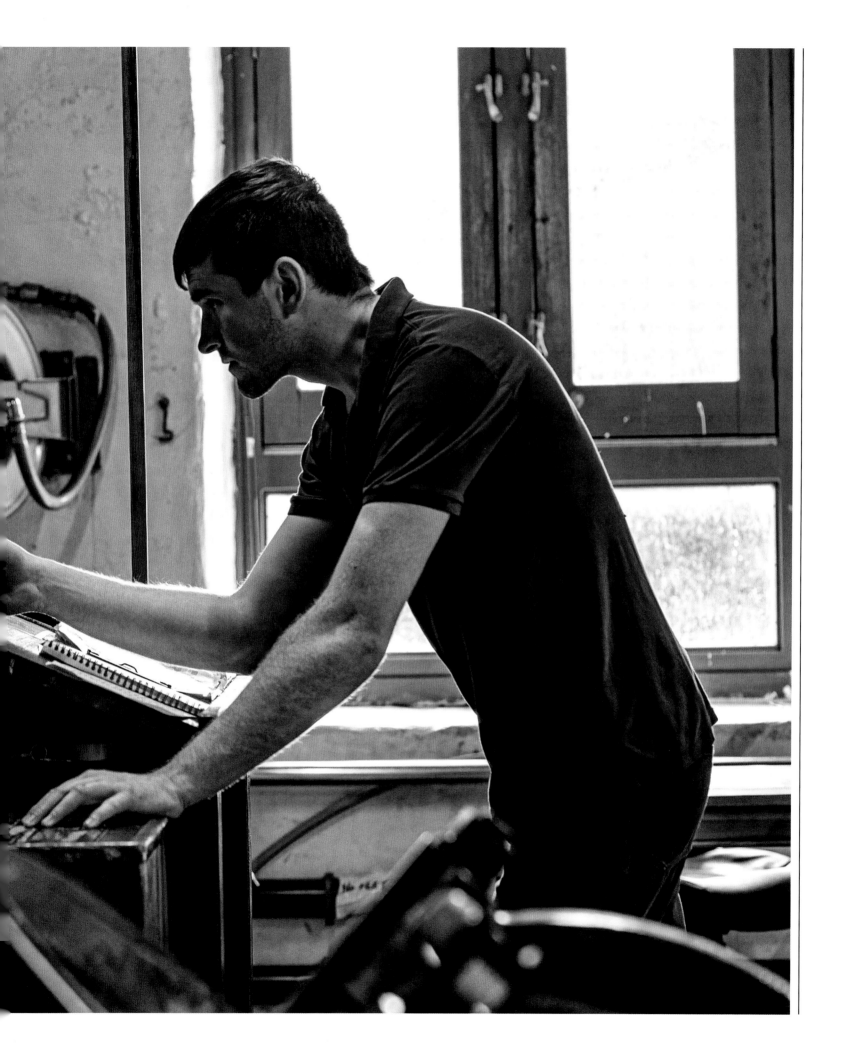

Kilchoman Distillery

When Anthony Wills told people he was building the first new distillery on Islay for 124 years, the same question seemed to recur with monotonous regularity: whatever possessed you? "He's mad, he's crazy, it'll end in tears," says Wills, recalling the reactions as ground was broken in 2001 and even as production began in 2005. He allows himself a smile. "And now look at it."

Wills is sitting in the airy, expansive visitor centre in the Kilchoman distillery; his hunch – that there was room in the market for a brand new premium single-farm, single malt spirit from Islay – has proved the doubters comprehensively wide of the mark. Kilchoman is tucked into the Cnoc Dubh headland amid the sweeping vistas of the island's north-west, with the ruins of Kilchoman Church and the sandy stretches of Machir Bay (and its spectacular sunsets) on one side, and the brooding shore of Loch Gorm on the other. Barley for the distillery is grown in the fields around the former farmstead and brought to its malting floor; the peat for its whisky is hand-cut from the banks of the Loch and fired under a kiln to give the malt that Islay-centric smoky infusion. "You have to stand out from the crowd, and doing the barley and the whole production process on-site was key," says Wills. "You have to capture people's imagination somehow."

As a former sales and marketing man – first in wine, then in single-cask whisky bottling – Wills was quick to see the potential in premium single malt Scotch; a family connection to Islay was the last piece of the jigsaw. "It was important to locate the distillery here because of Islay's reputation for producing stunningly good and different single malt," he says. "Thirty years ago you didn't see any single malt apart from the classics like Glenfiddich and Glenmorangie. Since then, whisky shops have sprung up everywhere and the online market has gone crazy. It's all driven by consumers demanding more choice."

Willis worked with whisky Yoda Jim Swan on his core range, from Kilchoman's signature peated Machir Bay expression, matured in bourbon and sherry casks, to 100% Islay, a slightly smokier variant produced exclusively from the local bounty. "We wanted a spirit that was approachable from a young age, and that could be bottled young," he says. "Our spirit stills, with their tall, narrow necks, give a lot of copper contact and produce a fruitier, lighter spirit. Then it's all about the best-quality casks from your bourbon and sherry suppliers. It's as simple as that." Well, not quite; Willis reserves the right to experiment, having just returned from a European trip to research Seville orange and Portuguese fortified wine casks; tequila and mezcal casks are also on the cards.

What does Islay bring to the table – and what does Wills bring to Islay? "The island brings a tradition of making superb peated whiskies which are different from any other region of Scotland," he says. "Thirty years ago people either loved or hated it; it was too medicinal. Now people are better at cask maturation, which has played a key role in making more receptive whiskies. And what do I bring? A vision and flexibility of approach which the larger distilleries may lack because of their size, and also innovation – in barley varieties, yeast varieties, varying peat levels on the malt floor, and the casks we use. We can change direction quickly, and we don't need to get bogged down in debate about it."

The late afternoon sun is slanting in through the ample windows of the visitor centre; soon it will descend like a fireball over the bay, turning the fields a burnished gold and provoking the migrating geese – who use the Kilchoman acreage as a way station – into honking ascent. Wills settles back, vindicated in his instincts and the genius loci his bottlings encapsulate. "It has the wow factor, doesn't it?" he says. "You can see why people take it to their hearts."

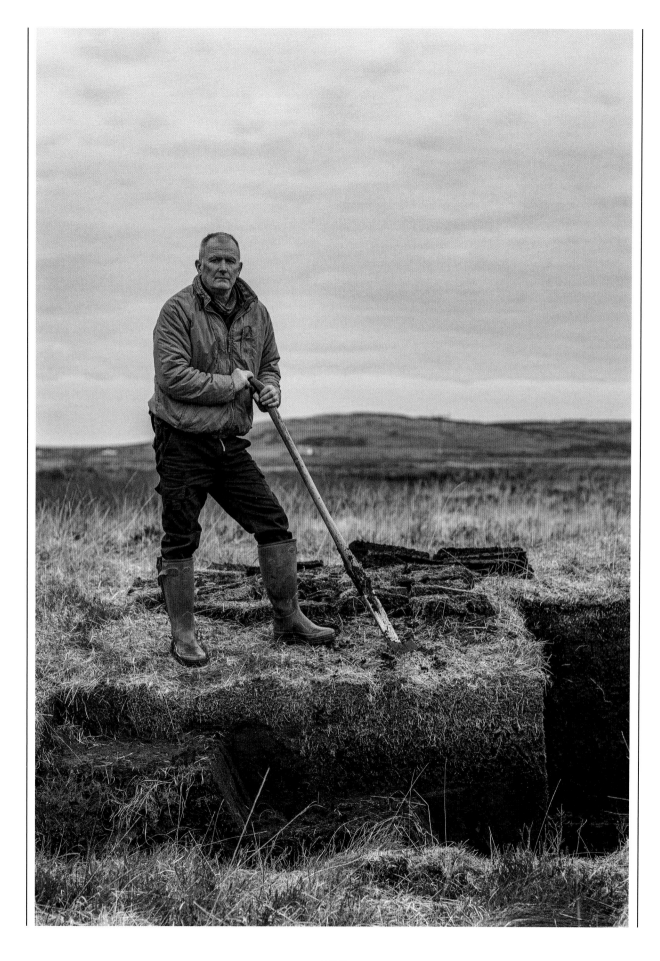

Kilchoman's Derek Scott hand-cuts peat "bricks" for the distillery's kilns from the bountiful bogs of Loch Gorm. A committed peat cutter can amass 1,000 bricks in a day.

"Islay brings a tradition of making superb peated whiskies which are different from any other region in Scotland," says Anthony Wills.

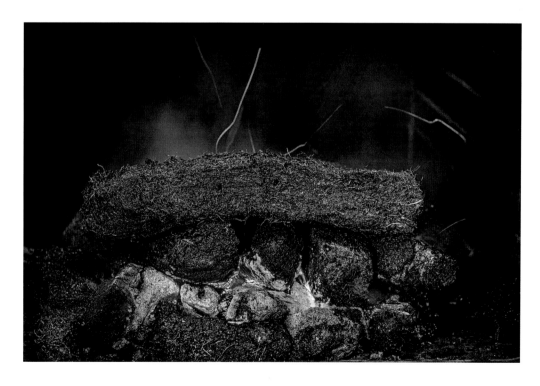

A peat fire is started twenty feet below the resting barley; the smoke then infuses it. The process takes about nine hours.

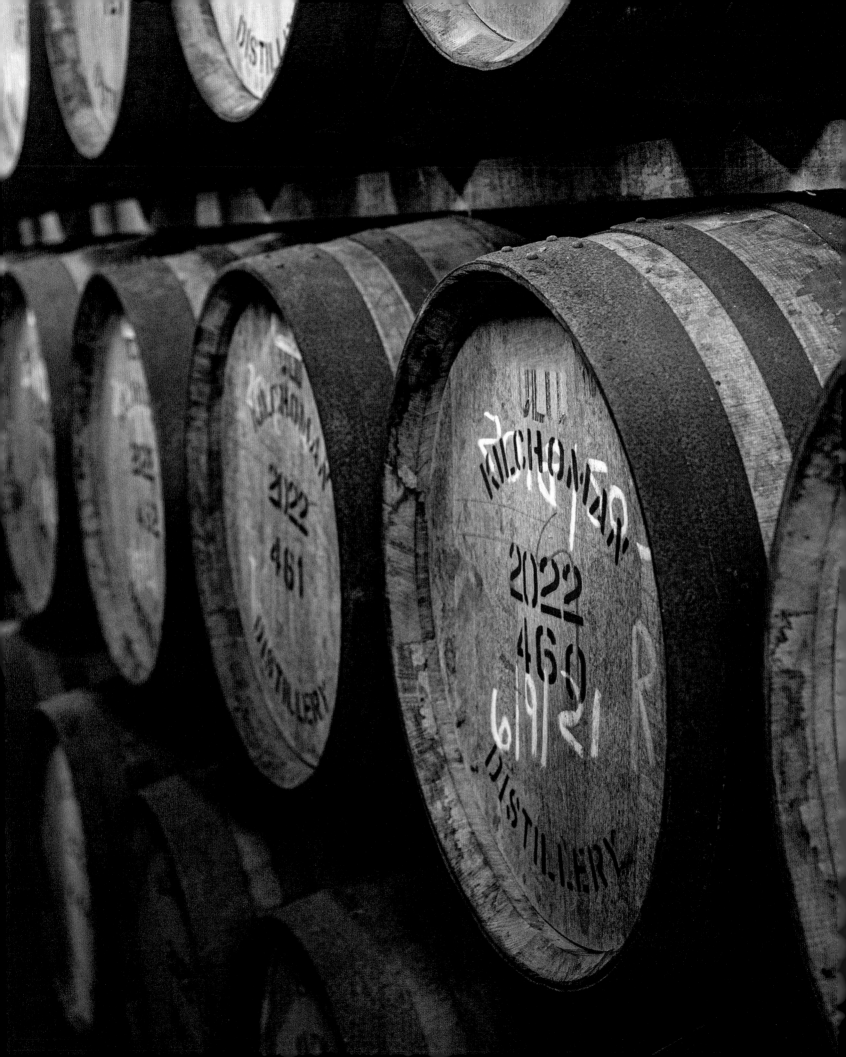

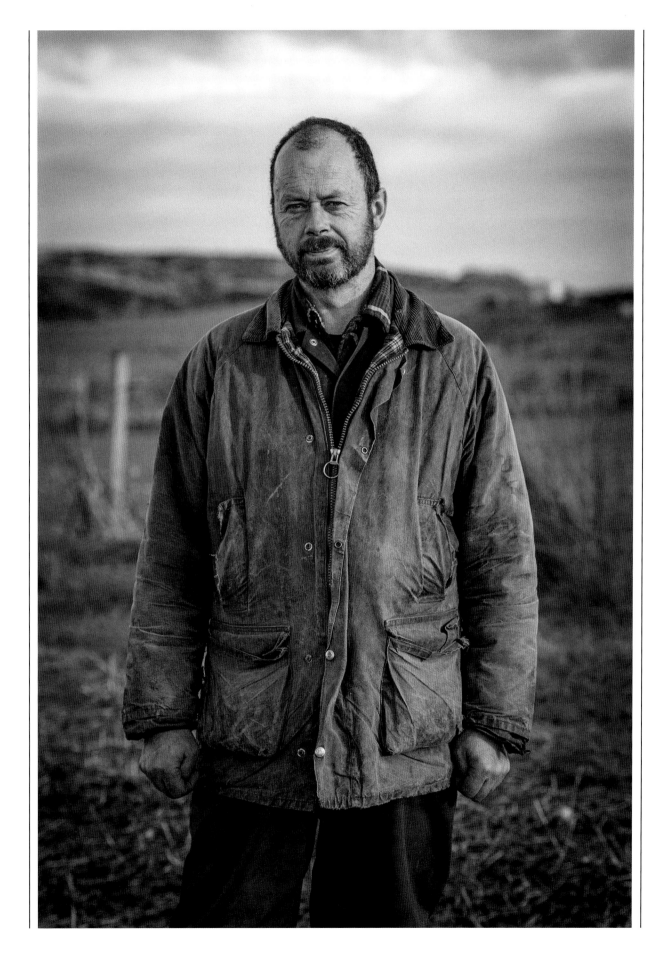

Kilchoman is a single-farm distillery, with all processes – from barley-growing to bottling – effected on-site: "And there are still very few who do it," says Anthony Wills, "which staggers me."

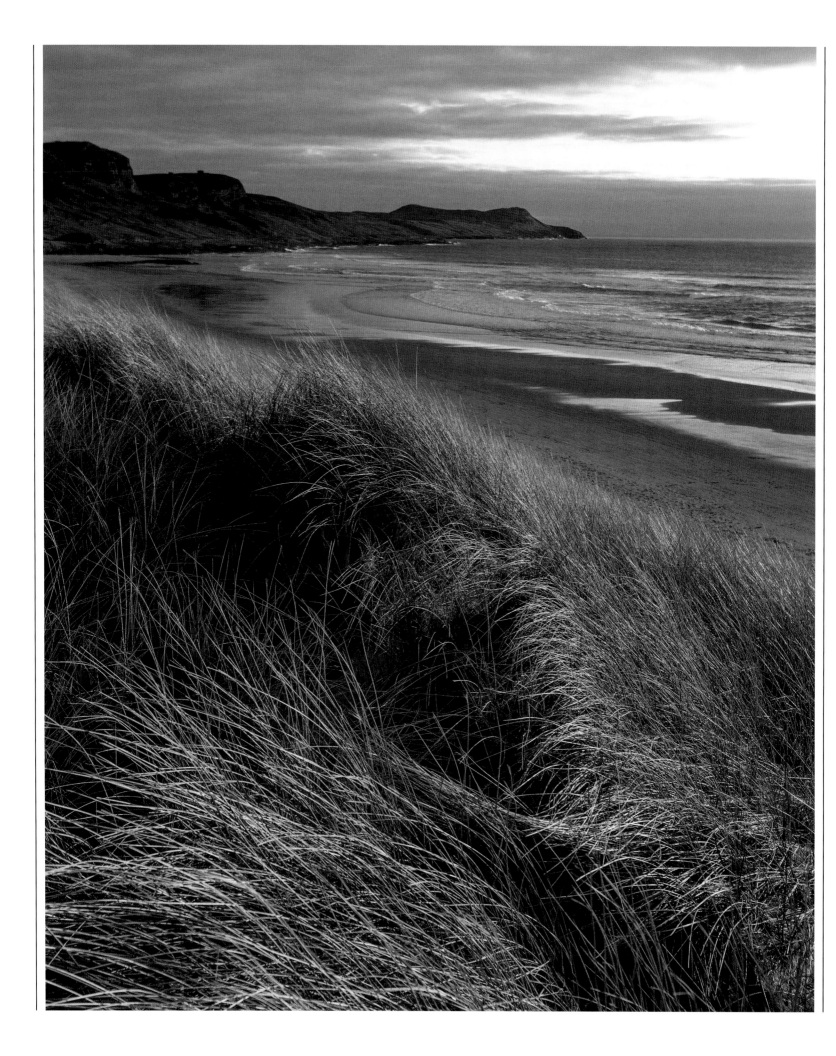

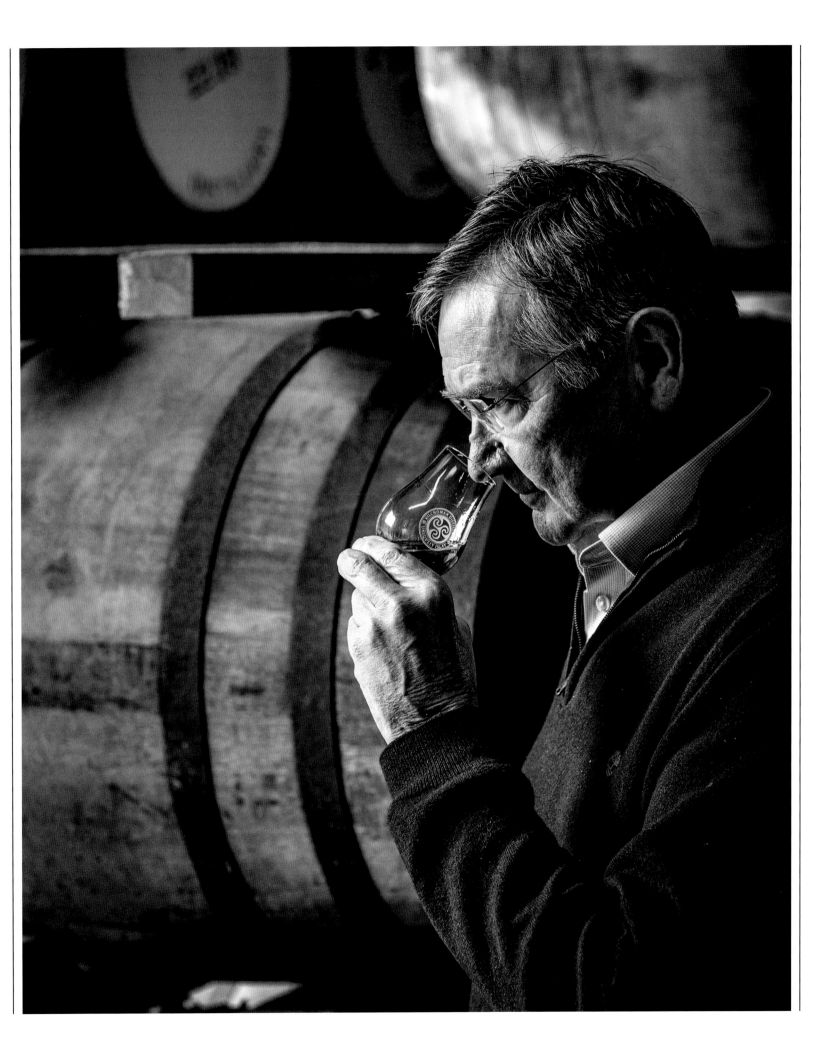

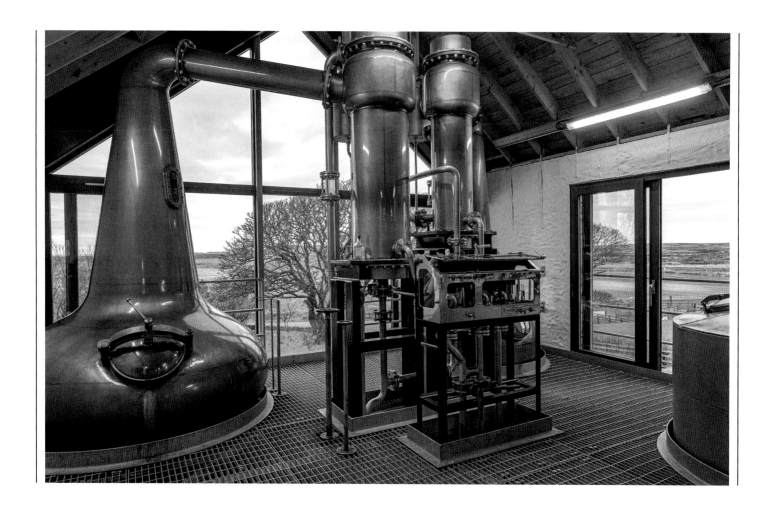

"This place has the wow factor – you can see why people take it to their hearts."

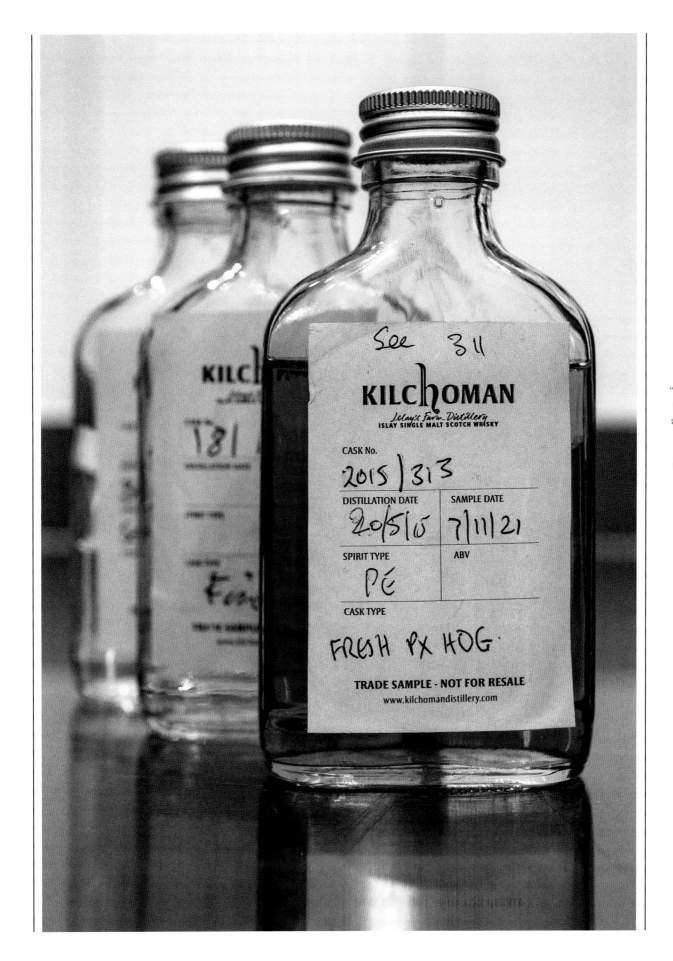

"We're fiercely independent, and living and working on Islay is key," says Anthony Wills. "I'm involved in everything going on in production, from the barley to the bottlings."

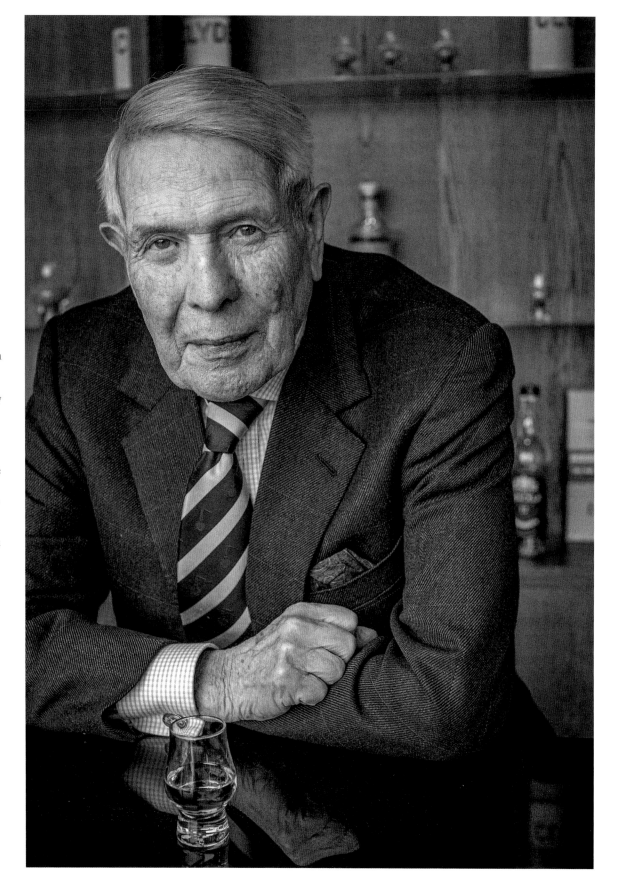

Clydeside chairman Tim Morrison has been in the whisky business for decades: "I actually drink very little Scotch. But I love the product, its history, the way the distilleries are woven into the fabric of Scottish society, and the personalities in the industry. It's a very rich world."

CLYDESIDE DISTILLERY

EST. 2017

THE LOWLANDS

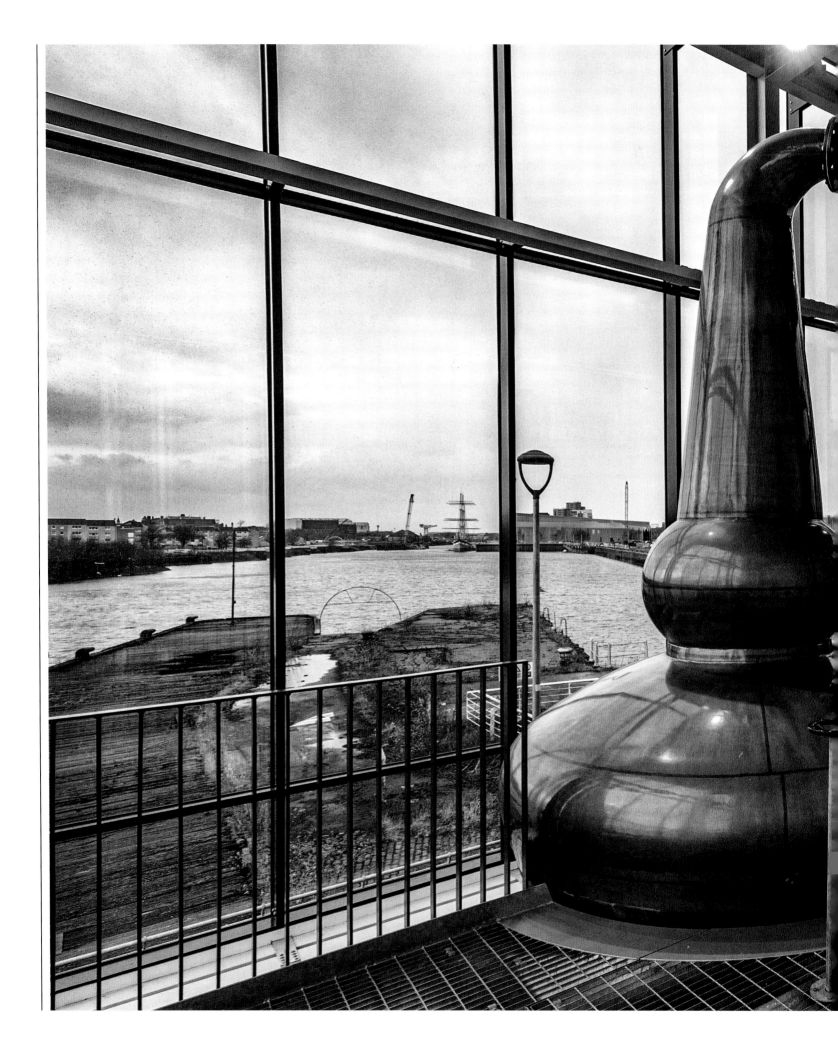

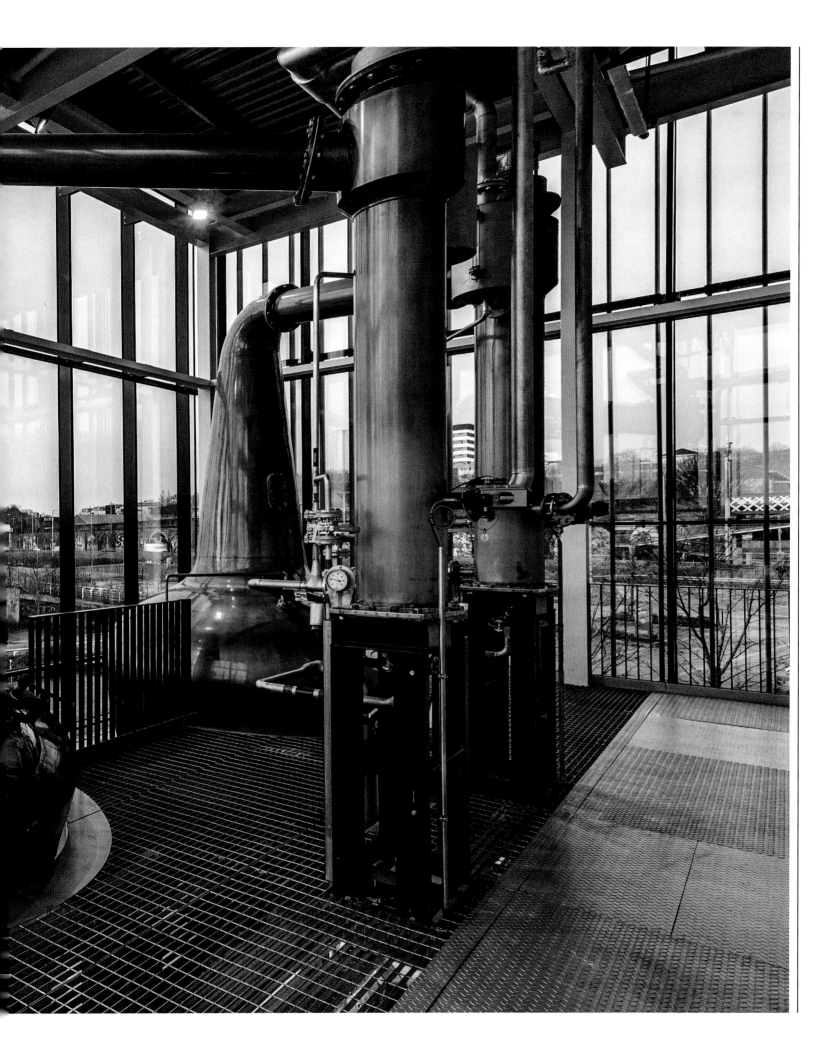

The still room looks onto the Queen's Dock, which was constructed in 1878 by Tim Morrison's great-grand-father John: "I only found that out when we decided to build the distillery here, which is extraordinary."

Clydeside Distillery

"It's a fine sight, isn't it?" says Tim Morrison, with a wave of his hand. He could be referring to the Clydeside distillery, the handsome steel and glass facility housed in an Italianate sandstone building that once served as a water pumping station, whose stills are the first that Glasgow has seen since the mid-1970s. Or maybe it's the Queen's Dock in which it sits, once rundown and now, with the nearby presence of the Scottish Exhibition Centre's duo of bulbous auditoria, and the gracious tall ship the SV *Glenlee* moored abreast of the Riverside Museum, emblematic of the regeneration of the city's west end.

And Morrison is no slouch in the appearance stakes himself; with his immaculate suit and white coif, he's the embodiment of the old-school whisky gent. He began his career blending and bottling for Bell's in the 1960s, and now, as chairman of Morrison Glasgow Distillers, he's overseen the build and operation of Clydeside, in the heart of the dock that was opened by Queen Victoria in 1877. The location, as it turns out, was more than serendipitous: "It was only when we'd chosen the site that I learned that my great-grandfather actually built the dock," he says. "It was a complete surprise to me. But the city used to be full of blending houses, cooperages and warehousing, so it's good to bring some of that back."

The pump house was in a sorry state when the Morrisons – Tim and his son Andrew – first looked at the site in 2014, with lead stripped from the roof, six feet of water inside, and a curry karaoke restaurant colonising its last viable extremity. Since Clydeside's opening in 2017, its refurbished tower has acted as a beacon for the renovated dockside. "Proud as I am of the distillery, I'm really proud that we saved another landmark from the wrecking ball," says Andrew, Clydeside's managing director. "Queen's was an excise dock where whisky was shipped out for export, and the site has a wonderful historical footprint, but we've built a modern distillery that makes that heritage contemporary and relevant."

Clydeside's light, airy still room, with its copper workhorses framed by floor-to-ceiling windows enabling sunset views over the water, is more than Instagram-ready; no small consideration when Clydeside, as an official stopping-point for the Glasgow sightseeing bus, has so far taken over 40,000 visitors on paid tours and sees twice that many coming through its doors annually. "Among those are a fair few who will have never visited a distillery before," says Alistair McDonald, Clydeside's manager. "So we wanted our first single malt to be delicate, easy drinking for first-timers, a gateway drug if you like." The result is the floral, delicate Stobcross, named after the railway that originally ran to the dock, resplendent in Clydeside's trademark crisp, clean, post-industrial packaging. "There's a lot of flavour in it," stresses McDonald, "but it won't give you a Glasgow kiss." It's also flexible enough, he continues, to accommodate more intense seasonings; the limited-edition COP26, created for the recent epochal climate conference held nearby (and sampled, approvingly, by a smattering of world leaders – whisky diplomacy, anyone?) started its life in Hudson maple casks before being finished in bourbon barrels. "We're going to have some wonderful sherry cask whiskies coming down the line, and we're also working on a peated expression," says McDonald (though it'll be a "sweet peat" rather than the heavier Islay style).

There's an educative aspect to Clydeside, but, like every aspect of its operation, it's worn lightly and approachably. "Here, people learn about the history of Glasgow, the old whisky barons, and the distillation process," says Andrew Morrison. "Only finally is it about what we do here. It's not intimidating – it's more like, have a couple of drams, have fun."

His father, meanwhile, is reflecting on his own rich Scotch heritage. "I love the product, the personalities behind it, the relationships it fosters, and the opportunities it creates," he says. "I'm proud that we're starting a new story right here."

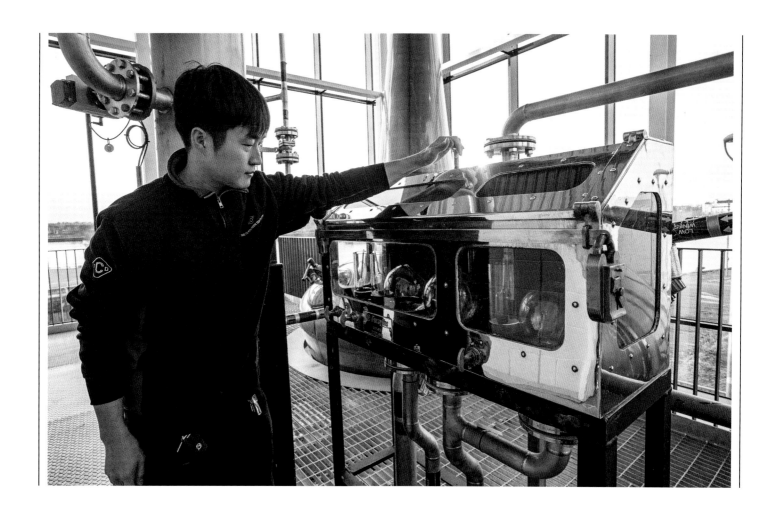

"It's delicate, easy drinking for first-timers. It won't give you a Glasgow kiss."

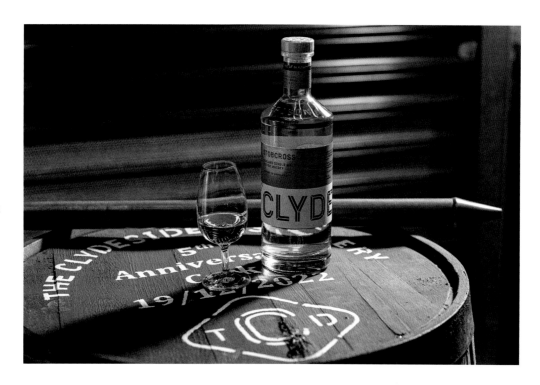

"The site has wonderful heritage with Glasgow and shipbuilding, but we've built a modern, contemporary distillery, tying the two together."

Holyrood is the first new distillery in Edinburgh for nearly 100 years: "It's liberating as distillers to be free of expectations, and free to experiment."

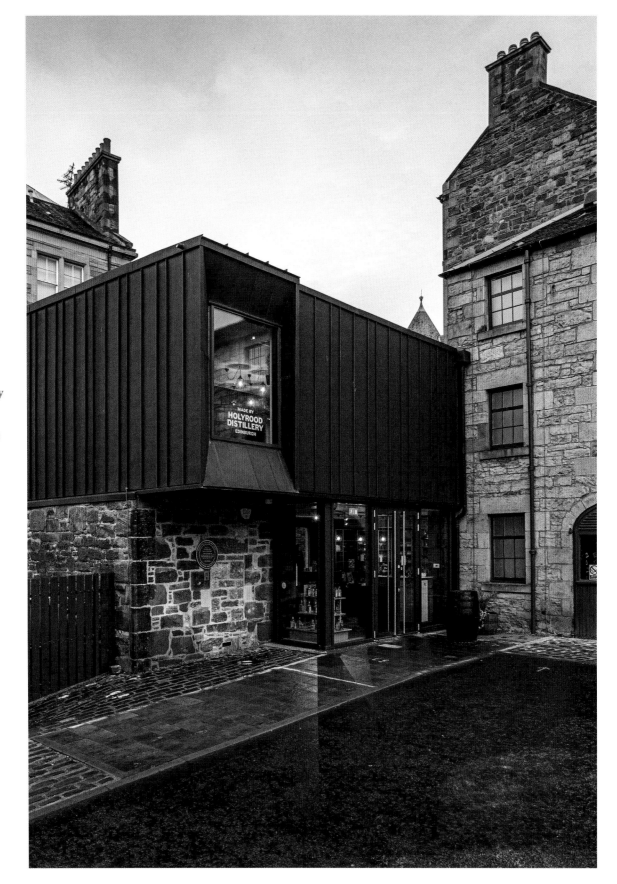

HOLYROOD
DISTILLERY

EST. 2019

THE LOWLANDS

Holyrood Distillery

Emblazoned on the wall in the blending room at Edinburgh's Holyrood distillery is a slogan that amounts to a mantra: "Test. Learn. Improve. Repeat." The space is packed with paraphernalia that suggests, if not a mad scientist's lair, then at least a laboratory for a chemistry grad's more outré flights of fancy: sample bottles, whiteboards, stoppered jars containing sugars, salts, juniper berries and beeswax, and boxes of "powdered botanicals" including Siberian pine needle powder and ground lime leaves.

"It's liberating for us as distillers to be free of expectations and given license to experiment," says assistant manager Callum Rae.

"I'm sure people think Callum and I are wack jobs or idiot savants," says manager Marc Watson. "But for us, it's all about relaxing into the unknown and being okay with it."

It's only fitting that, among the new wave of Scottish distilleries that includes Dornoch, Arbikie and Nc'nean, Holyrood is the one that's become known for its pioneering spirit when it comes to, well, spirit. When it opened in 2019, in a gracious Victorian warehouse building in the shadow of Arthur's Seat that once served as a train and coal depot, it was the first new distillery the Scottish capital had seen in nearly a hundred years, but the timing proved less than propitious; pandemic shutdowns saw its initial business model, dependent on attracting thousands of visitors, thrown into disarray. With the hiring of Nick Ravenhall, a New Zealander and a Scotch enthusiast, as managing director in 2021, Holyrood 2.0 was born. "The appeal was to run a distillery without any history," he says. "Strip out all the old thinking, and use science to make decisions about production and flavours and how to put them together."

For Rae and Watson, that means teaming with Edinburgh's Heriot-Watt University to study old barley varieties, including Chevalier and Golden Promise, and their effects on aroma and flavour, as well as experimenting with ale and sake yeasts, among others, in their fermentation – a nod to Edinburgh's storied heritage as a brewing city. "I think we tried out around ninety-nine recipes in the last year, which is madness," laughs Rae, "but we can distil that down, pardon the pun, into a real solid information bank of what works for us."

"I'd compare the barleys to grape varieties," says Watson. "They create a different character for the spirit. Some are really oily and tacky, others are light and perfumy. They give us another dimension to work with."

In the countdown to the launch of their first single malt, Holyrood's denizens have been showcasing the sometimes-quite-literally fruits of their experiments in a series of gins, rums and new-make spirits, featuring the likes of Perthshire raspberries and crystal malts. "For sensory trial", say the bottle labels, which, with their detailing of fermentation times and wash ABVs, confirm Holyrood's commitment to transparency; a commitment made manifest in the building itself, with its clear sightlines into the still room and the living-room ambience of its visitor centre, a place designed for lounging rather than perching. "We make the spirit, the city makes us," reads another wall slogan, and Holyrood does seem to embody its Southside neighbourhood – all repurposed Victorian architecture amid cobbled streets and leafy squares – in its youthful-boho vitality and eclectic vibe. "We're a young team – average age mid-twenties, I guess – and we come from really varied backgrounds," says Rae. "We've got former sound engineers, carpenters and students in medieval history. It's part of the uniqueness of this place."

"We're in a good place to move the whisky conversation forward," says Watson. "Our production is tiny – only 229,000 litres a year – so the spirit has to be impactful and exciting, driven by something different to heritage, because we don't have that. We're putting Scotland back into the conversation of making amazing whisky and being creative with it. But in the end, we just want people to enjoy it."

Rae: "You want the classic 'That was good, what was that?' kind of reaction." In other words: Nose. Taste. Savour. Repeat.

"We're heading the charge of the new wave in Scotch whisky," says assistant distillery manager Callum Rae, "which is super-exciting for us."

"We would compare the different barleys to grape varieties – they create a different character for the spirit."

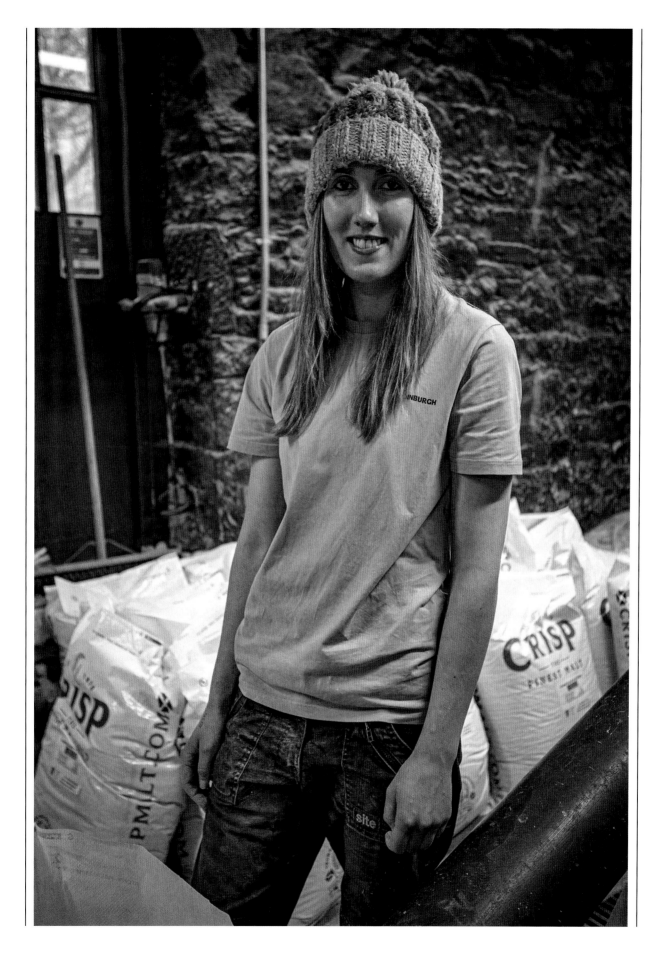

The average age on the Holyrood team is mid-twenties, with a 50/50 gender balance. "We're all from different backgrounds, and we've all come together in passion and love."

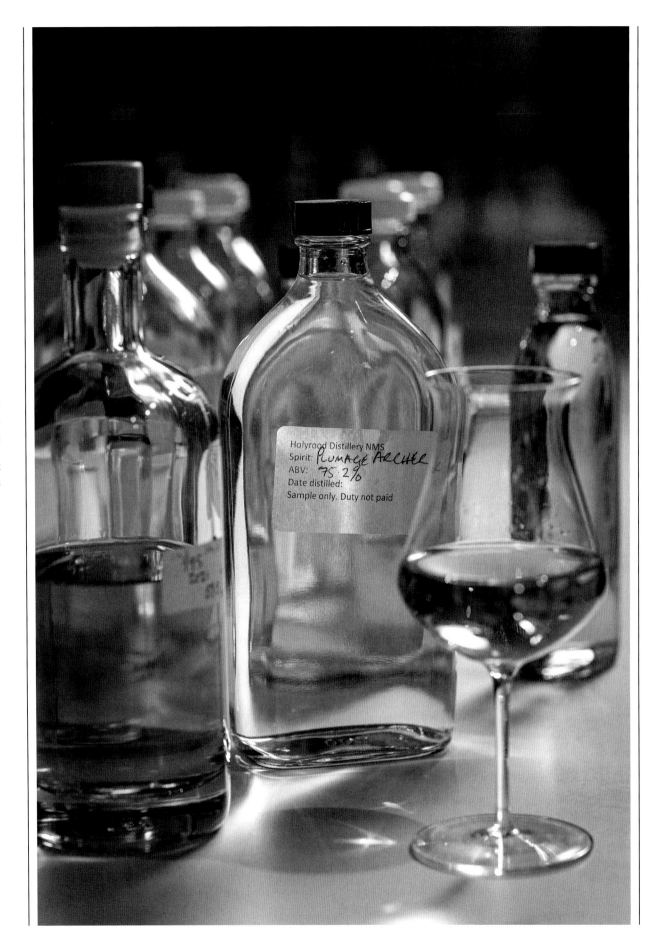

The distillery trials as many as 100 recipes per year: "we can distil that down, pardon the pun, into a real solid information bank of what works."

Holyrood Distillery NMS
Spirit: PLUMAGE ARCHER
ABV: 75.2%
Date distilled:
Sample only. Duty not paid

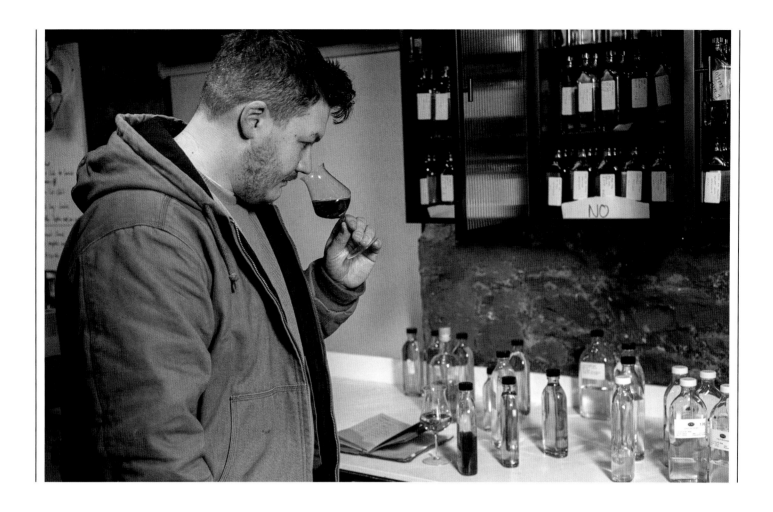

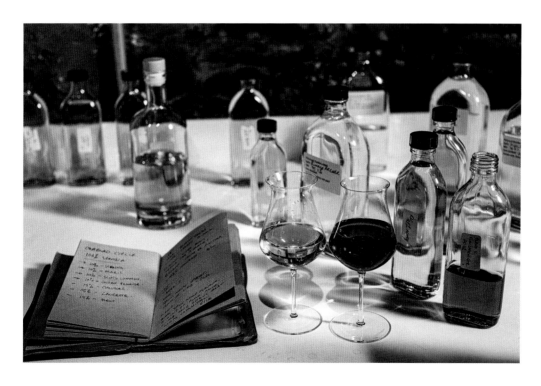

Manager Marc Watson is on the nose: "Our production is tiny, only 229,000 litres per annum, so the spirit has to be impactful and exciting."

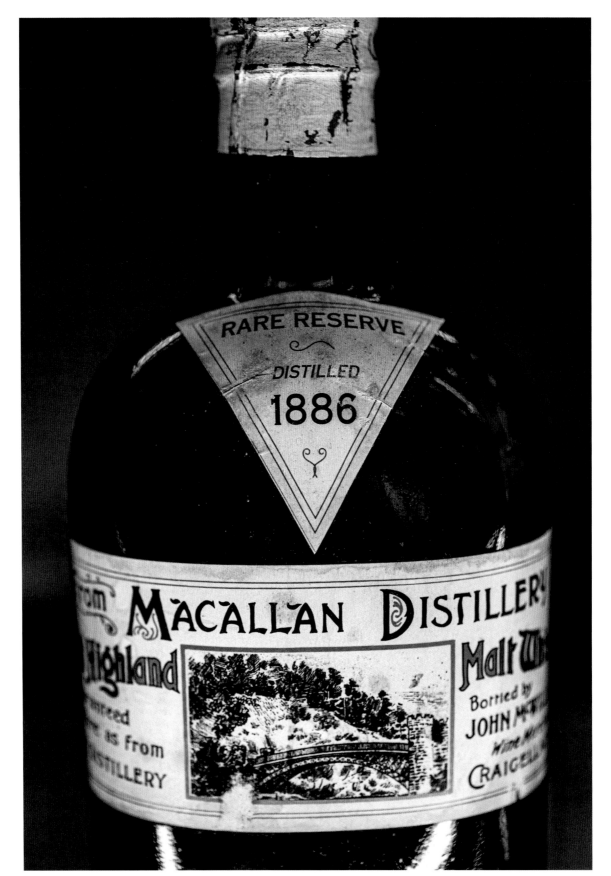

Part of
The Macallan's
visitor experience
is its Wall of Fame
– a collection of
398 historic
bottles, plus
nineteen decanters
and four flasks, on
permanent view.

THE MACALLAN DISTILLERY

EST. 1824

SPEYSIDE

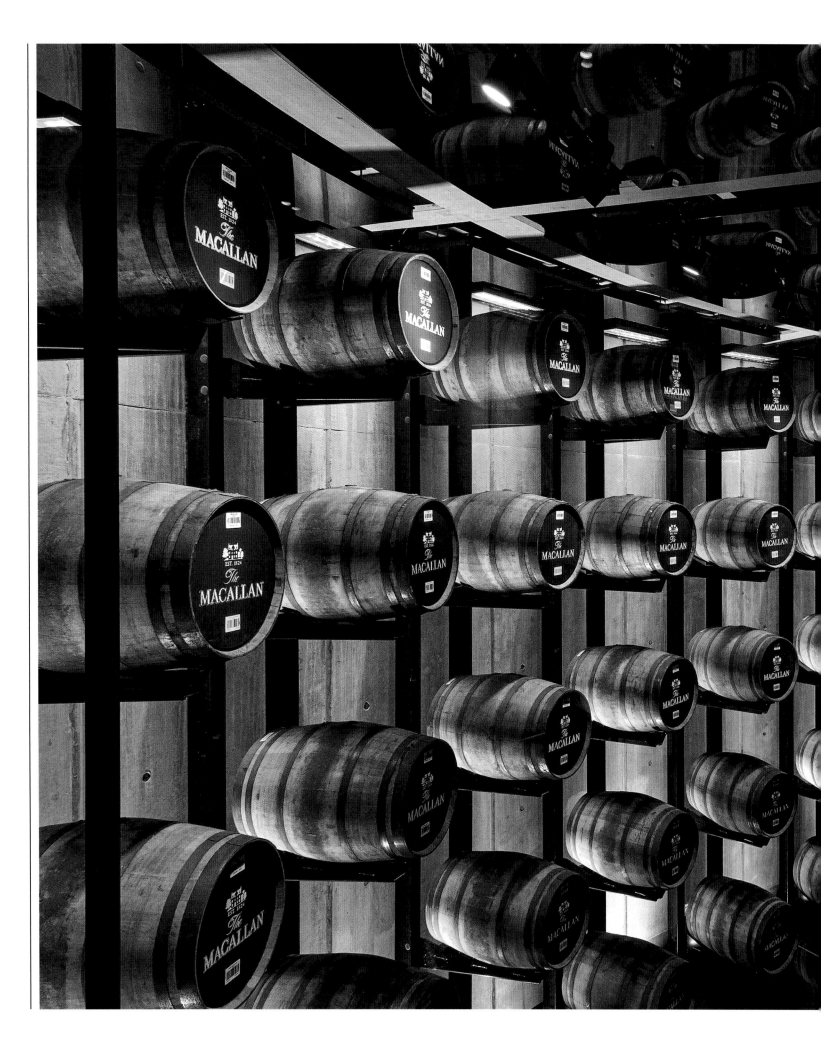

The Macallan Distillery

These are boom times for the Scotch whisky industry – twenty-plus new distilleries opened in the past few years, export rates rising by 20 per cent annually – and the embodiment of that confidence can be found clinging to a hillside a few hundred metres above the River Spey, near Craigellachie in Moray.

Many think The Macallan's £140 million facility, opened in 2018 and allegedly inspired by Scottish Iron Age roundhouses known as brochs, is the Disneyland of distilleries, but with its undulating grass roof studded with artificial hillocks, others liken it to… well, let's just say that Edrington, Macallan's owner, have reportedly forbidden all mention of the Teletubbies across the 485-acre estate. Once inside, all traces of the modest farm distillery The Macallan began life as in 1824 are obliterated by an expansive interior that, with its vaulted wooden ceiling and metal strut-work, is part first-class airport departure lounge, part private museum, with its 398-bottle archive (plus another 840 bottles in the "brand wall"). The distillery itself, pristine and oddly unpeopled with its thirty-six copper pot stills and twenty-one washbacks, looks to be housed in a kind of maximalist Damien Hirst vitrine. The Macallan had the foresight to target the emerging single malt market back in the 1980s and soon became a byword for premium collectability, pioneering the use of first-fill sherry-seasoned oak casks and enhancing its luxury brand status through collaborations with artists, designers and photographers (labels by Peter Blake and Ralph Steadman, photo shoots with Mario Testino, bottles designed by Fabien Baron and crafted by Lalique), and canny product placement: Macallan is behind the saloon bar in the sci-fi series *Westworld*; it's the tipple of choice for Frank Underwood in *House of Cards*; and, in 2012's *Skyfall*, supervillain Raoul Silva welcomes James Bond to his lair with "A fifty-year-old Macallan. A particular favourite of yours, I understand."

You'll find the latter quote on the distillery stairs (Macallan produced a ballot-only series of releases to mark the sixtieth anniversary of the Bond movie franchise in 2022), leading down from the amphitheatre-shaped bar to a cave privée, a private hosting space studded with 150 individually owned casks maturing within the building's foundations, which resembles the kind of inner sanctum a particularly louche dot-com billionaire might incorporate into his blast-proof bunker. The high-end high-jinks continue with honoured-guest accommodation in the gracious eighteenth-century Easter Elchies House, where Alexander Reid first established the distillery, and, down on the riverside, a chance to don Macallan tweed and go salmon fishing with their very own ghillie, the avuncular Robert Mitchell. You're not likely to land a bigger one than the record-breaking $2 million Macallan Fine and Rare 1926, sold at a Sotheby's auction in 2019, but, with every new release deemed a classic-in-the-making, this is one brand that's surely poised to ride the latest whisky wave.

You couldn't get much more "Speyside" than The Macallan – the storied river flows at the foot of the hillside on which the £140 million distillery stands.

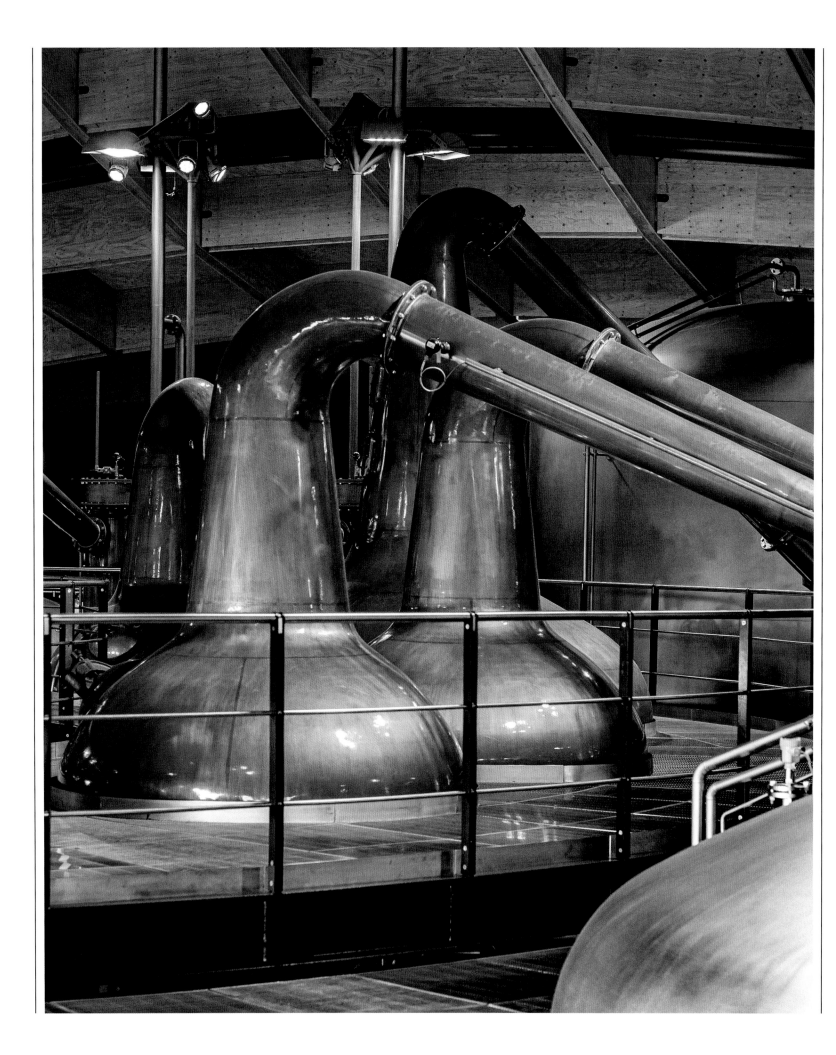

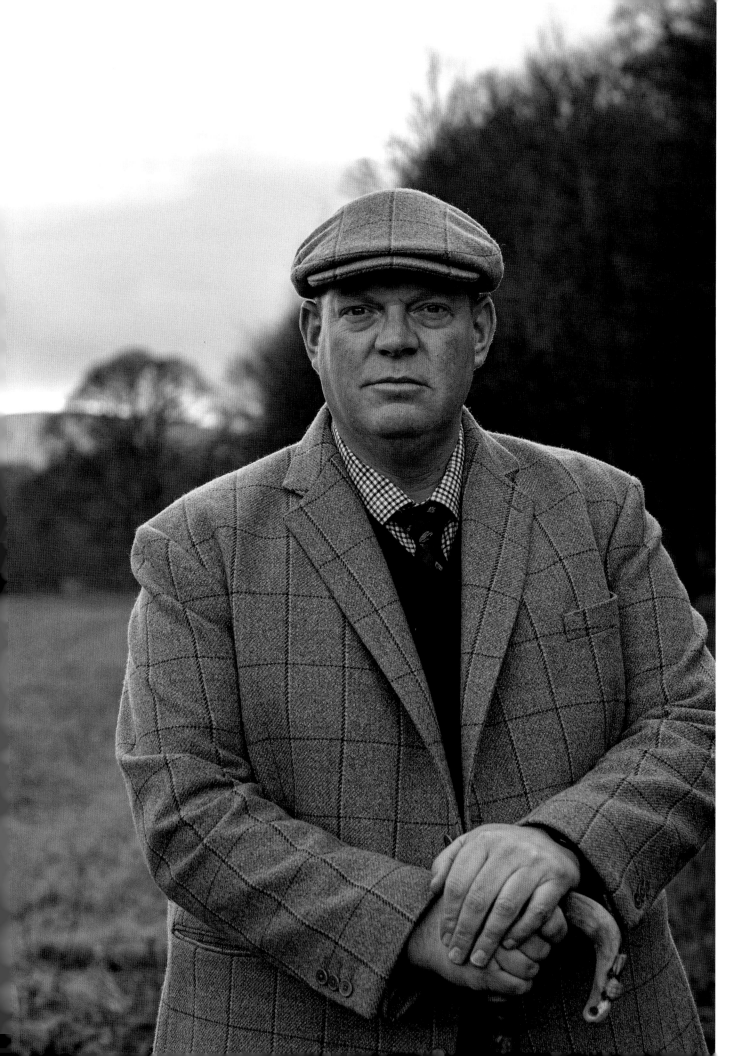

The order for thirty-six of The Macallan's "curiously small stills" was the largest in copper-smith Forsyth's history; less dauntingly, Robert Mitchell, The Macallan's ghillie, will take guests hunting and fishing on the Spey.

Where it all started: Easter Elchies House (and nonplussed bovine tenant), where barley farmer Alexander Reid established The Macallan (or, at least, made it legal) in 1824.

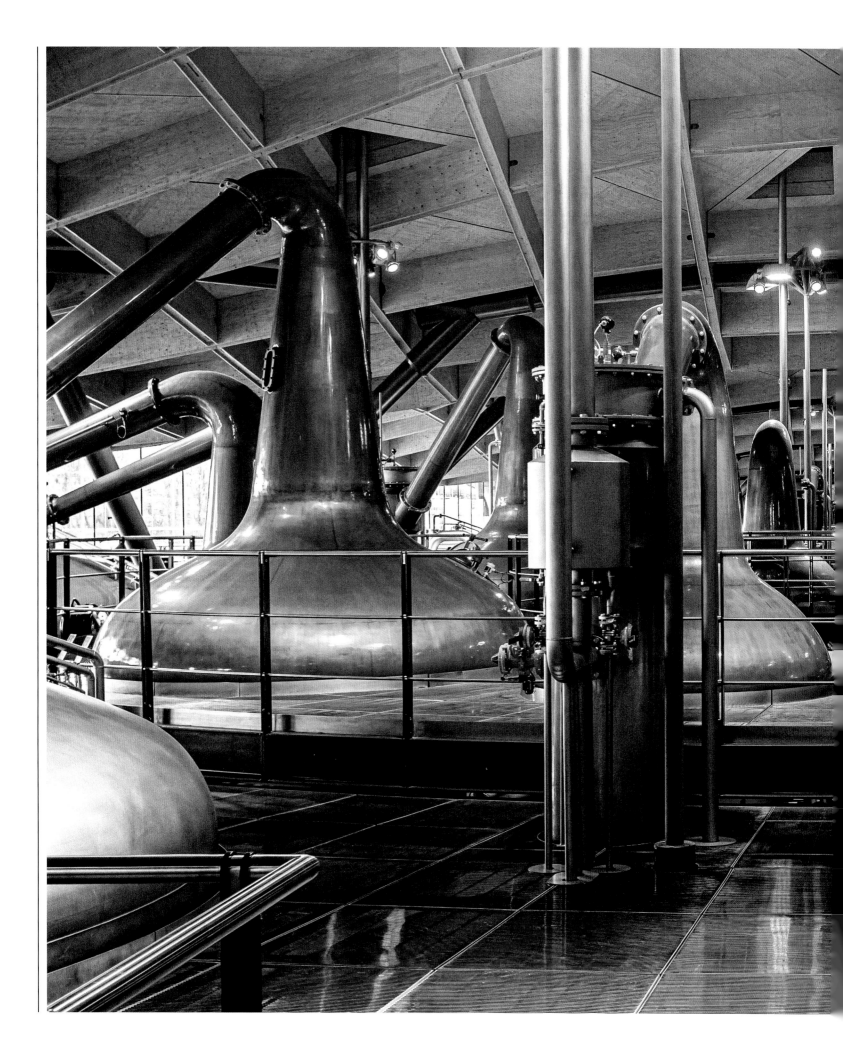

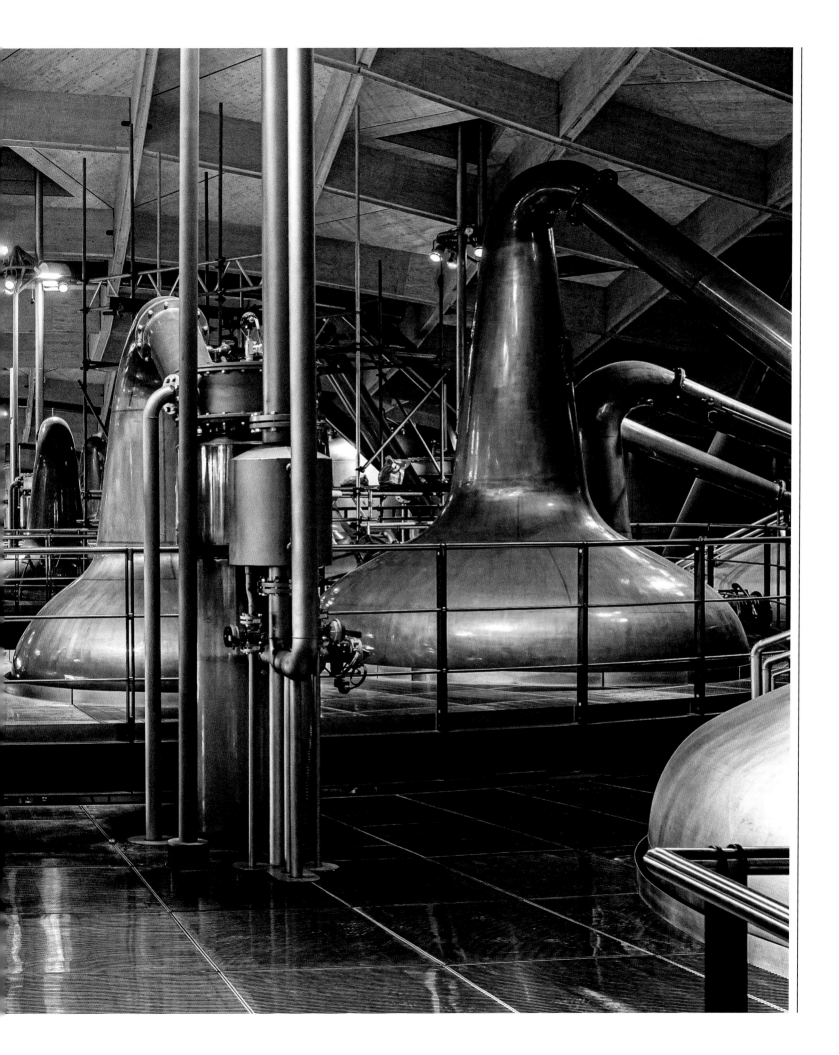

Strathisla has the distinction of being the oldest continuously operational distillery in Scotland; it's been producing whisky since 1786.

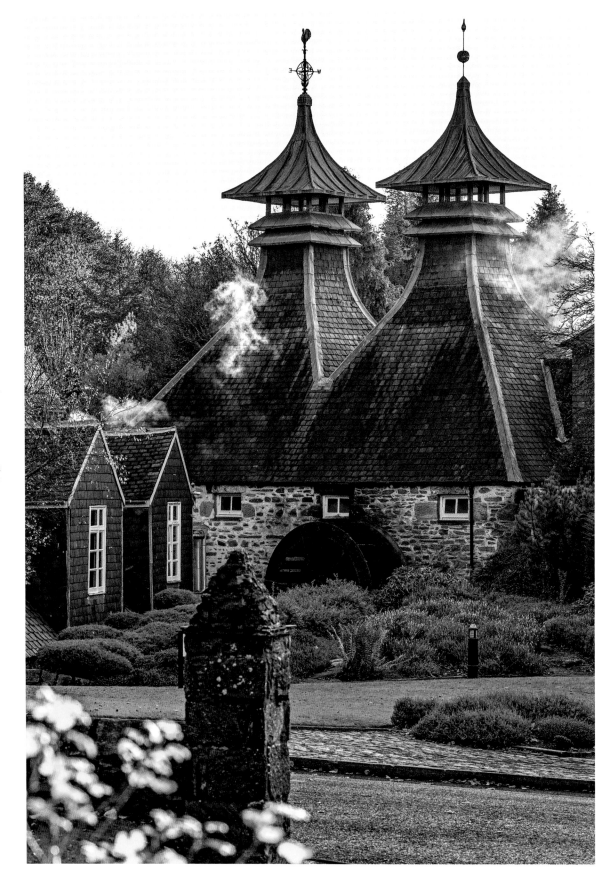

STRATHISLA DISTILLERY

EST. 1786

SPEYSIDE

"It's the stuff of chocolate boxes", says Strathisla's Sandy Hyslop, of the distillery's much-photographed facade.

Strathisla Distillery

Many distilleries come with bragging rights: this one's produced the most expensive bottle; that one's the most bracingly remote. Strathisla has the distinction of being the oldest continuously operational distillery in Scotland, having stood on its site in Keith, a historic town of solid Presbyterian manses in the Isla valley, since 1786. It may well also be among the most photographed, with its low-slung warehouse buildings, twin pagoda towers and manicured borders representing the Platonic ideal of the distillery vernacular. "It's the stuff of chocolate boxes", says Sandy Hyslop, "and, for me, the essential ingredient in making Chivas Regal whisky."

Strathisla has officially been the Home of the Chivas since the eponymous brothers acquired it in 1950; Hyslop, master blender here for nearly twenty years and only the fifth person to hold the post in almost two centuries, is responsible for such classic blends as Ballantine's, Glenlivet and Royal Salute, alongside Chivas Regal; in his blending room, "where my heart is", he oversees a team of fifty-four and personally noses around 250 samples a day, while tasting around five a week. "There are four tastes, five if you have to include umami," he says, "but there are 5,000 receptors inside your nose. That's why 95 per cent of my work is done on the nose."

Hyslop is the poster boy for the Chivas motto that "Success is a blend", In a world where single malts are getting sexed up, he carries the torch for the compounded. "If you love the single malt flavour you'll always be drawn to it," he acknowledges. "But a blend can offer you so much more. You get a myriad of flavours from different casks and distilleries in different proportions. It's a much more complex experience." And, he adds, a deeply subjective one. "It's filtered through everyone's individual sensibility. An apple note might conjure up the Cox's orange pippins your granny grew in her orchard. A cut grass note will remind you of the dens you built as a kid. You will access the flavour book inside your head."

Hyslop's task is twofold: ensuring quality and consistency among Chivas' marquee names (the citrusy, vanilla-y tang of a Glenlivet, the creamy butterscotch notes of a Chivas Regal), while going somewhat off-piste with limited releases like Royal Salute Polo or Glenlivet Caribbean Reserve. "That's where we can experiment with Argentinian malbec casks or Caribbean rum casks," he says. "I want the existing customers to get the flavours they like, topped off with these extra little nuances. It's taking the classics and giving them a twist."

Strathisla plays its part in conveying that enduring aspect to the world. Vintage wooden signage leads you to the still room, which looks out on more immaculate lawns; nearby is the Fons Bullen Well, from which the distillery draws its water, and which is said to be occupied by kelpies, shape-shifting spirits that pull the unwary down to a watery demise (thereby, in theory, enriching Hyslop's blends even further). In one of the earthen-floored dunnage warehouses is a crypt-like space containing the most prestigious Royal Salute cask of all, that sealed for Queen Elizabeth II's coronation in 1953 (and accessed by a key of suitably regal gleam and heft); Charles III's recent ascendancy has been similarly marked. These will be first among equals in the 6,500,000-strong cask inventory over which Hyslop and his team preside. What does he think a good whisky can do that no other drink can? "It's immensely versatile," he says. "Take Glenlivet Caribbean Reserve. We could make that into five completely different serves – neat, with ice, with water, in a cocktail, or a highball – and it has the flavour to support that. And whisky has an amazing finish, which you just don't get with other spirits."

Hyslop is the son of an antiques dealer, so he knows something about the way that covetable things, lavished with sufficient care and attention, appreciate with age. "My dad always stressed that it's not about one deal, it's about the long haul," he says. "And it's about attention to detail. This place" – he indicates Strathisla's jumble of roofs and cloistered courtyards – "reinforces that. You want venerability? It's all around us."

Fit for a king? The Royal Salute Vault houses the most regal blends.

The key to unlocking a good blend? "Taking the classics and giving them a twist," says master blender Sandy Hyslop.

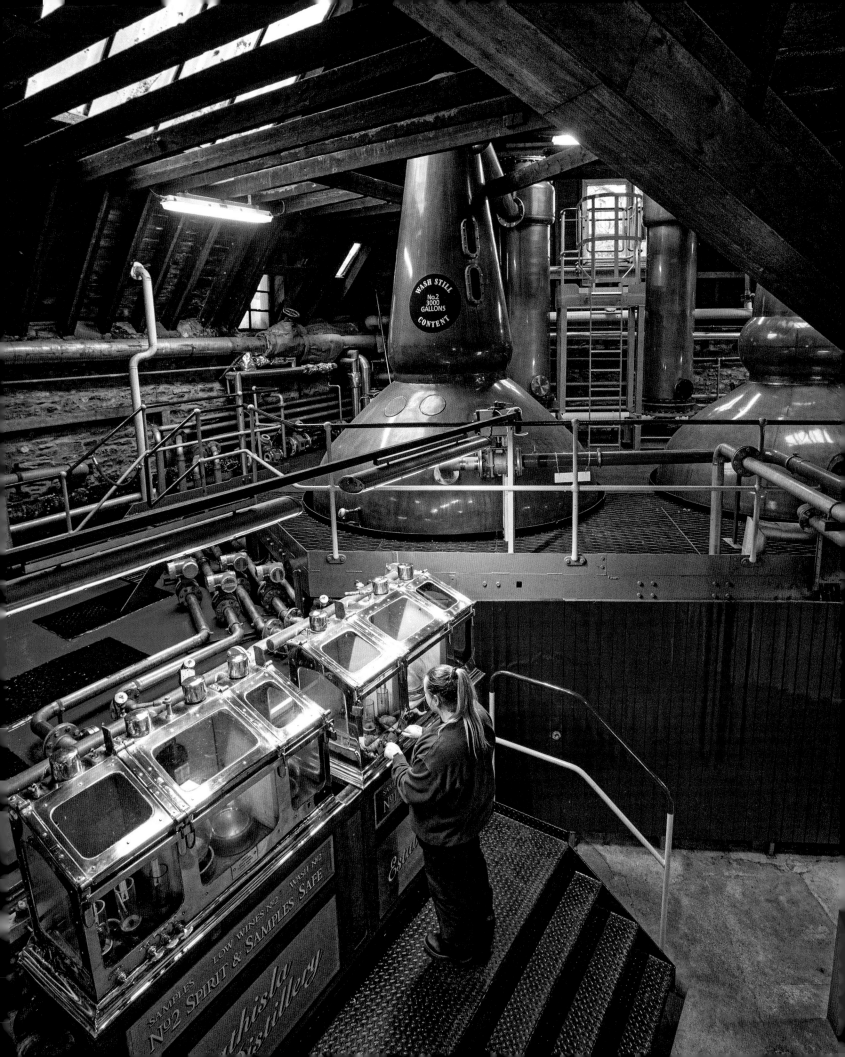

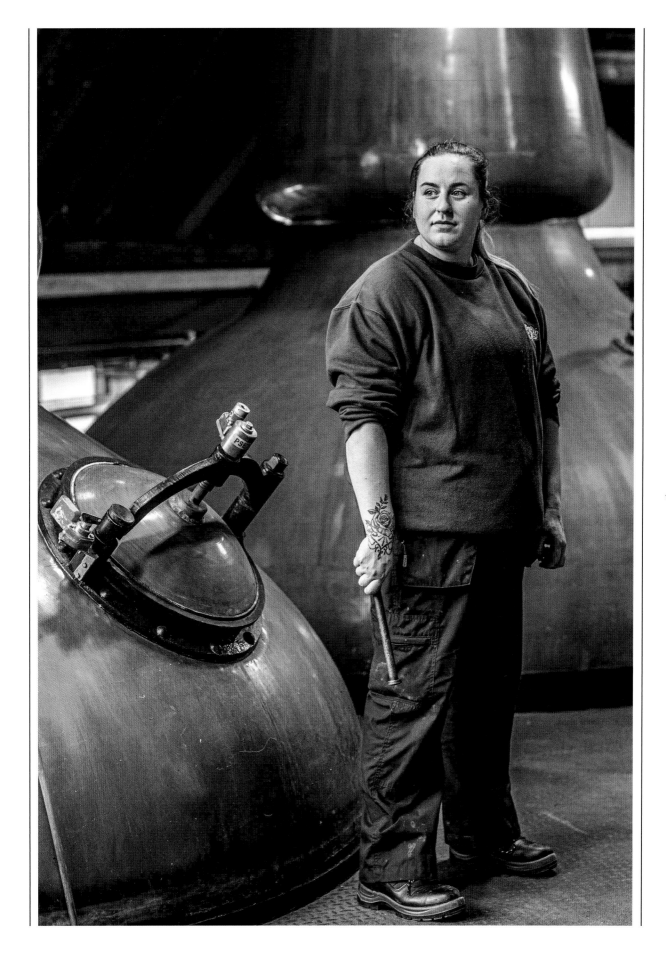

Strathisla has two spirit and two wash stills – and vintage signage. "It's the foundation malt in the Chivas Regal blend," says Sandy Hyslop.

"Everyone wants to know how you did it," says Sandy Hyslop. "What cask was it in? How long was the finish? It's not an exact science, which makes it perennially interesting."

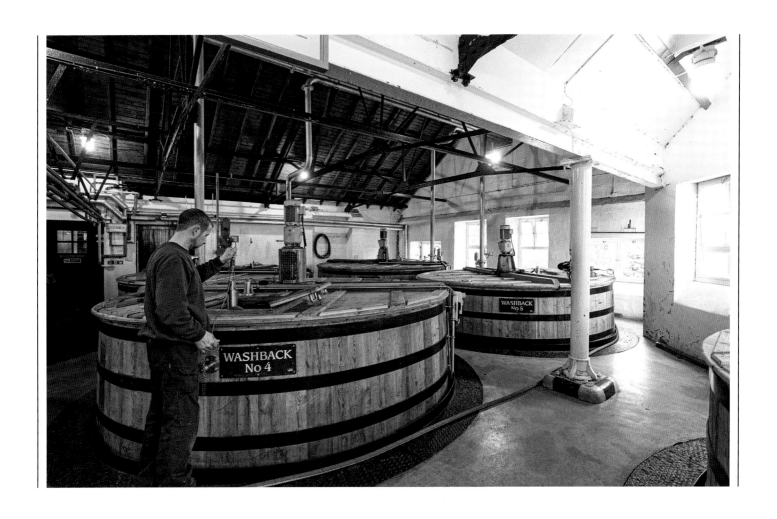

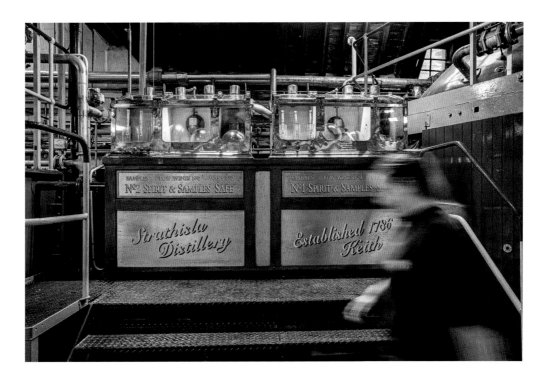

"What sets Strathisla apart? It's very beautiful, the stuff of chocolate boxes."

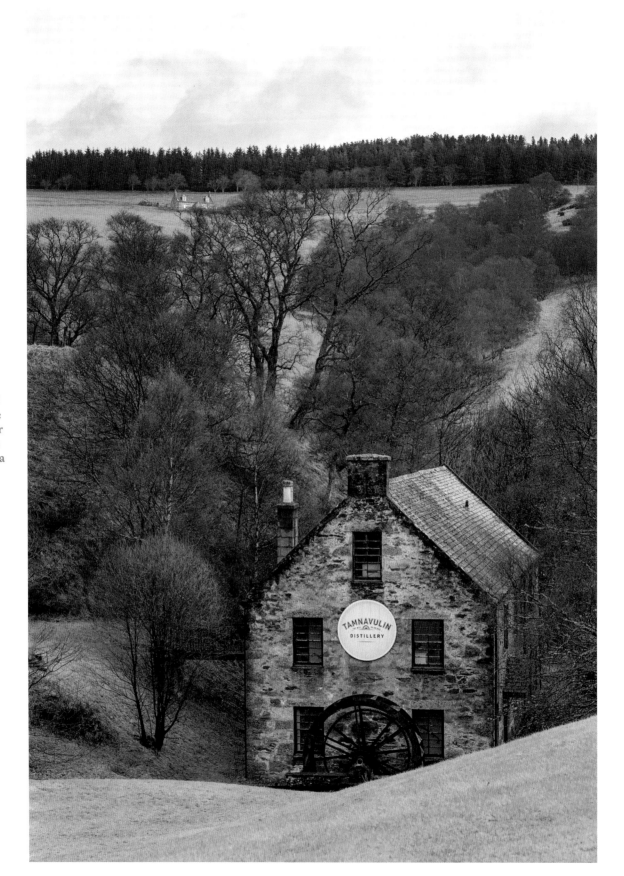

Tamnavulin's old mill house, on the banks of the River Livet, is set to be transformed into a visitor centre.

TAMNAVULIN DISTILLERY

EST. 1966

SPEYSIDE

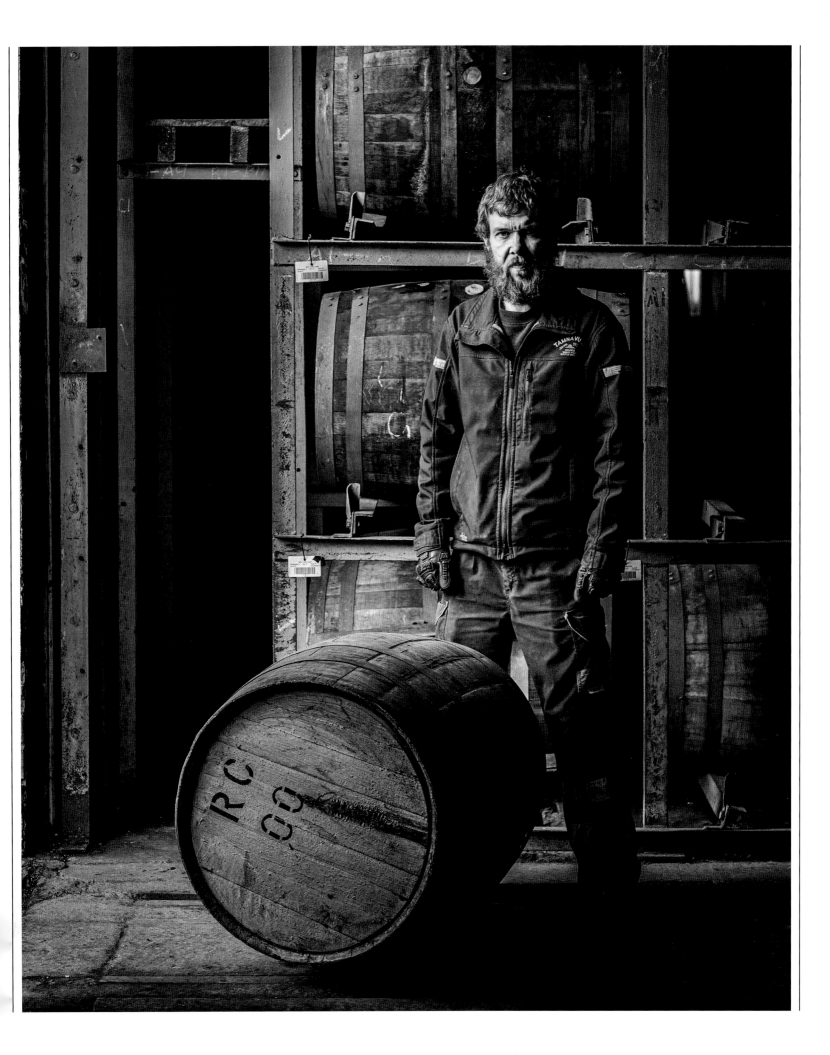

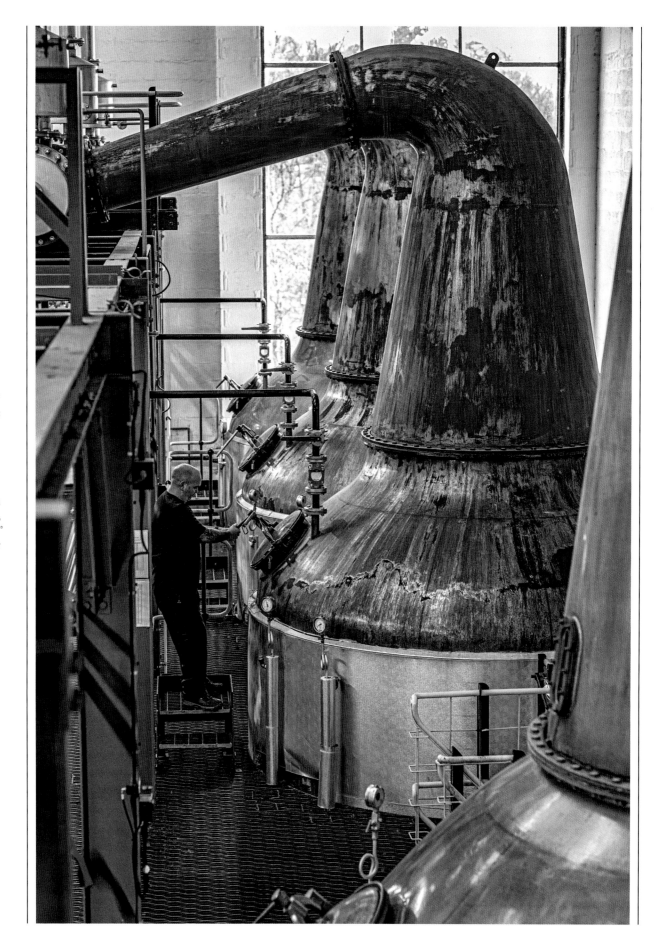

The shape of Tamnavulin's stills was changed in 2010: "The downward-sloping lyne arm gave us a much fresher, fruitier style," says manager Leon Webb.

Tamnavulin Distillery

Distillery interiors can sometimes resemble Heath Robinson fever dreams – all those copper workhorses and wooden washbacks and their attendant clanging, banging, mashing and thrashing. But they've taken the Robinsonesque spirit of ingenuity and improvisation to new heights at Tamnavulin, on Speyside, where one of their secret weapons is… a size 4 Mitre football. "It's the perfect size for what's called pigging the line, i.e. clearing the draff chute of draff," says Leon Webb, Tamnavulin's manager. "It barrels down the chute and flushes out the draff, so it doesn't freeze in the winter or cause a bad smell in the summer. It eventually winds up in a cage in the draff hopper, ready to use again."

It's not surprising to find such resourcefulness on display at Tamnavulin, which was built in the early 1960s, at the height of the last whisky boom, just above the glen of the River Livet (Webb is at pains to point out that they have the distinction of being closer to the Livet, from which the distillery draws its water, than a certain more celebrated neighbour). The brutalist exterior gives way to a power station-like interior with stunning sightlines across its half dozen stills, which were tweaked in 2010: "We went from a tall design with a horizontal lyne arm to a stumpier design, with a wide body and a downward-sloping lyne arm," says Webb. "It was a bold move to make, and a new direction for us."

It certainly seems to have paid off. The resulting spirit – short on fermentation, double-matured and enhanced through wine cask finishes, sweet, mellow and smooth on the palate, and described as "the taste of a summer breeze" by its burgeoning army of fans – has been the fastest-growing single malt in the past few years, winning gold at the Spirit of Speyside Awards and recently becoming a No. 1 bestseller in Sweden. How did that happen? "Great presentation, great liquid, great price," says Webb. "We keep things unpretentious here; we're sticking to our core principles of making good honest whisky in a beautiful rural setting. You'll find Tamnavulin in the supermarket at a competitive cost, and I think it punches way above its weight; I've heard people say that Tamnavulins are like old Macallans."

For the future, Webb intends to expand Tamnavulin's flavour profile, with oloroso, tempranillo and cabernet sauvignon casks taking their places alongside Tamnavulin's initial quartet of red wine casks: "It's a potentially more interesting group of flavours than pure ex-bourbon maturation," says Webb. They're also planning to make the most of their bucolic surroundings, converting the old mill house down by the Livet and its network of riverside footpaths into a visitor centre. Owners Whyte & Mackay have ambitions to double production and expand warehouse space. "We're relatively new kids on the block but the pace we're going at is extraordinary," says Webb. Just like that size 4 Mitre, Tamnavulin is on a roll.

Tamnavulin was built during the last whisky boom of the early 1960s: it now produces the world's fastest-growing single malt.

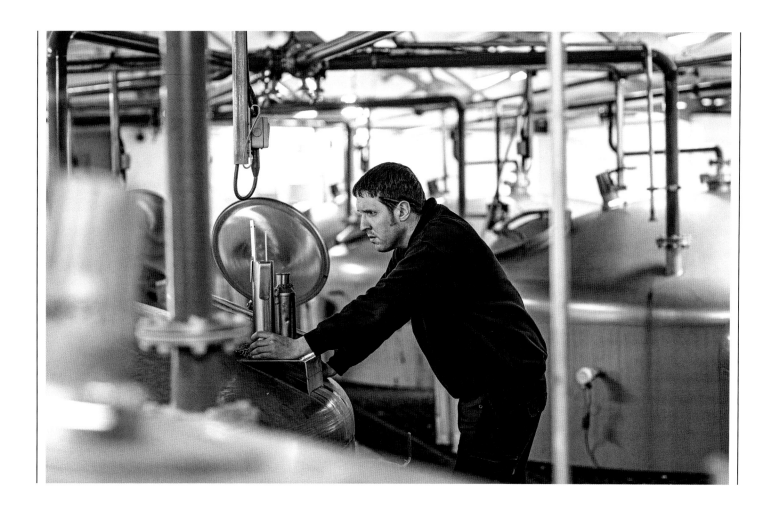

"We strip away the pretentiousness and the marketing," says Leon Webb; "the only thing that matters here is flavour."

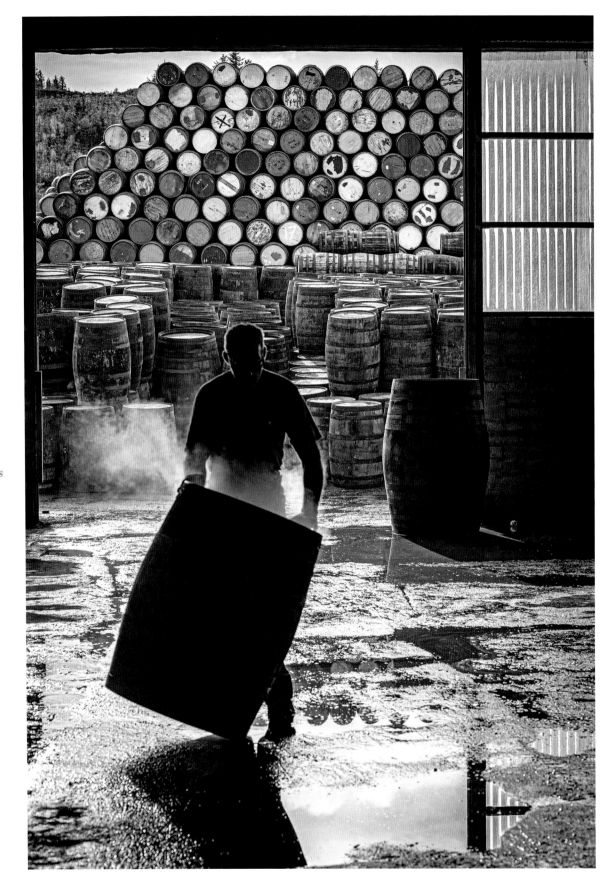

The Cooperage
was founded
in 1947, and
processes around
150,000 barrels a
year for distilleries
across Scotland.

SPEYSIDE COOPERAGE

EST. 1947

SPEYSIDE

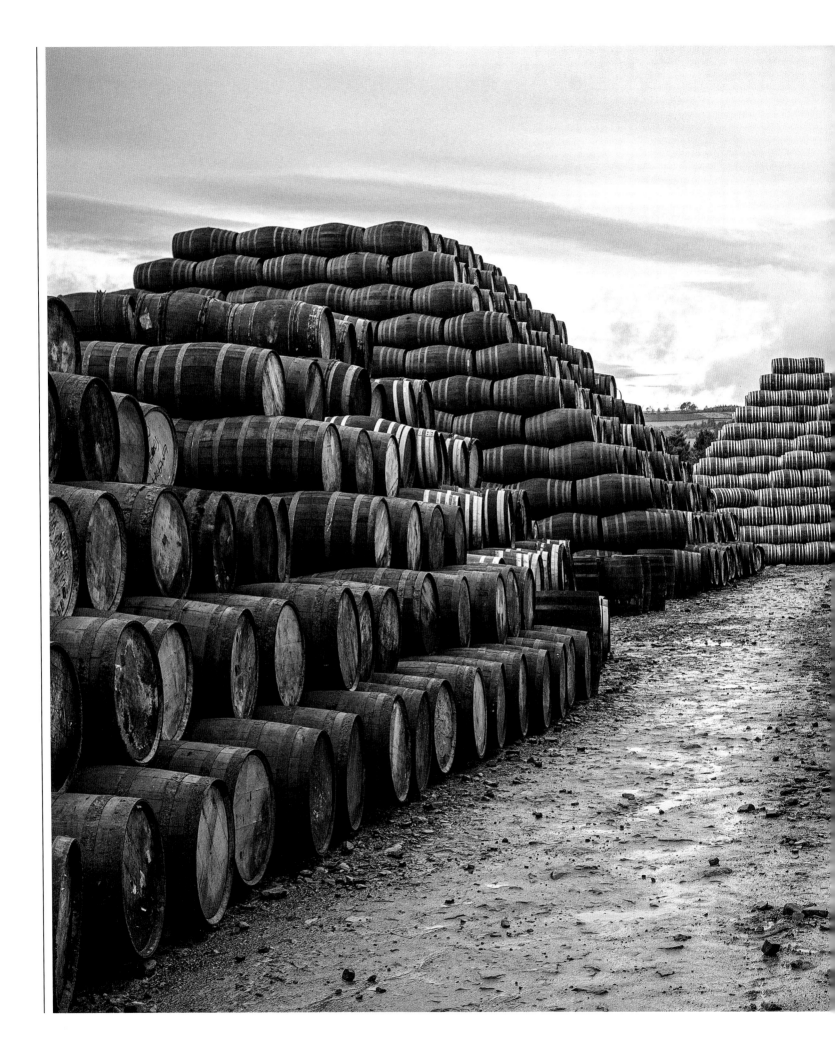

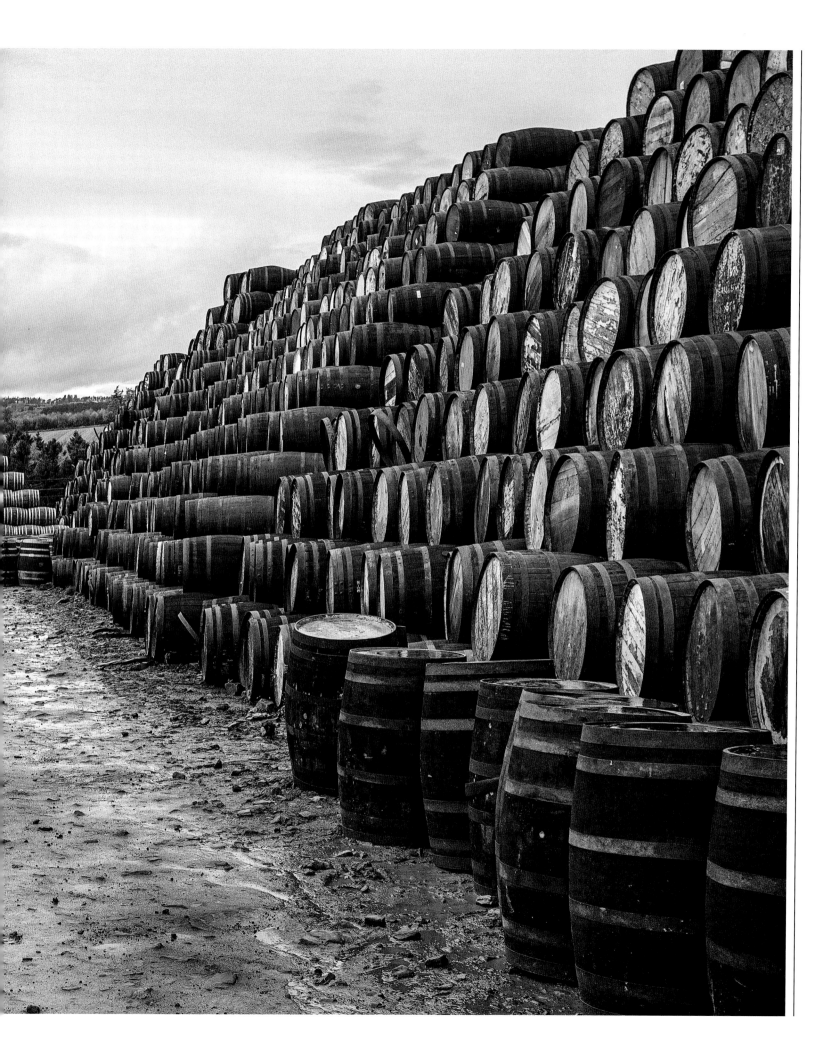

Speyside Cooperage

From the air, the precincts of the Speyside Cooperage could put you in mind of the banks of the Nile, rather than the river from which it takes its name, though instead of looming pyramids, you're confronted with great mastabas of oak barrels, multicoloured ends facing out, creating precipitous wooden canyons. It's rousing evidence that, here above the convivial town of Craigellachie, among Speyside's fifty-plus distilleries, there's an essential extra ingredient looming over whisky's traditional three: the cask.

"Any distillery will tell you that roughly 70 per cent of whisky's flavour comes from the barrel in which it's aged," says Stuart Hendry of the Glengoyne distillery, "so the integrity of the casks is absolutely crucial." That's where the Cooperage comes in. Founded by the Taylor family in 1947, and owned since 2008 by François Frères Tonnellerie, a cooperage group based in the Burgundy region of France with roots going back to 1910, it processes around 150,000 barrels every year, the majority of which will be European oak, largely from France, which has typically been used to age red wines and fortified wines like sherry and port in Spain and Portugal, or white oak from the Ozarks and the southern states of the United States which has previously housed bourbon (more exotic strains like Serbian black oak and Japanese mizunara oak are increasingly being deployed as resources grow scarce; Scottish oak, we're promised, is coming down the line as newly planted forests mature).

It's the coopers' job, after they've served their four-year apprenticeship, to reassemble and rejuvenate these barrels – or kilderkins, hogsheads, puncheons, butts or pipes, depending on their capacity – when they arrive at the Cooperage, making them whisky-ready. Wood shavings spill out of work stations like unruly mattress ticking; the metal hoops that girdle the casks pile up in corners like discarded giants' bangles; the many tools of the cooper's trade – adzes, stoup planes, jiggers, tapered augers, chivs – stand like sentinels, ready for deployment. The shop floor is a riot of thumping, clanging, roaring and whooshing, as its dextrous denizens inspect their charges for flaws with a fine brush, replacing any damaged staves without the aid of nails, glue or any adhesive – the whole thing is held together with precise fit and consummate skill – before rolling the casks to charring stations (where gas jets are trained on them for three to four minutes to break open the oak's pores and ensure the spirit and wood can thoroughly commingle) and steaming stations (where the wood is softened and made more malleable for finishing). Coopers here approach their tasks with alacrity, not least because they're paid by the barrel, though first among equals must surely be David McKenzie, who holds the Guinness World Record for building a 190-litre barrel from scratch, finishing in a scarcely credible 3 minutes 3 seconds. "The coopers are highly skilled, uniquely trained, and work against the clock on a daily basis," says Gill Reid, Speyside's Visitor Centre manager, "so setting a world record just seemed like a natural progression."

With the growing popularity of single malt, and the burgeoning interest among whisky aficionados in cask provenance, the Cooperage is, more than ever, the crucible of flavour; the casks that pass through the hands of these skilled artisans will have a decisive effect on the profile of tomorrow's drams. As the goggled-and-aproned coopers hammer, bore and roll away, the scene looks archaic, if not primal, and a visitor might recall the salient fact that the first recorded barrel-shaped vessel was made in ancient Egypt between 1580 and 525 BCE. Suddenly those allusions to Pharaonic splendour don't seem so fanciful after all.

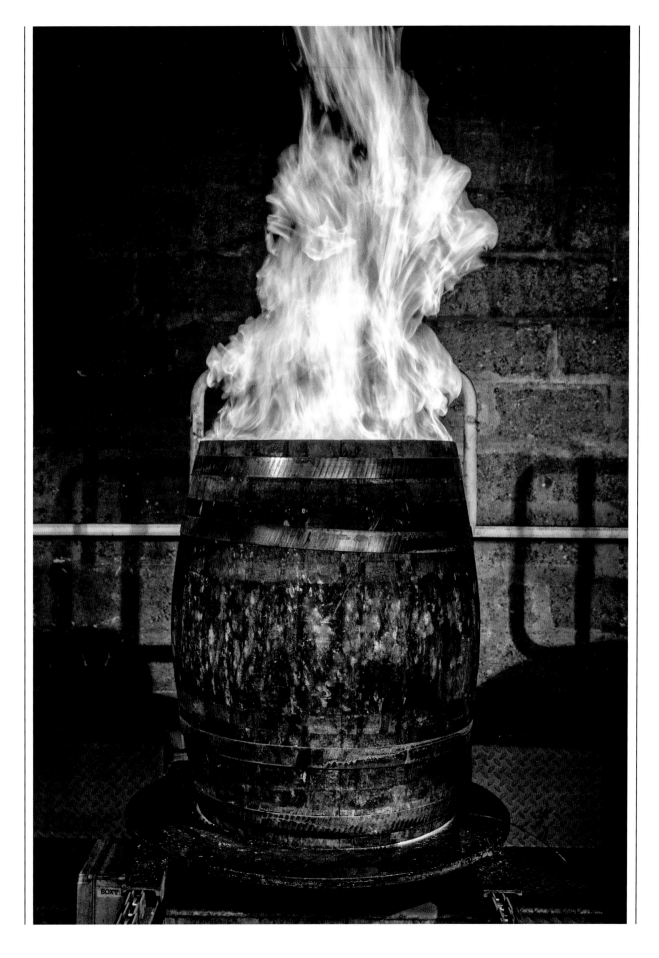

The heat is on; charring stations ensure that the oak's pores are opened to help deepen the flavour profiles in maturing spirit.

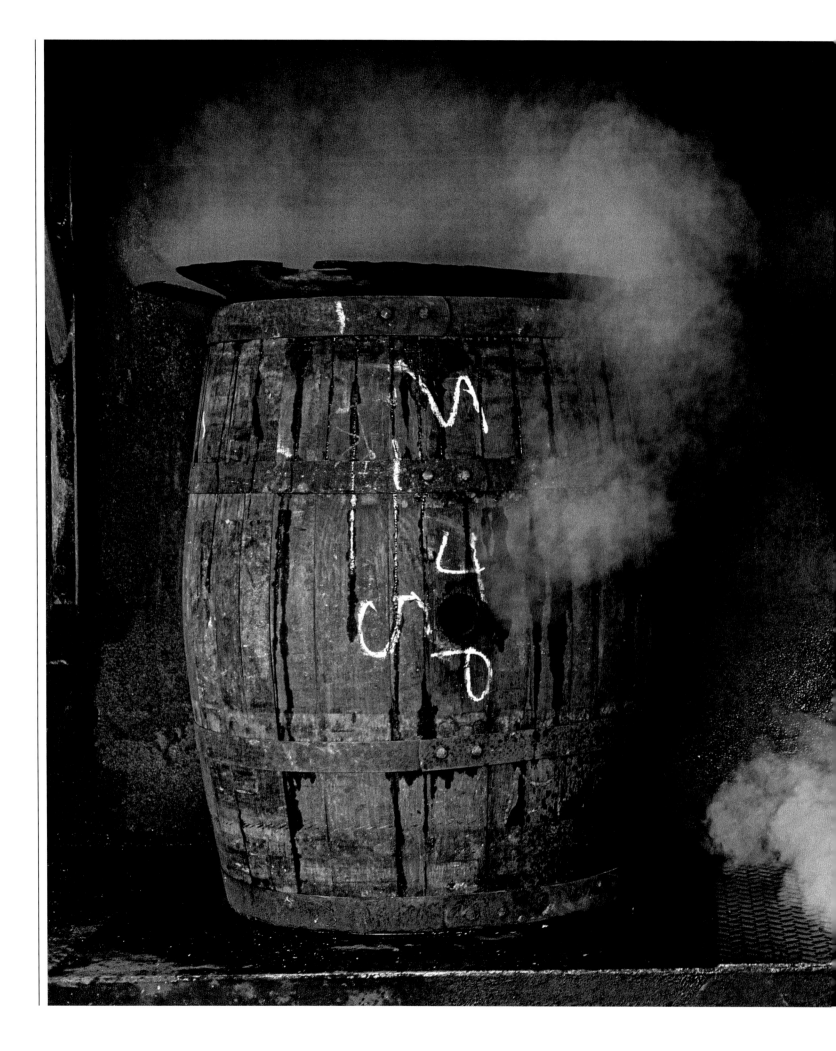

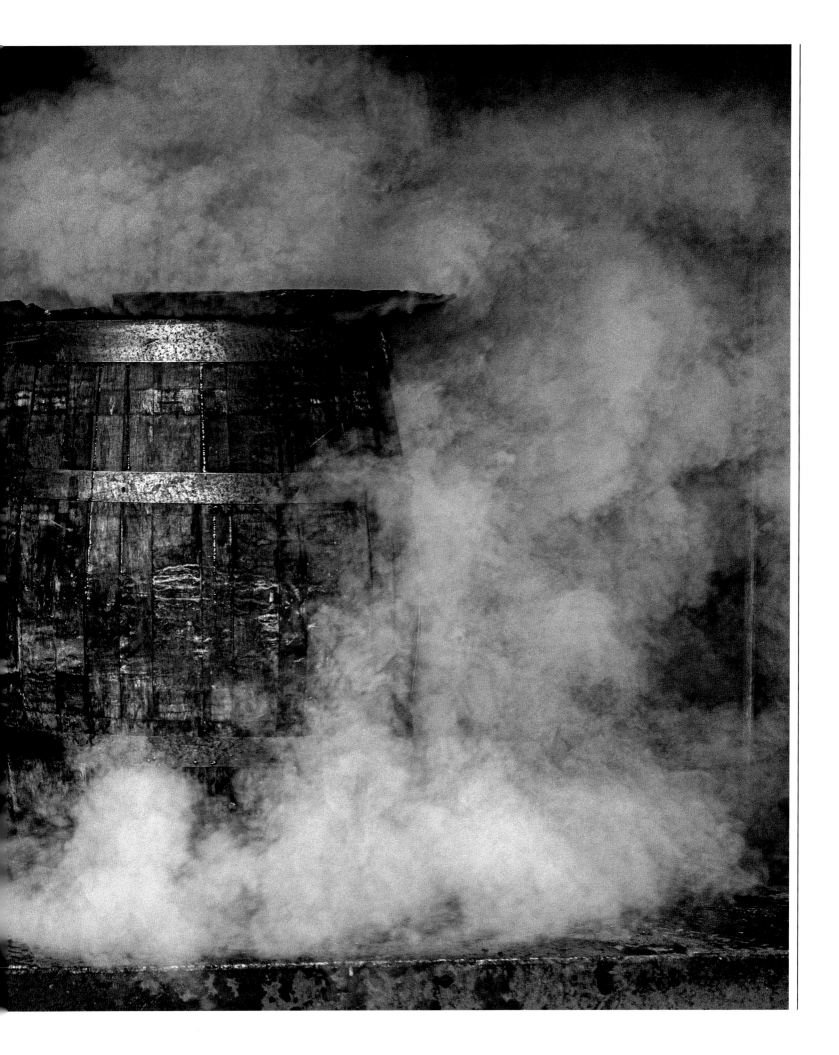

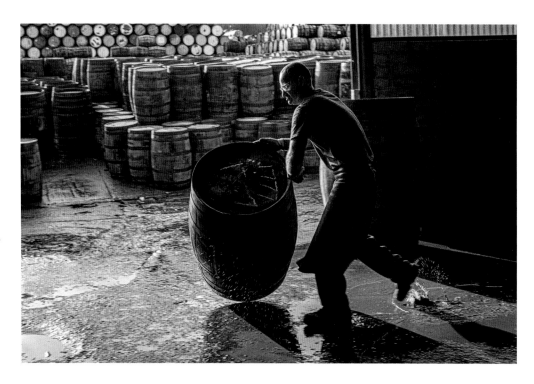

Over a barrel; the cooper's lot is an exceptionally skilful and physically demanding one.

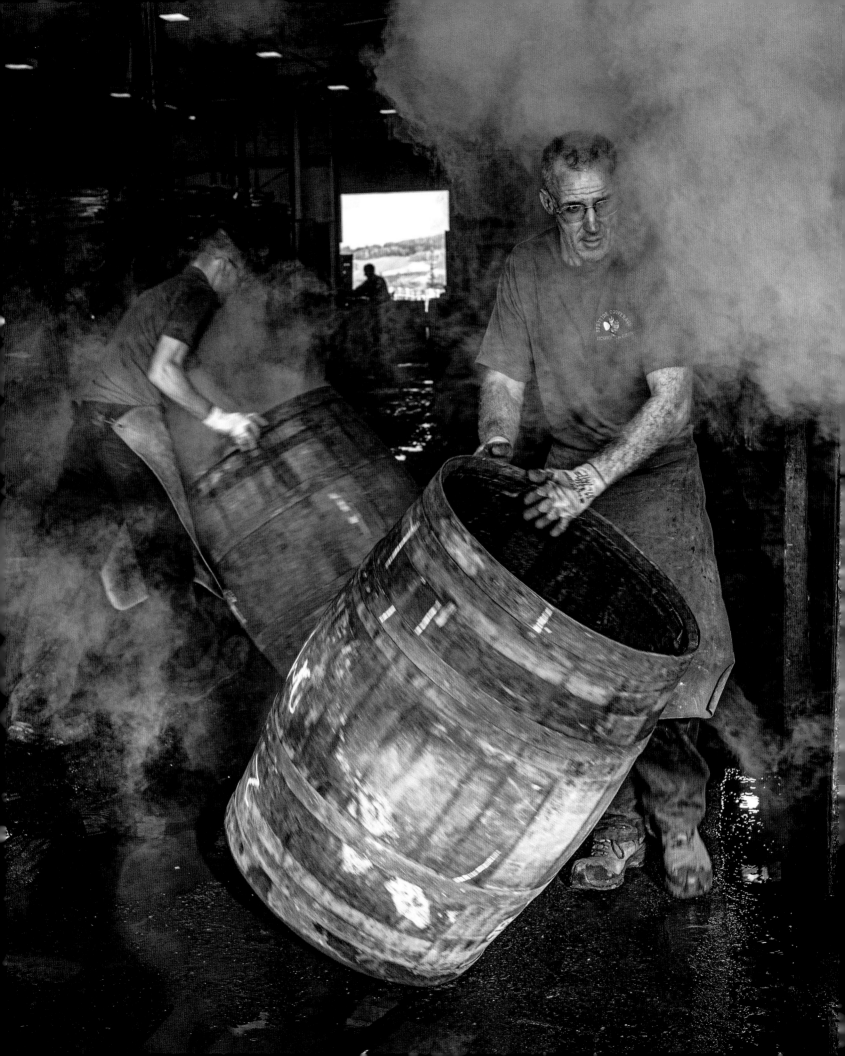

GLOSSARY

TYPES OF SCOTCH WHISKY

SINGLE CASK

A single cask whisky is a whisky hailing from a single distillery that's matured in just one cask rather than a range of casks. They're lauded among whisky enthusiasts for their higher alcohol content, unique flavour, and lack of colouring and filtration.

SINGLE MALT

Single malt whisky is, as its name suggests, singular. It must be distilled at a single distillery with only water and malted barley, and is produced by batch distillation in copper pot stills. Considered the purest expression of Scotch whisky, single malt is on the rise; in 1980 it accounted for just 1 per cent of global Scotch sales, today it's 15 per cent and counting.

SINGLE GRAIN

This type of Scotch is distilled at a single distillery with whole grains of malted or unmalted cereals (chiefly wheat) added to the core ingredients of water and barley. It is produced in continuous column stills and is relatively uncommon – you're more likely to find grain whisky in a blend – though Arbikie's rye whisky fits this category.

BLENDED GRAIN

Blended grain whiskies comprise a medley of single grain whiskies from multiple distilleries. In general, grain whiskies are less intense than malt whiskies.

BLENDED MALT

Blended malt whisky comprises a mixture of single malt Scotch whiskies from various distilleries.

BLENDED SCOTCH

Blended Scotch remains the most common type of Scotch whisky, accounting for 59 per cent of globally exported Scotch (though single malts, at 32 per cent, are catching up fast). It comprises a blend of single malt and single grain whiskies, with the exact components and proportions generally under the purview of master blenders such as Strathisla's Sandy Hyslop.

A TO Z

ABV

Abbreviation for "alcohol by volume" – the measure of how much pure alcohol, or ethanol, is contained in a liquid. Scotch whisky must contain a minimum of 40 per cent alcohol by volume.

AGE STATEMENT

This tells how many years the whisky has spent in the barrel before bottling. Scotch whisky must be aged for a minimum of three years before it can be sold as whisky. In the case of blended whiskies, the age statement must reflect the age of the youngest whisky used in the blend. Some distilleries now produce NAS – "no age statement" – where they disclose no information on how long the liquid has matured, arguing that age statements don't always reflect the quality of the product.

ANGEL'S SHARE

The name given to the alcohol that evaporates from a cask as the whisky is maturing in a warehouse. In Scotland, this amounts to 2 per cent of the contents of each cask each year.

BLENDED WHISKY

A whisky made by blending together any number of single malt and grain whiskies to create the required flavour and characteristics. These whiskies can originate from different distilleries and be of different ages.

CAMPBELTOWN

Once the whisky capital of the world, now on a roll again as a bunch of new distilleries open alongside the venerable Springbank. The smallest of the Scotch whisky regions, its distinctive smoky, oily and briny notes reflect its seaside location.

CASK

The wooden barrel used to mature the whisky, traditionally made from oak. Critical to its final taste and appearance, the chosen casks need to impart flavour without dominating the taste notes. The two workhorses for the Scotch industry are Oloroso sherry casks and American bourbon casks, though some are experimenting with red wine, tequila, mezcal and even Tokaji casks.

CASK FINISHING

When a whisky is transferred from one cask to another (usually one that formerly held a different type of alcohol) for a secondary, shorter period of maturation, to modify or deepen a flavour profile.

CASK STRENGTH

The strength of whisky as it comes from the cask. It is not diluted further before bottling and the strength can vary from 40 to 65 per cent ABV, depending on age. The younger the whisky, the higher the ABV will generally be.

CHARRING

The process of burning the inside of a cask. This blackens the interior, encouraging the natural compounds in the wood to mingle with the spirit once the cask is filled. The level of charring can be controlled to create the desired balance of compound to spirit.

CHILL FILTRATION

The process by which the natural substances that make whisky go cloudy when cold or diluted with water are removed before bottling. The whisky is chilled and the natural substances coagulate and are then removed by being passed through a series of metal meshes.

COLUMN STILL

Patented by Aeneas Coffey in 1860, a column or Coffey still is a large industrial still, consisting of two stainless steel columns, which allows for continuous, mechanised distillation.

CONDENSATION

The process where the alcohol vapours turn into the liquid spirit, with the help of a cooling apparatus that forms part of the still.

COOPER/COOPERAGE

A cooper is a person who makes or reconstitutes wooden casks, barrels, vats and similar vessels from staved timber for use in the whisky industry. The cooperage is the facility where the work takes place.

DISTILLATION

The alchemical process that turns the mildly alcoholic wash into highly alcoholic spirit. The wash is heated in a still and the alcoholic vapours evaporate and travel up the neck of the still and along the lyne arm, where they are condensed back into liquid form. Using single batch pot stills or column stills, distillers control the alcohol levels and the flavour profile of the final product.

DRAFF

The residue from the mashing process. It consists of barley husks and other detritus, or "combings", which are collected and removed and used as animal feed.

DRAM

A single serving of neat whisky, traditionally a 25-millilitre or 35-millilitre pour, hence the phrase "you'll have a wee dram?"

EXPRESSION

The name given to a different version of whisky – whether by age, distillation process or barrel type – from the same distillery.

FERMENTATION

The process of turning sugar into alcohol. In whisky production, a sugary liquid called wort is put into a container called a washback and yeast is added. This triggers the start of fermentation, and after a couple of days, when all the sugar has turned to alcohol, it is re-christened wash. At this point it has a strength of 5–8 per cent ABV.

FLOOR MALTING

A traditional method of producing malted barley now practised in very few distilleries, Springbank and Kilchoman among them. The barley is soaked in water and laid out on a wooden floor for about a week until germination starts to take place. It's very labour-intensive, with the barley needing to be turned by hand with a malt rake every four hours, day and night, to allow the heat and carbon dioxide to be released.

GRIST

Malted barley that has been ground up into a powder so that it can be added to water to become mash and the natural sugars present will dissolve.

HIGHLANDS

The most expansive Scotch whisky-producing region, covering an area stretching from just north of Glasgow and Edinburgh up to the far north coast, and encompassing full-bodied and sweet Northern Highland whiskies to peaty Eastern Highland varieties.

ISLANDS

The Scottish whisky region that covers all whisky produced on an island, from Lewis and Skye to the Orkneys. Most are known for their peaty, smoky character.

ISLAY

Nicknamed "Whisky Island" for its preponderance of distilleries – nine in total – and famous for its heavily peated expressions. Peat bogs cover most of the land and their freshly dug product is often used to fuel the fire in the malting process for smoky single malts.

KILN

The large vessel where malted barley is heated to stop the germination process and to remove moisture so that the barley is ready for milling. Most are powered by coal or oil, though some island distilleries still use peat fires, while the more eco-conscious deploy biomass boilers.

LOWLANDS

The Scotch whisky-producing region that covers the Central Belt between the cities of Glasgow and Edinburgh and everywhere south of that. Once a traditional powerhouse region, now just a few distilleries remain.

LYNE ARM

The part of the still where the spirit vapours are transported to be condensed back into a liquid. The arm is normally horizontal or close to it, though some distilleries have steeper angles, allowing some liquid spirit to travel back down into the still and be redistilled; distilleries tend to vigorously defend their individual styles as contributing something unique to the final product.

MALTED BARLEY

A type of cereal grain, similar to wheat or corn. Barley is malted when steeped in water and spread on a malting floor. The grain germinates, or sprouts, before being dried and heated. Many beers are also made with malted barley.

MASHING

The procedure where grist is added to warm water and the natural sugars are dissolved to form a sugary solution. It's then known as wort and is passed to a washback tank for fermentation to take place.

MASH TUN

A large circular tank or vessel made from cast iron, stainless steel or wood where the mashing process takes place. The mash tun is filled with a mixture of grist and warm water and the soluble sugars in the grist dissolve to form wort.

MASTER BLENDER

The person working for a company or distillery who scientifically/intuitively selects and then mixes whiskies of different origins or ages together – usually in the lab-like confines of a blending room – to form the required final flavour profile of a blended whisky.

MATURATION

The time taken for a whisky to gain the optimum amount of character from the cask in which it is being stored. The whisky spirit draws natural oils and substances from the pores of the wood while the cask pulls in air from the surrounding environment.

MILLING

The process where the dried malted barley grains are ground down into grist.

NECK

The section of a still between the pot (at the bottom) and the lyne arm (at the top). The width and height of the neck control the amount and type of alcohol vapours that are able to reach the top in order to be condensed back into liquid spirit.

PAGODA

The pyramid-shaped roof that provides ventilation from the kiln where the malted barley is dried. Pagoda roofs were the brainchild of architect Charles Doig, who drew inspiration from the graceful lines of Chinese and Japanese architecture.

PEAT

A layer of earth that lies below topsoil and consists of a heady mixture of grasses, plants, tree roots and mosses, compressed over thousands of years. The dense substance, when dried, makes excellent fuel, burning at a consistently high temperature and emitting acrid blue smoke. Traditionally used in the whisky industry to dry malted barley – it was often the only fuel available, particularly in the outer islands – the thick smoke is absorbed into the grains and infuses the rest of the whisky-making process.

POT STILL

Most commonly used in the production of single malt whisky, the pot still is made of copper, used for its excellent conductive qualities, and is formed of the squat "pot" at the base (where the alcoholic wash is heated), the neck (where the vapours rise up) and the lyne arm or condenser (where the vapours return to liquid form).

PPM

Stands for "parts per million" – the scientific measurement for showing the amount of phenols present in a whisky absorbed from the burning of peat. A heavily peated single malt typically has a PPM of 40 to 50; the highest-PPM whisky made so far, Bruichladdich's Octomore 8.5, boasts a PPM of 309.

PURIFIER

A device connected to the lyne arm that condenses heavier alcohol vapours extrinsic to the whisky-making process. It guides the liquids back down to the base, where they undergo further distillation.

QUAICH

A shallow two-handled drinking cup or bowl, traditional in Scotland for the drinking of whisky or brandy. "Quaich" derives from the Scots Gaelic for "cup." In the nineteenth century Sir Walter Scott dispensed drams in silver quaichs.

REFLUX

The name given to the recondensing of alcohol that then runs back into the still for redistillation. The amount of reflux is determined by the shape and size of the still and the angle of the lyne arm.

SHELL AND TUBE CONDENSER

A copper tubing that surrounds the lyne arm on a still. Cold water is fed through the tubing and this process cools the alcohol vapours and condenses them into liquid spirit. It is the most common type of condenser used in today's distilleries.

SINGLE MALT

Whisky that's made from 100 per cent malted barley and originating from a single distillery location. They generally contain slightly different ages of whisky from numerous different casks within the distillery's warehouse, brought together in a larger container to establish the required flavour profile. The age stated on the bottle is the youngest age of any whisky included.

SPEYSIDE

The largest Scottish whisky-producing region in terms of volume, with more than fifty distilleries stretching roughly between the cities of Inverness and Aberdeen, and all being at least within a lyne arm's distance of the mighty River Spey, which runs throughout. Speyside expressions are known for their fruity and spicy flavour profiles, generally going easy on the peat.

SPIRIT SAFE

A brass-framed box with glass walls, attached to the spirit still, used to analyse the spirit as it leaves the still. By law, the operator cannot come into contact with the spirit, and so it's padlocked, with a Customs & Excise officer having custody of the key.

SPIRIT STILL

The second and smaller in a pair of stills. The "low wines" from the wash still – the raw product of the first distillation stage – are redistilled in the spirit still, raising the alcohol level to 64–69 per cent ABV and clearing the alcohol of unwanted impurities. Only the idle section of this distillate – called "the cut" – is collected for maturation.

WAREHOUSE

The area where whisky is consigned during its maturation, often compared to vaults, hangars or (by whisky romantics) cathedrals. There are two main types: the dunnage or traditional warehouse with earthen floors and stone walls where casks are stored no more than three high; and the modern racked warehouse with temperature and humidity control, where casks are stored on racks up to twelve stories high.

WASHBACK

A large deep tub or vat in which the fermentation process takes place. Purists advance the efficacy of traditional wooden washbacks (particularly Douglas fir, both tight-grained and free of knots), but others advocate for modern stainless steel washbacks, for efficiency and consistency.

WASH STILL

The largest and first in a pair of stills. The fermented wash is heated and the alcohol vapours evaporate and are then cooled and reformed into a liquid by a condenser. The resulting liquid has an alcohol content of 20–22 per cent ABV and are called the low wines, which move on to the spirit still.

WHISKY VS WHISKEY

Broadly speaking, whiskey made in Ireland and the United States includes an *e*, while that produced in Scotland, Japan, Canada and India omit it (by law, in Scotland's case). It's believed that Irish producers began adding the extra vowel in the nineteenth century to differentiate their product from the Scottish version, and this new spelling was taken up elsewhere.

WORM TUB

A vintage apparatus used for cooling alcohol vapours back to a liquid spirit. The worm tub is connected to the lyne arm of a still and is formed of a long downward-spiralling copper pipe that is submerged in a wooden tub of cold water. The tub is usually positioned outside and was traditionally filled with rainwater. Less than ten distilleries in Scotland still have this system in operation, Springbank being one of them. Most others use shell and tube condensers.

WORT

The sweet liquid that results from mixing dried malt and hot water which kickstarts a chemical reaction leading to the creation of fermentable sugars.

AUTHORS

HORST A. FRIEDRICHS

Internationally renowned photographer Horst A. Friedrichs was born in Frankfurt in 1966. He studied photography in Munich and has worked for a number of leading publications including *National Geographic*, *The New York Times* and *The Observer*, taking portraits of everyone from Robbie Williams and Peter Gabriel to Tony Blair and Stephen Hawking. He alternates commercial commissions with more personal book-length projects in which he turns his incisive eye on various tribes and subcultures, from the Sufis in Pakistan to the Mods and Rockers of the British underground, and from independent booksellers to incorrigible British publicans (and their punters). He has published numerous books including the bestselling *Cycle Style*; *I'm One: 21st Century Mods*; *Or Glory: 21st Century Rockers*; *Drive Style*; *Denim Style*; *Coffee Style*; *Best of British*; *Bookstores*; *and Great Pubs of England* (all Prestel). He is currently based in London.

STUART HUSBAND

Stuart is a Hastings-based journalist whose work has appeared in *The Telegraph*, *The Observer*, *The Sunday Times*, *The Independent*, *Conde Nast Traveller*, *World of Interiors*, *Monocle* and *The Rake*. He is the author of *Bookstores* and *Great Pubs of England* with Horst A. Friedrichs.

ACKNOWLEDGEMENTS

This book could not have been realised without the enthusiasm and support of the following people: Neil Macleod Mathieson, CEO of Mossburn Distillers; and Chris Dumont, who gave invaluable advice.

Thanks to all who welcomed us in: Arbikie: Dr Kirsty Black, Christian Perez-Solar, John Stirling; Ardbeg: Colin Gordon, Kathryn Wilkie; Bruichladdich: Amy Brownlee, Adam Hannett, Allan Logan, Mary McGregor; Clydeside: Becky Marshall, Alistair McDonald, Andrew and Tim Morrison; Dornoch: Phil and Simon Thompson; Fettercairn: Kieran Healey-Ryder, Lucy Joss, Stewart Walker; Glengoyne: Liz Gunn, Stuart Hendry, Robbie Hughes, Katy Muggeridge; Holyrood: Calum Rae, Marc Watson; Isle of Harris: Mike Donald, Simon Erlanger, Eilidh Macdonald; Isle of Raasay: Norman Gillies; Speyside Cooperage: David McKenzie, Gill Reid; Kilchoman: Robin Bignal, Derek Scott, Anthony Wills – thanks for going above and beyond for the dig; The Macallan: Robert Mitchell – ghillie extraordinaire, Louise Mulholland, Lucy Walker; Nc'nean: Amy Stammers, Annabel Thomas, Gordon Wood, Doug the dog; Springbank: David Allen, Joyce Boyd, Barry Gray, Nicole Lindsay; Strathisla: Sandy Hyslop, Lauren Sendles White; Tamnavulin: Leon Webb; Torabhaig: Niall Culbertson, Iona Macphie, and Graham and Tracey for their expansive hospitality.

And thanks to Tom Lewis and Meeghan Murdoch for the intros and Jan Vissers for rolling the barrel. And to Wm Cadenheads: Cameron McGeachy, Jenna McIntosh, Carly Robertson.

Thank you to all at our publisher Prestel: Jonathan Fox, Andrew Hansen, Johanna Hansjakob, Curt Holtz, Corinna Pickart, Christian Rieker, Sabine Schmid, Will Westall and Pia Werner.

Thank you Charlie MacLean for the benefit of your whisky wisdom.

Special thanks to creative director Lars Harmsen, the book's design director, for your unerring work, unstinting enthusiasm and unbridled creativity. Your input during the making of this book, and your enduring friendship, are invaluable to us.

From Horst: Special thanks to my wife Adriana and my daughters Greta and Zoe, for their love, faith and inspiration.

From Stuart: Thanks to DC for keeping the glass half full.

Dedicated to our friend Toby Egelnick, who helped show us the way.

Slàinte Mhath
Horst A. Friedrichs & Stuart Husband

BRAND INDEX

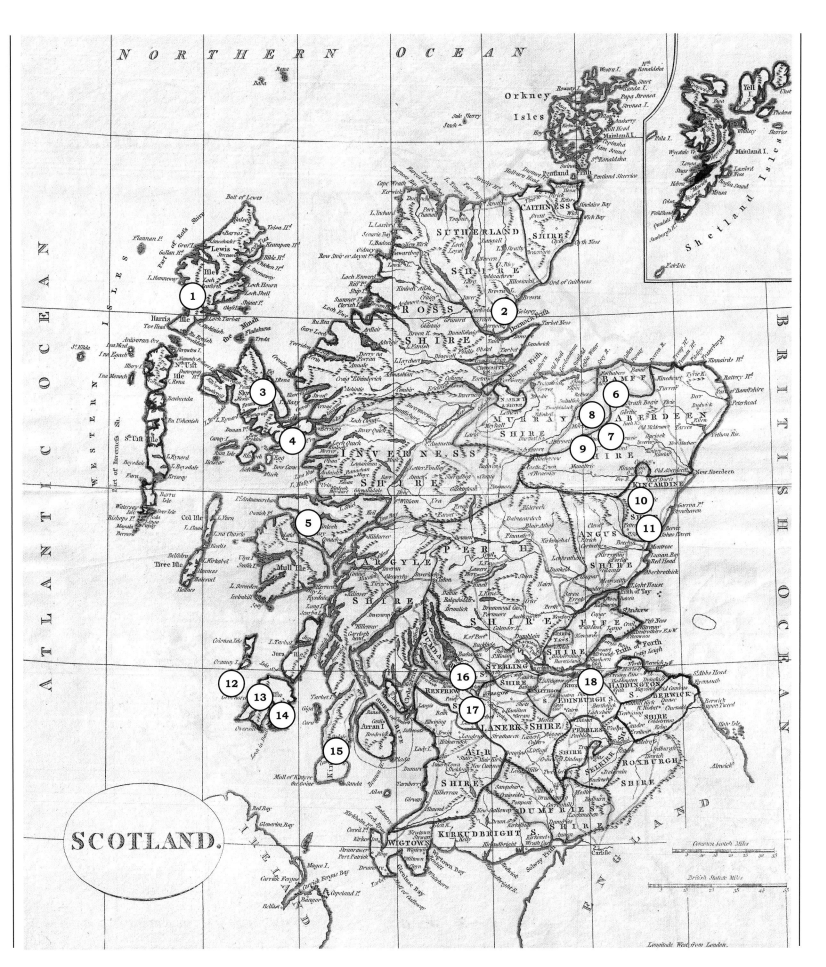

SCOTLAND.

© Prestel Verlag, Munich · London · New York, 2024
A member of Penguin Random House Verlagsgruppe GmbH
Neumarkter Straße 28 · 81673 Munich

© for images by Horst A. Friedrichs, 2024
© for texts by Stuart Husband and Charles MacLean (Foreword), 2024
© for design by Lars Harmsen, 2024
p. 239: PicturePast / stock.adobe.com

Front cover: Nc'nean Distillery, see pp. 82–97
Back cover: Springbank Distillery, see pp. 14–29

Library of Congress Control Number is available; a CIP catalogue record for this book
is available from the British Library.

Editorial direction: Sabine Schmid
Copy-editing: Jonathan Fox
Design, layout and typesetting: Lars Harmsen, Melville Brand Design
Production: Corinna Pickart
Separations: Reproline mediateam
Printing and binding: TBB, a.s., Banská Bystrica
Paper: Condat matt perigord

Penguin Random House Verlagsgruppe FSC® N001967

Printed in Slovakia

ISBN 978-3-7913-8972-1

www.prestel.com